TREASURES FROM CHATSWORTH
THE DEVONSHIRE INHERITANCE

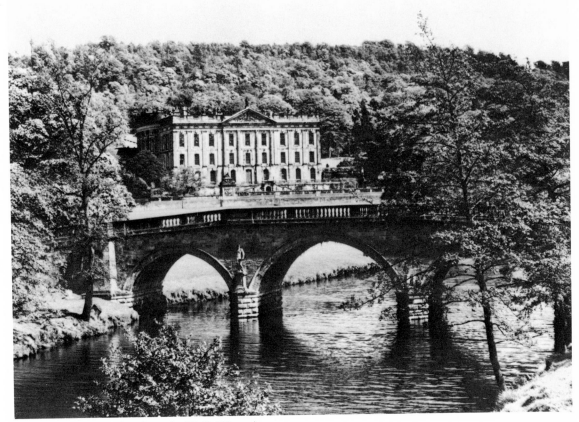

View of Chatsworth (photo by T. S. Wragg)

Treasures
from Chatsworth

The Devonshire Inheritance

INTRODUCTION BY SIR ANTHONY BLUNT

A loan exhibition from the Devonshire Collection,
by permission of the Duke of Devonshire and the
Trustees of the Chatsworth Settlement

ORGANIZED AND CIRCULATED BY THE
INTERNATIONAL EXHIBITIONS FOUNDATION
1979 – 1980

Corporate sponsors

AMCON GROUP, Inc., a Consolidated Goldfields Group Company

HAMBRO AMERICA, Inc.

SOTHEBY PARKE BERNET & CO.

This exhibition is supported by a Federal indemnity from the Federal Council on the Arts and the Humanities, and by a grant from the National Endowment for the Arts (a Federal agency). The catalogue is underwritten in part by The Andrew W. Mellon Foundation and by a grant from the British Council.

Special consultant: Washington Corporative Arts, Inc.

Front Cover: Cat. No. 12, Sir Joshua Reynolds, *Georgiana Spencer, Duchess of Devonshire, with Her Daughter*

Back Cover: Coat-of-arms of Spencer Compton Cavendish, 8th Duke of Devonshire

Participating Museums

VIRGINIA MUSEUM OF FINE ARTS
RICHMOND, VIRGINIA

KIMBELL ART MUSEUM
FORT WORTH, TEXAS

THE TOLEDO MUSEUM OF ART
TOLEDO, OHIO

SAN ANTONIO MUSEUM ASSOCIATION
SAN ANTONIO, TEXAS

NEW ORLEANS MUSEUM OF ART
NEW ORLEANS, LOUISIANA

THE FINE ARTS MUSEUMS OF SAN FRANCISCO
CALIFORNIA PALACE OF THE LEGION OF HONOR
SAN FRANCISCO, CALIFORNIA

Contents

Acknowledgments

IT IS WITH THE GREATEST PLEASURE that I write these few words preceding the catalogue of "Treasures from Chatsworth," the fourth loan exhibition from the collection of the Dukes of Devonshire that it has been my privilege to organize. It continues the tradition begun in 1962–63 with "Old Master Drawings from Chatsworth: I," and followed by "Festival Designs by Inigo Jones" (1967–68) and "Old Master Drawings from Chatsworth: II" (1969).

The present exhibition, however, represents a departure from these earlier projects, since it is drawn from the entire collection of masterpiece paintings, jewelry, furniture and decorative arts objects assembled at Chatsworth by fifteen generations of the Cavendish family. For this reason the exhibition not only constitutes an exceptional aesthetic experience but also provides a unique opportunity to view the development of one of the world's foremost private collections in a social and historical context.

The organization of an exhibition of this scope and complexity, developed over the course of four years, necessarily requires extraordinary efforts from those involved in bringing the project to fruition.

First and foremost, we are profoundly grateful to Their Graces, the Duke and Duchess of Devonshire, and the Trustees of the Chatsworth Settlement, for so generous a loan. Their willingness to part with these treasures for an extended period in order that they may be seen and appreciated by American audiences is in keeping with the warm spirit of cooperation that has characterized our long and rewarding association with Chatsworth.

A similar debt of gratitude is owed our late friend and colleague Thomas S. Wragg, Keeper of the Devonshire Collections for some fifteen years, who gave unstintingly of his time and expertise from the moment the idea was conceived in 1976. The work begun by Tom has been carried on in exemplary fashion by his successor Peter Day, ably assisted by Michael Pearman and Christine Tindale. In addition to attending to the many complex practical details involved in preparing the loans for travel, Peter Day has contributed to the organization and writing of the exhibition catalogue, and we are deeply in his debt.

Our warm appreciation goes also to Sir Anthony Blunt, who so willingly under-

took the difficult task of organizing and editing the catalogue, in addition to preparing the illuminating catalogue Introduction and many of the entries.

We are pleased to acknowledge our debt to the National Endowment for the Arts (a Federal agency), which has given a most generous grant in support of this project. Additional support has been received from AMCON GROUP, Inc., a Consolidated Goldfields Group Company; HAMBRO AMERICA, Inc.; SOTHEBY PARKE BERNET & CO.; the British Council; and The Andrew W. Mellon Foundation. The exhibition is also supported by a Federal indemnity from the Federal Council on the Arts and the Humanities. Our sincere thanks go to all these public-spirited organizations for making the exhibition financially possible.

Special thanks are due the British Ambassador, Sir Nicholas Henderson, who has graciously agreed to serve as honorary patron of the exhibition during its American tour. We also wish to express our gratitude to Mr. Hugh Crooke, Cultural Attaché at the British Embassy, for his interest throughout the organization of the exhibition.

Many others have contributed their assistance. George Sexton's considerable talents in the design field have proved invaluable to the success of the project and we have enjoyed this opportunity to collaborate with him. Anne Somers Cocks, John Cushion, Arthur Grimwade, Helena Hayward and Diana Scarisbrick deserve our special gratitude for their scholarly contributions to the exhibition catalogue. We are likewise most grateful to the directors and staff members of the six participating museums, who have provided enthusiastic cooperation at every stage. Thanks also go to Mabel H. Brandon for her invaluable assistance in securing financial support for the project. And we appreciate the willingness of John A. Dent to lend the architectural model of Chatsworth which he has so expertly crafted.

Once again we wish to express our gratitude to William Glick of The Meriden Gravure Company and to Freeman Keith of The Stinehour Press, whose interest and expertise have resulted in the production of yet another fine catalogue. Special mention is due Taffy Swandby, who has devoted countless hours to the task of compiling and editing the catalogue material and seeing the publication through the press.

Lastly, I want to extend heartfelt thanks to the Foundation staff—notably Christina Flocken, Crystal Sammons, Taffy Swandby and Heidi von Kann—who have patiently and efficiently coped with a myriad of practical details and labored diligently to insure the exhibition's success.

ANNEMARIE H. POPE
President
International Exhibitions Foundation

Foreword

MY FAMILY and I are immensely proud that this exhibition from Chatsworth should be presented at a number of famous museums in the United States. Although many of the works of art from the collection have been shown all over the world, this is the first comprehensive exhibition that reveals the breadth and scale of what Chatsworth contains.

Sir Anthony Blunt, in his brilliant and lucid Introduction, has written of the former Dukes of Devonshire who have contributed to the collections at Chatsworth and there is little I wish to add.

I think it is fair to say that Chatsworth and its contents have been built up by a fortunate combination of circumstances.

The 1st Duke built the main part of the house as it is today. The 2nd laid the foundations of the great collection of drawings. The 4th altered the park and garden and built the beautiful bridge and the stables; and perhaps even more important, he married a great heiress, Lady Charlotte Boyle, daughter of the collector and architect, the Earl of Burlington. The 5th Duke married the famous Georgiana and although he did not treat her particularly well, he did at least pay her enormous gambling debts and had her and his second wife, Lady Elizabeth Foster, painted by Sir Joshua Reynolds. The 6th Duke, who remained a bachelor, bought lavishly—two complete libraries, sculpture, pictures and many curiosities. He laid out the garden as it is today, and he indulged his passion for building by adding the long north wing to the house.

After the 6th Duke died in 1858 my family ceased to be collectors. However, succeeding dukes had the great merit that while they may not have been buyers of works of art, they did not sell them either; and the depredations sustained by the Chatsworth collection have been due solely to the demands of taxation.

On the death of the 8th Duke of Devonshire my grandfather was compelled to sell the incomparable collection of Shakespeare items and Caxton printed books. And worse was to follow on the death of my father in 1950 when, as Sir Anthony has mentioned in his Introduction, eight of the finest treasures from Chatsworth were sold to the nation in part payment of death duties. They are now in public museums in England and I suppose it is ungracious of me to regret their departure from the

house, but I am afraid I do. Many wonderful things remain here at Chatsworth, nevertheless, and my wife and I do not regard them as our possessions but ourselves as the life custodians of what has been at Chatsworth for centuries.

As to the present, it poses many serious problems. High taxation and inflation affect every family, mine included, but thanks largely to the support Chatsworth receives from the people who visit the house and garden (over 250,000 a year), and a devoted staff, it is possible to maintain it in good order. I have every reason to hope that, given reasonable cooperation by future governments, arrangements can be made to ensure that Chatsworth will continue to be a focal point for visitors who wish to come and see beautiful objects in a magnificent house surrounded by splendid scenery, as it has been for 150 years.

As for myself, I have tried to add to the collection, albeit on a far more modest scale than my forebears. I am particularly interested in augmenting what already exists—such as the collection of minerals, to which I have been fortunate enough to add some very fine specimens. Again, we have a splendid selection of illustrated books of flowers, plants, birds and shells; and I have been able to make a considerable contribution to this special section of the library. As to the paintings and sculptures I have bought, time alone will show whether my judgement is right or wrong.

Devonshire

The History of the House and Collections

THE EARLS AND DUKES OF DEVONSHIRE were active in many fields—politics, finance, industry and agriculture—but their energies and abilities found what was perhaps their most splendid expression in the Fine Arts, particularly building and collecting. In Tudor times the great foundress of the Cavendish family fortunes, Bess of Hardwick, was never happy unless she was building, and her descendants, at least from the 1st to the 6th Duke, devoted much time and zeal to building Chatsworth, rebuilding Devonshire House in London after it was destroyed by fire in 1733, and filling both houses—as well as the great Elizabethan mansion remaining at Hardwick—with the superb furniture and works of art that are now all concentrated at Chatsworth.

The combined result of the energies and ambitions of the Dukes of Devonshire was to create something unique—and uniquely English. In no other country do we find the blend of features which go to make up the great English country house: a magnificent park; a grandly designed house; elegant furniture—whether purely formal or luxuriously comfortable; portraits commissioned from English painters; other works of art bought from earlier collections or acquired on the Grand Tour; a library containing rare books, but also current literature; almost always a collection of drawings and prints; and sumptuous plate. It would include accommodation for the family and the vast staff needed to maintain the house, gardens and park, and outside would be stables, a formal or walled garden, a kitchen garden, and, in the park, a lake or a waterfall, and probably deer grazing. Such a house would be a complete community in itself and the center of the estate, stretching to many thousands of acres and including whole farms and villages.

Such houses are, as I said, unique to England. The great châteaux of France have magnificent architecture, fine interior decoration and elaborate formal gardens, but their furniture was either destroyed or sold at the time of the Revolution. Further, except in the remoter provinces, the French aristocracy never lived in their country houses as did the English nobility and gentry. The center of their life was the court at Versailles and their Paris house, in which their collections of works of art would be concentrated. Moreover, even the French acknowledged the grandeur of English

parks by laying out round their châteaux what they thought to be imitations of them, which they termed *jardins anglais*. In Italy, again, all the great collections were concentrated in the towns, and the country house was a villa to which the rich townsmen retired in the summer. Only in the Veneto, the province on the mainland opposite Venice, was the villa the center of an agricultural community like the English country house. Before the eclipse of the Holy Roman Empire the great families of central Europe built vast houses which were the center of their country estates, but very few of them survived the disturbances of the Napoleonic Wars with more than a fraction of their contents.

It is therefore only in England that houses like these are to be found, and it is no exaggeration to say that even in England it would be hard to name another house in which the features of the species are to be found so splendid and complete as they are at Chatsworth. But its creation was not achieved in a day: it took three hundred years and was the work of ten generations of Cavendishes.

In 1549 Sir William Cavendish, who came of an old Suffolk family and had been awarded monastic lands for his services to the King, bought the estate of Chatsworth from the Leche family and soon afterwards began to build on the site of the present house. The building was incomplete at the time of his death in 1557 and was completed by his widow, Bess of Hardwick. She also built the great Elizabethan house of Hardwick, some fifteen miles to the east, and laid the foundations of the Cavendish family by her marriage to George Talbot, Earl of Shrewsbury, her fourth husband, whose estates she was able to bequeath to her son, Henry Cavendish. Henry sold the estate to his younger brother William, who became 1st Earl of Devonshire in 1618 and was the ancestor of all the later Earls and Dukes of Devonshire.

The house, the appearance of which is known from a painting attributed to Richard Wilson after the 17th-century artist Jan Siberechts, was a massive Elizabethan structure enclosing a square court with square turrets at the corners and octagonal ones beside the entrances. It covered roughly the area of the present house (without the addition made by the 6th Duke) and its walls were largely incorporated into the existing structure when the house was remodelled in the last years of the 17th century for the 4th Earl, who was later made a duke by William III for his share in the "Glorious Revolution" of 1688, which brought William to the throne of England. Work was begun in 1685 under the direction of William Talman, who had recently established his reputation by the building of Thoresby, some 25 miles to the south of Chatsworth, for Lord Kingston. At first the Earl only intended to rebuild the south

front, but with the accession of William III and the elevation of the Earl to a Dukedom his schemes became grander, and by 1707 he had in fact rebuilt the whole house. Talman was certainly responsible for the south and east fronts, and Thomas Archer—the creator of St. John's, Smith Square and other churches in London—for the north. The designer of the west front remains something of a mystery, but it is possible that it may have been the invention of the Duke himself, who certainly had claims to be at least a competent amateur architect. This possibility is perhaps substantiated by the fact that the design is based on two famous French models which the Duke could have known from engravings: Jules Hardouin Mansart's central pavilion at Marly, and the east front of the Louvre. Both of these were built for Louis XIV, a great enemy of England and a particular object of hatred to a Whig like the 1st Duke; but it is typical of the relations between European countries in the 17th and 18th centuries that political differences did not prevent cultural interchanges.

The Duke devoted as much attention to the interior of the house as to the exterior. A team of the finest craftsmen available in England had been busy since 1689 with the painting and stuccoing of ceilings, the panelling of walls and the forging of wrought iron for banisters, thereby making the rooms, halls, staircases and chapel of Chatsworth among the most splendid to be found in any English country house. The painters were the Frenchman Louis Laguerre, the Italian Antonio Verrio, and in the last phase the Englishman James Thornhill; the sculptors included Caius Gabriel Cibber, who designed the altarpiece in the chapel, and Samuel Watson, whose wood carvings (also in the chapel) long passed as the work of Grinling Gibbons; the ironwork was by Jean Tijou, the greatest virtuoso of the period in his art.

The 1st Duke was also responsible for the layout of the gardens at Chatsworth. Between 1687 and 1694 an elaborate parterre was made below the west front of the house, and in the latter year the Duke, taking advantage of the liberal water supply from the hills above Chatsworth, created the first cascade, which flowed down on a line parallel with the south front. Later he developed this on a grander scale and added at the top a "cascade house," consisting of a domed central structure flanked by curved wings, based on the designs of Alessandro Francini, an Italian architect who had worked for Marie de'Medici in France and whose treatise had been published in England in 1669.

During the 18th century relatively few changes were made to the house, but between 1755 and 1764 the 4th Duke commissioned James Paine to build the magnificent stables, whose richly rusticated style justifies their description as among the most baroque buildings in England. He also employed Lancelot Brown, usually known

as "Capability" Brown, to replant the park in the new picturesque style, during which process a part of the village of Edensor which interfered with the scheme was demolished.

The 6th Duke was possessed of an almost dangerous passion for building, and he gave free rein to it when he succeeded his father in 1811. He began by making alterations to the existing house, of which the most important, carried out in 1816, was the transformation of Talman's gallery into a library. In 1818, however, he embarked on a much more ambitious project which involved adding a new wing to the north in continuation of the east wing of the old house. This was to contain a large dining room and sculpture gallery and lead to a new service block to replace one built by Paine for the 4th Duke. While the building was going up the Duke decided to insert an orangery on the ground floor and to add a theatre in a tower over the north end of the wing. At the same time a forecourt was laid out parallel with the new wing, and the whole complex was closed by an entrance screen to the north with three arches, of which the middle one led to the forecourt and the two side ones to the west front and the service court respectively. At the same time certain parts of the old building—notably the east and north fronts and three of the façades on the court —were altered to make them harmonize with the new building.

The Duke's architect was Jeffry Wyatt, who was recommended to him by the 6th Duke of Bedford, for whom Wyatt had worked at Woburn Abbey. A few years later, having changed his name to Wyatville, he was to gain fame by his remodelling of Windsor Castle for George IV.

Externally Wyatt's new wing and screen strike a note of restraint in comparison with Talman's almost baroque façades, and this was in accordance with the revival of classical taste which marked the Regency and the reign of George IV. In the interior this restraint is combined with a certain lightness, both in decoration and in color, which makes the rooms added by the 6th Duke more habitable than the 1st Duke's rather solemn State Rooms—which were in fact hardly ever used, even in the 18th century. Not content with what he had added to the house, the 6th Duke also modified a number of the rooms which he used most frequently and in some of them—for instance, the Blue and Yellow Drawing Rooms—it is not at first sight easy to distinguish his work from that of his predecessors, so completely do the two fuse into a harmonious whole.

The 6th Duke also became passionately interested in the gardens and in 1826 he had the good fortune to take on as head gardener a young man called Joseph Paxton, who between 1836 and 1840 built the celebrated Conservatory. In erecting the Con-

servatory, Paxton developed the use of iron and glass which he was later to apply with such brilliant results in the building of the Crystal Palace for the Great Exhibition held in Hyde Park in 1851. Unhappily the Conservatory fell into disrepair during the First World War and was demolished in 1920.

The paintings and works of art shown in the present exhibition fall into two categories: those collected, in the strict sense of the word, and those commissioned or bought for the use of the Dukes or their families. To the first category belong the paintings, drawings and engravings by the Old Masters, the books and manuscripts, the engraved gems and certain "curiosities" such as the Kniphausen Hawk (No. 174); to the latter belong the family portraits, the plate, the china and the furniture.

The 1st Duke was not a collector of pictures and the walls of the great rooms at Chatsworth were mainly panelled or painted, or hung with tapestries; but he owned a few easel pictures, among them Vouet's *Allegory of Peace* (No. 30), and he may have bought some of the Old Master drawings at the sales of the Lely and Lankrink collections in the years 1688 to 1694. His principal interest seems to have been in plate (see p. 75). He received the superb toilet set (No. 149) as a present from William III and he commissioned magnificent pieces from the leading French Protestant silversmiths who had taken refuge in England after the Revocation of the Edict of Nantes. A number of these pieces are shown in the present exhibition, but size, weight and fragility prevented the inclusion of the silver chandelier made in 1694 for the State Dressing Room.

The real creator of the Devonshire collection was the 2nd Duke, one of the most noteworthy enthusiasts of the 18th century, that great age of collecting. His main passion was for drawings, and to those bought from the Lely and Lankrink sales he added a magnificent group of Italian and Dutch drawings from the collection of N. A. Flinck, son of Rembrandt's pupil, Govaert Flinck; and Claude Lorraine's *Liber Veritatis*, the artist's record in drawings of his own painted compositions, which is now in the British Museum.

The 2nd Duke probably also acquired most of the magnificent collection of engravings, of which some of the rarest pieces are shown in the exhibition (see p. 52), but the records are regrettably incomplete and it is not always possible to distinguish his acquisitions from those of his son. The same is true of many of the pictures: a few are recorded at Chatsworth in the 2nd Duke's time—including the great Holbein cartoon of Henry VIII, now in the National Portrait Gallery—but the greater part were kept in the Duke's London house in Piccadilly and of these the earliest record

is in Dodsley's *London*, a guide-book printed in 1761, towards the end of the life of the 4th Duke. It is certain that the 2nd Duke owned Claude's landscape depicting the story of Mercury and Battus (No. 33), because in the list of owners at the end of the *Liber* he wrote "mine" against the drawing representing the picture. And the 3rd Duke is known to have made one important addition to the collection: Van Dyck's *Portrait of Arthur Goodwin*, which was given to him by the great Whig Prime Minister, Sir Robert Walpole. (This is still at Chatsworth, but its great size and delicate condition prevented it from being included in this exhibition.) There does not seem, however, to be any means of knowing who was responsible for buying Poussin's *Shepherds in Arcadia* (No. 31), his *Holy Family* (No. 32) or Rubens' *Holy Family with St. John and St. Elizabeth* (now in the Walker Art Gallery, Liverpool), all of which are recorded by Dodsley in 1761.

The 2nd Duke also assembled a very important collection of engraved gems, including fine Greek and Roman pieces, and one of coins. Both collections were once housed in cabinets made specially for them by Boulle, one of which can be seen in the 2nd Duke's portrait by Jervas (No. 3).

The 4th Duke does not seem to have bought many paintings by the Old Masters, but he played a great part in the development of the collection by his marriage in 1748 to Charlotte Boyle, daughter and heiress of the 3rd Earl of Burlington. She brought with this marriage not only great estates but two houses which her father had built: Burlington House in Piccadilly, London; and Chiswick House, near the Thames some ten miles west of London, which housed his magnificent collection of paintings and drawings. The paintings included several shown in the present exhibition: the portraits by Rembrandt (No. 39), Velasquez (No. 35) and Cornelis de Vos (No. 37) and the two religious compositions by the Venetian, Sebastiano Ricci (Nos. 27, 28), whom Burlington employed to decorate some of the rooms at Burlington House.

Burlington's collection of architectural drawings was even more spectacular. It was formed to further his revival of the style of Palladio, of which he was an enthusiastic admirer and which he more than anyone else helped to establish as the most fashionable style in England during the first half of the 18th century. Of the two houses which he built for himself, Chiswick (cf. Nos. 120–123, 125) was a direct imitation of the villa called the Rotonda, built by Palladio outside Vicenza, not far from Venice, and it was surrounded by one of the earliest examples of the informal gardens which were to become popular in England—and later elsewhere—during the 18th century. As will be seen from Burlington's own drawing (No. 121A), he was a com-

petent architect in his own right and certainly exercised a great influence on the professionals whom he employed to design his own houses. In the collecting of drawings his most important acquisition was the almost complete corpus of drawings by Palladio which had been brought to England in the early 17th century and had belonged to Inigo Jones, the architect who first established the Palladian style in England, a century before Burlington. (These drawings have been for eighty years on loan to the Royal Institute of British Architects, London.) In addition, Burlington bought the designs made by Inigo Jones for the "masques" given at the court of James I and Charles I, of which the best are on view in this exhibition (Nos. 108–119).

Burlington's favorite architect was William Kent, whom he commissioned to design Chiswick, and it was no doubt owing to his influence that Kent was chosen by the 3rd Duke to rebuild Devonshire House after the old house burnt down in 1733. In addition to planning the actual buildings Kent was responsible for designing the furniture for the principal rooms, of which fine specimens are shown in this exhibition (Nos. 178–181).

The 5th Duke lived more in London than at Chatsworth, but he made a considerable contribution to the collection now in the house by commissioning portraits of himself, his Duchess, Georgiana, and other members of his family. He himself was painted while on a visit to Rome in 1768 by Pompeo Batoni, then the most famous portrait painter in Europe (No. 14), and he commissioned portraits of his Duchess (Nos. 11, 12) from Sir Joshua Reynolds, who as a young man had painted the 3rd Duke (No. 6) and the Duchess as a child with her mother, Countess Spencer (No. 10).

The 6th Duke left his mark on the collection as strongly as on the house. In the first place, he was responsible for buying almost all the sculpture in the house. This included a number of important Roman pieces and, above all, the colossal bronze head of Apollo—one of the very rare original Greek bronzes dating from the middle of the 5th century B.C., and now in the British Museum. But the Duke was even more interested in the sculpture of his own day and he built up what remains today unquestionably the most important gallery of neoclassical sculpture in England. His favorite was Antonio Canova, by whom he owned a series of marbles, including one of his masterpieces, the *Endymion*, the colossal bust of Napoleon and the life-size seated figure of "Madame Mère," the Emperor's mother. In addition he acquired works by the Italians Adamo Tadolini and Lorenzo Bartolini, the Dane Betel Thorvaldsen, and the Englishmen John Gibson, Thomas Campbell and Joseph Gott. Unfortunately most of these statues are too large and too fragile to transport—Thorvaldsen's *Venus* was broken into three pieces on the journey from Rome to Chatsworth—and this

aspect of the 6th Duke's taste can only be represented in the exhibition by Canova's beautiful *Head of Laura* (No. 185).

The 6th Duke was also the real creator of the Library, one of the greatest glories of Chatsworth. In 1812 he bought the books collected by Bishop Dampier and added them to those acquired by his ancestors, among which were a number of fine 18th-century editions bought by his mother, Duchess Georgiana. The greatest treasure of all, the 10th-century Anglo-Saxon manuscript called the *Benedictional of St. Aethol-wold*, is now in the British Museum, but the range of the Library is shown by the books, manuscripts and letters in the exhibition (see p. 63).

Little was added to the collection in the century after the death of the 6th Duke in 1858, though many pictures and objects were relocated after Chiswick House was handed over to the local authorities in 1929 and Devonshire House was pulled down in 1924, resulting in a concentration of all the most important works of art at Chats-worth. The death of the 10th Duke in 1950 brought death duties which could only be met by the sacrifice of much that the Cavendish family had owned for centuries. In addition to Hardwick with all its contents, which was accepted by the Treasury in part payment and handed over to the National Trust, some of the rarest works of art were also ceded. The British Museum was enriched by the Greek head of Apollo, the *Benedictional*, Claude's *Liber Veritatis*, Van Dyck's Italian Sketchbook, and a number of the rarest books and manuscripts; the National Gallery acquired both a portrait by Rembrandt and the Memling Triptych, which was painted in 1468 for Sir John Donne and which passed through his descendants, the Boyles, to the Cavendishes; and the National Portrait Gallery acquired Holbein's cartoon of Henry VII and Henry VIII made in preparation for the fresco at Whitehall, which was destroyed in the fire of 1698. As the present exhibition shows, however, despite these losses Chatsworth still contains collections of incomparable range and quality.

They have been enriched by the present Duke and Duchess, who have not only rearranged and redecorated many of the rooms at Chatsworth so that what was already there could be seen to greater advantage, but have also bought additional works. Some of these helped to complete existing groups, while others continued the collection into the late 19th and 20th centuries and showed that Chatsworth is not a museum, frozen into perpetual stability. To the first category belong the two exceptionally fine watercolors by Samuel Palmer (Nos. 98A, 98B), which represent an aspect of English Romanticism otherwise unrepresented at Chatsworth, several rare and beautiful botanical books (Nos. 145–147) and the unusual specimens of minerals which expand the 6th Duke's collection of "curiosities." The second cate-

gory includes the bust of Lady Sophia Cavendish by Epstein (No. 186), the portraits of the Duke and Duchess by Lucian Freud (Nos. 42, 43) and paintings and drawings by, amongst others, Tissot, Camille Pissarro, Degas (No. 99), Vuillard, Sickert, Gwen and Augustus John, Duncan Grant and L. S. Lowry (No. 44).

By a tradition which goes back at least as far as the mid-18th century, the Dukes of Devonshire have always been generous in allowing others to enjoy their treasures. Many travellers in more leisured times have recorded how they drove up to Chatsworth unannounced and were immediately shown round the house, and sometimes, if the host and hostess were there, even asked to dinner. Now it is visited every year by hundreds of thousands from all parts of the world, and individual works of art are frequently lent to exhibitions in England and abroad. The present exhibition, however, is the first occasion when a really representative selection of treasures has been presented to the public in six American cities. Is it too much to hope that many of those who see them here will at a later date enjoy them again in their natural setting at Chatsworth?

ANTHONY BLUNT

THE CAVENDISH FAMILY, FROM 1500 TO THE PRESENT DAY

Sir William Cavendish 1505–1557 *son of Thomas Cavendish of Suffolk* = **Bess of Hardwick** 1520–1608 *later Countess of Shrewsbury*

William Cavendish 1552–1625 **1st Earl of Devonshire** (1618) = **Anne Keighley** –1625 *daughter of Henry Keighley*

Richard Boyle 1566–1643 *1st Earl of Cork* = **Catherine Fenton** –1629 *daughter of Sir Geoffrey Fenton*

William Cavendish 1590–1628 **2nd Earl of Devonshire** = **Christian Bruce** 1595–1675 *daughter of Lord Bruce of Kinloss*

Richard Boyle 1612–1697 *2nd Earl of Cork, 1st Earl of Burlington* = **Elizabeth Clifford** 1621–1698 *heiress to the Earls of Cumberland; estates in Yorkshire*

Robert Boyle 1627–1691 *the scientist*

William Cavendish 1617–1684 **3rd Earl of Devonshire** = **Elizabeth Cecil** 1619–1689 *daughter of the Earl of Salisbury*

William Cavendish 1640–1707 **4th Earl of Devonshire: 1st Duke of Devonshire** (1694) = **Mary Butler** 1646–1710 *daughter of the Duke of Ormonde*

Charles Boyle c. 1674–1704 *3rd Earl of Cork, 2nd Earl of Burlington* = **Juliana Noel** 1672–1750 *daughter of the Hon. Henry Noel*

William Cavendish 1673–1729 **2nd Duke of Devonshire** = **Rachel Russell** 1674–1725 *daughter of Lord William Russell*

Charles Cavendish

Richard Boyle 1695–1753 *4th Earl of Cork, 3rd Earl of Burlington* = **Dorothy Savile** 1699–1758 *daughter of the Marquis of Halifax*

Anne Grey –1733 *daughter of the Duke of Kent* =

William Cavendish 1698–1755 **3rd Duke of Devonshire** = **Catherine Hoskins** –1777 *daughter of John Hoskins*

Henry Cavendish 1731–1810 *the scientist*

William Cavendish 1720–1764 **4th Duke of Devonshire** = **Charlotte Boyle** 1731–1754

Through a succession of four marriages, Bess of Hardwick rises in wealth and status to found a Cavendish dynasty, and endows her heirs with the great Derbyshire estate purchased by Sir William out of personal profits made in the fiscal service of King Henry VIII. Two great houses are built, at Chatsworth and Hardwick.

Enjoying the first fruits of Bess's achievement, her son William uses influential connections at court, and wealth from his estates at home and lavish investments overseas, to procure an earldom from King James I. A vacant title—Devonshire—is bestowed, although he owns no land in that county.

Richard Boyle, the Great Earl of Cork and Lord High Treasurer of Ireland, makes his fortune in Munster out of lands purchased from Sir Walter Raleigh, and rebuilds Lismore Castle as his principal seat. Thomas Hobbes, the philosopher, is made tutor to the 2nd Earl of Devonshire and later to his son, the 3rd Earl.

The 3rd Earl of Devonshire, a supporter of the Royalist cause, narrowly secures his Derbyshire estates from sequestration by Parliament at the time of the English Civil War, preferring cautious moderation to the military valor displayed by his kinsmen Colonel Charles Cavendish and the Duke of Newcastle.

The 4th Earl, a fierce opponent of royal despotism and papal aggression, becomes one of the leaders of a political movement that culminates in the protestant succession of William of Orange to the English throne. A dukedom is his reward, and a new and grander Chatsworth is built as the material expression of his hard-won status.

The 2nd Duke, a great virtuoso at the time of the first true flowering of English connoisseurship, founds the Devonshire collections of paintings, drawings, gems and coins, and continues to uphold in Parliament the same principles as his father. Dismissed from office by Queen Anne, he returns to royal favor with the Whigs at the Hanoverian succession of King George I.

The 3rd Duke serves in the Whig ministries of his friend Sir Robert Walpole as Lord Privy Seal and later Lord Lieutenant of Ireland. The 3rd Earl of Burlington, patron of the arts and himself an architect, conceives a Palladian revival in architecture. Devonshire House in London is rebuilt for the 3rd Duke in the new style.

The 4th Duke serves like his father as Lord Lieutenant of Ireland and, for a brief period, as Prime Minister of England. The park and gardens at Chatsworth are radically redesigned and planted in the informal landscape style, and new roads are built making the house and its estate more easily accessible to

Elizabeth Compton 1760–1835 *heiress to the Earls of Northampton; estates in Sussex*
George Cavendish 1754–1834 *1st Earl of Burlington (2nd creation)*

Louisa O'Callaghan –1863 *daughter of Lord Lismore*
William Cavendish 1783–1812

William Cavendish 1808–1891 *2nd Earl of Burlington (2nd creation)* **7th Duke of Devonshire**

Louise von Alten 1832–1911 *Duchess of Manchester*
Spencer Compton Cavendish 1833–1908 **8th Duke of Devonshire**

(2) Elizabeth Foster 1759–1824 *daughter of the Earl of Bristol*

Blanche Howard 1812–1840
George Howard 1773–1848 *6th Earl of Carlisle*

(1) Georgiana Spencer 1757–1806 *daughter of the Earl Spencer*

Georgiana Cavendish 1783–1858
William Spencer Cavendish 1790–1858 **6th Duke of Devonshire**

William Cavendish 1748–1811 **5th Duke of Devonshire**

William Lascelles 1798–1851 *son of the Earl of Harewood*
Caroline Howard 1803–1881

Edward Cavendish 1838–1891
Emma Lascelles 1838–1920

Evelyn Fitzmaurice 1870–1960 *daughter of the Marquis of Lansdowne*
Victor Cavendish 1868–1938 **9th Duke of Devonshire**

Mary Cecil 1895– *daughter of the Marquis of Salisbury*
Edward Cavendish 1895–1950 **10th Duke of Devonshire**

Deborah Mitford 1920– *daughter of Lord Redesdale*
Andrew Cavendish 1920– **11th Duke of Devonshire**

Amanda Heywood-Lonsdale 1944– *daughter of Commander Heywood-Lonsdale*
Peregrine Cavendish 1944– *Lord Hartington*

William Cavendish 1969– *Lord Burlington*

Duchess Georgiana reigns as queen of society and fashion at Devonshire House, now the acknowledged center of Whig party politics. The 5th Duke commissions alterations to his London houses, a new private suite at Chatsworth, and a scheme to redevelop the local spa town of Buxton as a rival to fashionable Bath.

The "Bachelor Duke," collector, bibliophile, traveller and close friend of the Prince Regent, alters and greatly expands Chatsworth, and creates a new library and sculpture gallery there. The gardens and conservatories attain world renown under the direction of Sir Joseph Paxton, and railways penetrate the Peak District bringing a new public to visit both house and grounds.

The 7th Duke, Victorian churchman and intellectual, combines estate management with industrial development in a life-long program to provide a firmer base for the family fortunes, depleted by the extravagance of his predecessors as builders and collectors. Heavy investments concentrated in the steel town of Barrow, however, finally bring greater debts as market prices fall.

The 8th Duke as Marquis of Hartington plays a central rôle in the cabinets of Gladstone and later Liberal governments, and is offered the premiership three times, but declines. Inherited debts and the introduction of death duties force him to make the first major sales of the family's land in Derbyshire and Ireland, setting a pattern of retrenchment for the 20th century.

The 9th Duke, a Governor-General of Canada, and Duchess Evelyn become the last to maintain in style the annual circuit of all their houses, visiting each with a full retinue of servants, and entertaining at Chatsworth both King Edward VII and King George V. Simultaneously, the reduction of the family estates continues, culminating in the sale of Devonshire House and its subsequent demolition.

Chatsworth in wartime is converted to the use of a girls' school, evacuated from Wales, and works of art are stored or dispersed to regions of greater safety. Following the sudden death of the 10th Duke, death duties are levied on his estate, and Hardwick Hall together with major works of art are handed over to the government in lieu of payment.

The present Duke and Duchess return to Chatsworth to make it their home, and many rooms are refurbished with paintings and furniture long stored away, some the contents of the family's former houses. The house and gardens are reopened to visitors on a permanent basis, the public now providing the major source of income for their upkeep.

A Note on the Use of Hereditary Titles

It may be useful to include a note on the somewhat complicated system which controls the use of titles by the English peerage, insofar as it affects the Cavendish family.

The basic titles—leaving out those of the Royal Family—are those of "Duke," "Marquess" (or "Marquis"), "Earl," "Viscount," and "Baron," which were awarded by the King in return for services rendered either to himself personally or to the public cause, and which descended from father to eldest son.[1] So for instance William Cavendish, son of Sir William Cavendish and Bess of Hardwick, was made, first, Baron Cavendish and then Earl of Devonshire by James I. His grandson, the 4th Earl, was raised to a dukedom by William III, and the title has descended from father to son, with two exceptions: when the 6th Duke died unmarried in 1858, the title went to the great-grandson of the 4th Duke through a younger son, Lord George Cavendish, for whom William IV revived the title of Earl of Burlington (which had become extinct at the death of his grandfather, who had no male heir). And when the 8th Duke died childless in 1908, the title passed to Victor Cavendish, the son of his younger brother.

English peers above the rank of baron have in addition to their principal title subsidiary ones, usually those which had been conferred on their ancestors. For instance, the Duke of Devonshire is also Marquess of Hartington and Earl of Burlington. According to a longstanding usage one of these titles is usually taken as a "courtesy" title by the peer's eldest son in turn. In the case of the Cavendish family the Duke's eldest son has the title of Marquess of Hartington (though this is purely a name and does not entitle him to a seat in the House of Lords); and according to the same usage, *his* eldest son has the title of Earl of Burlington.

The younger sons and daughters of dukes and marquesses are referred to as "Lord" or "Lady," followed by the given name and family name. When a daughter marries, however, she continues to use the title "Lady" but adds her husband's surname (unless he is a peer, in which case she takes his title). For instance, when Lady Elizabeth Hervey, daughter of the Earl of Bristol, married Mr. John Foster, she became Lady Elizabeth Foster, but when later she married the 5th Duke of Devonshire she became simply "Duchess of Devonshire." The title "The Honourable," followed by given name and family name, is used by the children of viscounts and barons and by the sons of earls (although the daughters of earls have the title of "Lady").

In ordinary parlance all peers—except dukes—and their wives and the bearers of courtesy titles are referred to as "Lord" or "Lady," not by their title of Marquess, Earl, Viscount or Baron. In formal language, however, each rank has a specific qualification: a duke is "His Grace," a marquess "the Most Honourable," and other peers, by courtesy, "the Right Honourable."

Below the peerage comes "Baronet," a title created by James I which carries the prefix "Sir" and is hereditary; and "Knight," which carries the same prefix but is not hereditary.

The titles of most peers were derived from their estates or the county in which their biggest estates were to be found, but in the 16th and 17th centuries it was the practice that if a title became "vacant"—either because the holder had no heir, or because he was attainted and his titles were confiscated—the title would normally be allotted to any new candidate for a peerage. Thus it happened that when Baron Cavendish was made an earl he was given the earldom of Devonshire, which had fallen "vacant," although in fact he had no connection with the county of Devon. In certain cases, relatively rare before the 20th century, newly created peers kept their family names in their titles, as, for instance, Earl Spencer and Earl Granville, both of whose names appear in the history of the Cavendish family. A.B.

1. In a few cases titles can—like the Crown—pass through the female line. "Life-peerages" were only invented in 1958.

CATALOGUE

The entries in each section are listed chronologically;
in those sections which are arranged by schools,
entries appear chronologically within each school.
Unless otherwise indicated, height precedes width.
Numbers appearing in parentheses after the title of
a work are Chatsworth inventory numbers.

Catalogue Authors and Contributors

SIR ANTHONY BLUNT, former Director of the Courtauld Institute of Art and from 1972 to 1978 Adviser for the Queen's Pictures and Drawings. (*Introduction*; *Note on Hereditary Titles*; *Paintings and Miniatures*; *Drawings*; *Prints*; *Designs for Court Masques*)

ANNE SOMERS COCKS, Assistant Keeper, Metalwork, Victoria and Albert Museum. (*The Kniphausen "Hawk"*)

JOHN CUSHION, retired from the Ceramic Department, Victoria and Albert Museum. (*China*)

PETER DAY, Librarian and Keeper of the Devonshire Collections. (*Manuscripts, Letters and Books*; also Nos. 1–15, 19–21, 41–45, 104–107, 129, 160, 164, 186 and 187)

ARTHUR GRIMWADE, Senior Director, Christie's. (*Gold, Silver and Firearms*)

HELENA HAYWARD, Director, Attingham Summer School Trust. (*Furniture and Woodwork*)

DIANA SCARISBRICK, author and authority on gems and finger rings. (*The Châtelaine*; *The Devonshire Parure*)

Information and assistance has been provided by the following individuals: Dr. Jonathan Alexander (illuminated manuscripts); Timothy Clark (*Augustus the Strong*, No. 189); John Harris (architecture section); Professor Howard Warrender (Hobbes manuscript, No. 133); Dr. Martin Henig (Greco-Roman gems); and Professor George Potter. The Family Tree was compiled by Peter Day and designed by Christine Tindale; the Indices were prepared by Taffy Swandby.

Paintings and Miniatures

The paintings at Chatsworth fall into two categories: family portraits—including miniatures—mainly commissioned by the Earls and Dukes of Devonshire and members of their families; and paintings by the Old Masters collected as works of art. The portraits in the present exhibition include a complete series representing the heads of the family from the 4th Earl (1st Duke) to the 6th Duke, covering a period of over 200 years, as well as portraits of the present Duke and Duchess. The most striking among these are the portraits by Sir Joshua Reynolds which include those of the 3rd Duke and of the "beautiful Duchess," Georgiana Spencer, first wife of the 5th Duke.

Some of the Old Master paintings could not be included in the exhibition owing to their size or delicate condition, but the collection—formerly kept at Devonshire House in London—is represented by two masterpieces by Nicolas Poussin (Nos. 31, 32) and one of Claude's finest landscapes. Further paintings came into the possession of the 4th Duke through his marriage to the daughter of the 3rd Earl of Burlington, including the *Portrait of a Lady in a Mantilla* ascribed to Velasquez (No. 35) and a great portrait by Rembrandt (No. 39).

Portraits of the Cavendish Family and Their Circle

SIR ANTHONY VAN DYCK (1599–1641)

1 *Charles Cavendish, 2nd Son of the 2nd Earl of Devonshire* (178)

Canvas; 27⅝ × 22⅞ in. (69 × 57 cm.)
Provenance: At Devonshire House with its pendant (No. 2) in 1761 (Dodsley, II, p. 225). For the attribution see No. 2.

Colonel Charles Cavendish (1620–1643) was the younger son of the 2nd Earl of Devonshire, and his brief life was distinguished by a brilliant career in the English Civil War. He served first under Prince Rupert and was later given command of his own regiment, gaining victories for the Royalist side at Grantham, Ancaster and Burton-on-Trent. He was eventually outwitted by the Parliamentarian commander Oliver Cromwell himself (see No. 17), at the battle of Gainsborough, where it is recorded that "he died magnanimously, refusing quarter."

SIR ANTHONY VAN DYCK

2 *Lucius Cary, 2nd Viscount Falkland* (179)

Canvas; 27⅝ × 22⅞ in. (69 × 57 cm.)
Provenance: At Devonshire House with its pendant (No. 1) in 1761 (Dodsley, II, p. 225).
Literature: Catalogue of the exhibition, *The Age of Charles I*, Tate Gallery, 1972, No. 111.

During the reign of Charles I, Falkland at first supported the Commons in their resistance to the King, but later, when the Civil War broke out, joined him and served him as Secretary of State. He fell at the first battle of Newbury in 1643. He was described by Lord Clarendon in his *History of the Rebellion* as follows: "That little person and small stature was quickly found to contain a great heart, a courage so keen, and a nature so fearless, that no composition of the

strongest limbs, and most harmonious and proportioned presence and strength, ever more disposed any man to the greatest enterprise." Falkland (1610–1643) was a close friend of Charles Cavendish (No. 1).

The attribution of this portrait and its pair to Van Dyck has in the past been challenged, but it is now generally accepted by specialists. Both portraits were probably painted in the late 1630s. Another version of the Falkland portrait is at Narford Castle.

Attributed to CHARLES JERVAS
(c. 1675–1739)

3 *William Cavendish, 2nd Duke of Devonshire* (314)

Canvas; 49×39¼ in. (122.5×99.6 cm.)

The 2nd Duke (1672–1729) was the founder of the Devonshire collections (see Introduction, p. 17, and Old Master Drawings, p. 39) and his portrait shows the Boulle cabinet made to contain his collection of coins. A pair to this cabinet housed the gems he collected, and many of the finest and rarest of these are now mounted in the great Parure (No. 176).

GEORGE KNAPTON (1698–1778)

4 *Richard Boyle, 3rd Earl of Burlington* (546)

Canvas; 49×39⅝ in. (122.5×99.7 cm.)
Signed and dated (on back of canvas, under lining):
George Knapton pinx. 1763

For the sitter (1694–1753) see Introduction, p. 18, and Architecture, p. 59. The portrait symbolizes Burlington's admiration for Inigo Jones, whom he regarded as the father of true architecture in England. His bust by Rysbrack, which is still at Chatsworth, appears in the background, and the Earl rests his hand on a book recognizable from its binding as *The Designs of Inigo Jones*, published at Burlington's expense in 1727. The book, too, is now in the Chatsworth library.

BENEDETTO LUTI (1666–1724)

5 *Portrait of the Architect William Kent* (609)

Canvas; 19×17¼ in. (48.2×43.8 cm.)
Inscribed on the back of canvas:
 W: Kent Rittrato
 Caulier (i.e. Cavaliere) *Benidetti Luti*
 Pinxt: in Roma
 1718.

It was in the studio of Luti, who established a flourishing practice in Rome in the first quarter of the 18th century, that William Kent (1684–1748) first trained as a painter. Kent had been sent to Italy in 1709 at the expense of a group of gentlemen from his native Yorkshire who placed great faith in his talents. He returned to England in 1719 in the train of Lord Burlington, who thereafter became his most important patron and encouraged his development as a designer and architect. His best known buildings are Holkham Hall in Norfolk, the Horse-Guards in Whitehall, and, before its demolition in 1924, Devonshire House, Piccadilly, built for the 3rd Duke of Devonshire. This portrait comes presumably from the collection of the Earl of Burlington. For Kent's furniture, see Nos. 178–181.

SIR JOSHUA REYNOLDS (1723–1792)

6 *William Cavendish, 3rd Duke of Devonshire* (524)

Canvas; 50×40 in. (127×101.6 cm.)
Literature: A. Graves and W. V. Cronin, *A History of the Work of Sir Joshua Reynolds*, London, 1899–1901, I, p. 242; E. Waterhouse, *Reynolds*, London, 1941, p. 39.

The 3rd Duke (1698–1755), whose share in the formation of the collections founded by his father has never been fully determined, was a much respected connoisseur. Horace Walpole said of him: "No one knows pictures better," and there is a tantalizing reference in a letter at Chatsworth which suggests that he may also have been the author of the scheme to transform the park and gardens at Chatsworth—a plan carried out for his son, the 4th Duke, by the architect

James Paine and the gardener Capability Brown (see Introduction, p. 15). He was certainly, in any case, a patron of William Kent, giving him the commission to rebuild Devonshire House, Piccadilly, after the old house had burnt down in 1733. It was for the 3rd Duke, too, that Kent's unexecuted designs for the Chatsworth Cascade were made (see No. 124). Nevertheless, it is as a prominent Whig politician that he has come down to posterity, appointed as Lord Lieutenant of Ireland in 1737 during the ministry of Sir Robert Walpole and serving in that office until 1744.

The Duke wears the Star and Ribbon of the Garter in this portrait, painted in 1753–54 when Reynolds was establishing his practice in London. One of his early biographers, William Mason, wrote: "When Reynolds returned from his studies in Italy his early friend, Lord Edgcumbe, persuaded many of the first nobility to sit to him for their pictures, and he very judiciously applied to such of them as had the strongest features and whose likeness therefore it was the easiest to hit. Amongst these personages were the old Dukes of Devonshire and Grafton, and of these the young artist made portraits not only expressive of their countenance but of their figures, and this in a manner so novel, simple and natural, yet withal so dignified, as procured him general applause and set him in a moment above his old master Hudson and that master's rival Vanloo."

THOMAS HUDSON (1701–1779)

7 *William Cavendish, 4th Duke of Devonshire* (512A)

Canvas; 49½ × 39½ in. (125 × 100 cm.)
Provenance: Bought by Lord Hartington, later 10th Duke, in 1934.

Throughout his short life the 4th Duke (1720–1779) was looked to as a leader among the great Whig landowners, by virtue of the strong political tradition established by his forebears. Like his father (see No. 6) he served as Lord Lieutenant of Ireland, but at a much more critical period of factional dispute, during which he gained respect on all sides for his scrupulous fair dealing. From November 1756 until May 1757 he was Prime Minister of England, holding the ring between the two great rival Whig leaders, William Pitt and the Duke of Newcastle, and was subsequently appointed Lord Chamberlain. He was eventually dismissed from office following the accession of George III, who, with his favorite minister, Lord Bute, determined to oust the Whigs from power. For the vast inheritance that came to him through his marriage to Charlotte Boyle, and the part he played in transforming the park and gardens at Chatsworth, see the Introduction, p. 18.

JOHANN ZOFFANY (1734/5–1810)

8 *The Children of the 4th Duke of Devonshire* (276)

Oil on canvas; 39⅜ × 49¼ in. (100 × 125 cm.)
Provenance: Probably commissioned by the 4th Duke.

The late Librarian of Chatsworth, T. S. Wragg, discovered in a volume of Household Accounts for the period 1760–65 at Chatsworth the following entry on the last page, which contains payments for 1765: "Paid ye Guardians what they had paid for a picture by Zophenii £84 . . 0 . . 0."

The Guardians were those responsible for the family's affairs after the death of the 4th Duke in 1764, but the portrait group by Zoffany was probably commissioned by the Duke before his death, since it is unlikely that the Guardians would have initiated such a project. The children, who are represented playing in the garden at Chiswick, are William (1748–1811), afterwards 5th Duke (see No. 14), Dorothy (1750–1794), afterwards Duchess of Portland, Richard (1751–1781) and George (1754–1834), who was made Earl of Burlington of the second creation in 1831. The attribution of this painting—one of the most enchanting depictions of children in the 18th century—was challenged by some critics until the discovery of the payment established that it was by Zoffany, the master of portrait groups of this kind.

THOMAS GAINSBOROUGH (1728–1788)

9 *Georgiana Poyntz, Countess Spencer (237)*

Oil on canvas; 49⅛×39⅜ in. (125×99.5 cm.)
Provenance: Said to have been bequeathed to the family
by an old governess.
Literature: E. Waterhouse, *Gainsborough,* London, 1958,
No. 630.

Georgiana Poyntz (1738–1814) was the daughter of
Stephen Poyntz, who had risen from humble origins
to become Privy Councillor to George I. She mar-
ried John Spencer, grandson and heir to the estate of
Sarah, Duchess of Marlborough, created first Earl
Spencer in 1765. The Countess sought superior matches
for both her daughters, Georgiana and Harriet, and
after the former married the 5th Duke of Devonshire
(see No. 14), kept a solicitous and often disapproving
eye on the irregularities of their household.

Although this is the only painting by Gainsborough
at Chatsworth, the artist completed at least two por-
traits of Countess Spencer's daughter, the beautiful
Duchess Georgiana, and both are now in America.
One is the famous picture stolen from an exhibition
in London in 1876 and recovered by Pinkerton agents
in Chicago in 1901, when it was bought by Pierpont
Morgan, and the other is in the National Gallery,
Washington.

SIR JOSHUA REYNOLDS (1723–1792)

10 *Georgiana Poyntz, Countess Spencer,
with Her Infant Daughter Georgiana
Afterwards Duchess of Devonshire (526)*

Canvas; 29½×24½ in. (75×62 cm.)
Literature: Graves and Cronin, III, p. 916; Waterhouse,
p. 47.

For the sitters, see Nos. 9, 11. A study for the painting
of which the finished version is in the collection of
Earl Spencer at Althorp, although painted curiously
in the reverse direction. The sketch was probably
painted in 1759 and the finished picture in 1761. The

sketch was bought by the 5th Duke of Devonshire
at the sale of Sir Joshua Reynolds' possessions after
his death in 1793, as is recorded in a letter from the
Duchess to her mother, dated 18th September 1793:
"The Duke has bought my picture (rather yours)
with the child at Sir Joshua's sale."

A beautiful example of Reynolds' earlier slightly
formal style. As is often the case in the artist's canvases
of this date, the crimson lake used in the painting of
the cheeks has faded, giving the sitter a slightly pallid
complexion.

SIR JOSHUA REYNOLDS

11 *Georgiana Spencer, Duchess of
Devonshire (527)*

Canvas; 28¼×23 in. (72×58.5 cm.)
Literature: Graves and Cronin, I, p. 249; Waterhouse,
p. 71.

Georgiana (1757–1806), daughter of the 1st Earl Spen-
cer, is second only to Bess of Hardwick, two centuries
before, as the most celebrated woman to take the
Cavendish name. She married William, 5th Duke of
Devonshire (see No. 14), in 1774 at the age of 17,
and quickly became the queen of society and fashion
in an era renowned for its elegance. The part she
played in history centered upon the notorious West-
minster election of 1784 when she helped secure the
return of the Whig candidate, Charles James Fox, by
gallantly canvassing for votes through the disorderly
streets and alleyways of Covent Garden, with her
sister Harriet, Lady Duncannon. Together they made,
as was reported, "the two most lovely portraits that
ever appeared on a canvass!" Georgiana's involved
personal life at Devonshire House with the Duke, her
best friend—and the Duke's mistress—Lady Elizabeth
Foster (see No. 13), and the children produced by
this *ménage à trois,* has proved as fascinating to posterity
as it did to her contemporaries, and has been the sub-
ject of many books, both serious and romantic. Painted
in 1780 and in 1818 given to the 6th Duke of Devon-
shire by Lady Thomond, niece of the artist, as we
learn from a letter at Chatsworth:

SIR JOSHUA REYNOLDS

12 *Georgiana Spencer, Duchess of Devonshire with Her Daughter, Georgiana Dorothy, Afterwards Countess of Carlisle* (528)

Canvas; 44¼×55¼ in. (111×142 cm.)
Literature: Graves and Cronin, I, p. 248; Waterhouse, p. 77.

For the sitter, see No. 11. Painted in 1784, when the Duchess was in mourning for her father, Earl Spencer, and exhibited at the Royal Academy, 1786 (No. 166).

One of Reynolds' most celebrated portraits, in which he indulges in a playfulness and informality rarely to be found in his work.

SIR JOSHUA REYNOLDS

13 *Lady Elizabeth Foster, Later Duchess of Devonshire* (529)

Canvas; 29½×24½ in. (74×62 cm.)
Painted in 1787 and exhibited at the Royal Academy, 1788 (No. 219).
Literature: Graves and Cronin, I, p. 328; Waterhouse, p. 80.

Lady Elizabeth Foster (1759–1824) was the daughter of Frederick Hervey, Bishop of Derry and 4th Earl of Bristol. She made an unhappy marriage to an Irish politician, John Foster, and after separating from him was befriended by Georgiana, Duchess of Devonshire (see No. 11), who gave her financial support, and before long provided her with a home at Devonshire House. The ensuing love affair between Lady Eliza-

beth and the 5th Duke (see No. 14) was never broken off and produced a daughter and a son. Georgiana, who throughout remained her closest friend, died in 1806 and in 1809 Lady Elizabeth's trials—some thought her schemes—were rewarded by marriage to the Duke. He himself died less than two years later and Duchess Elizabeth then made her retirement to Rome, where she became a leader of fashionable and intellectual society. Besides supporting at her own expense important excavations at the Forum, and commissioning deluxe editions of the classics, she was a frequent visitor to the studios of many of the famous sculptors then working in Rome in the neo-classical style. In 1819 she was visited by her stepson, the 6th Duke (see No. 15), whose enthusiasm for marble statuary originated from that year.

POMPEO BATONI (1708–1787)

14 *William Cavendish, 5th Duke of Devonshire* (29)

Canvas; 53×38½ in. (134×98 cm.)
Signed: *P. Batoni Pinxit. Rom. Anno. 1768*
Provenance: Commissioned by William (afterwards Sir William) Fitzherbert with whom Lord Hartington (afterwards the 5th Duke) was travelling in Italy. (The companion portrait of Fitzherbert remains in the family's possession at Tissington.) Given to the 6th Duke by William's son, Sir Henry Fitzherbert, in 1819.
Literature: J. Steegman, "Some English portraits by Pompeo Batoni," *Burlington Magazine*, LXXXVIII, 1946, p. 60, no. 48.

The 5th Duke of Devonshire (1748–1811), as the son of the 4th Duke (see No. 7) and Charlotte Boyle, the Burlington heiress, inherited vast estates in England and Ireland, traditionally the source of great political influence and power. As a Cavendish, much was expected of him, but he fixedly turned aside all offers of public office except of a purely nominal kind, and made it apparent that his aversion included all social occasions as well, withdrawing from the elegant and lively world inhabited by his Duchess Georgiana, and

turning for affection to Elizabeth Foster instead (see Nos. 11, 13). "Constitutional apathy formed his distinguishing characteristic," it was said.

Batoni was the most fashionable portrait painter in Rome in the 1760s and 1770s and was much patronized by English gentlemen making the Grand Tour. It is interesting to compare the formal elegance and cool, almost neoclassical coloring of this portrait with Reynolds' much more direct and naturalistic treatment of his sitters. Batoni has transformed his English sitter into a cosmopolitan nobleman who could have appeared at any court in Europe.

SIR EDWIN LANDSEER (1799–1873)

15 *William Spencer Cavendish, 6th Duke of Devonshire* (343A)

Oil on panel; 23½×17⅞ in. (60×45.5 cm.)
Provenance: Presented in 1929 by Lady Wester Wemyss, who inherited it from her great-aunt, the Duke's friend, Lady Newburgh, for whom it was painted.

The 6th Duke of Devonshire (1790–1858) was the son of the 5th Duke and Georgiana Spencer (see Nos. 11, 14). Born in May 1790 in Paris in the first days of the Revolution, he was presented as a baby to Queen Marie-Antoinette before his mother and father returned with him to England. Like his father, he was to shun politics, but he inherited his mother's love of social entertainment and foreign travel, and made his own great contribution to the building of Chatsworth, its gardens and collections. He remained a lifelong bachelor and was held in great affection by all who knew him, especially his friend the Prince Regent, afterwards George IV. In a delightfully discursive guidebook to his houses which he wrote himself, and which earned the praise of Charles Dickens, no less, he ended his account of Chatsworth thus: "To enjoy such sources of happiness and to see the pleasure they cause to others would make it as impossible to treat them with indifference, as it is to deserve the possession of them" (*Handbook of Chatsworth and Hardwick*, privately printed 1845).

Miniatures

Miniatures have long been fashionable in England. The art was introduced from Flanders in the early 16th century by the Horenbout family, from whom Holbein learned the technique, producing some of the finest miniatures ever painted. His style is represented in the exhibition by a copy of his full-size portrait of Edward, Prince of Wales, by Peter Oliver, one of the most accomplished miniaturists of the early 17th century, who specialized in making copies in miniature of famous easel pictures. In the 18th century miniatures were often exchanged between members of a family; they were worn as lockets by the women, sometimes with locks of hair in the back (cf. the Châtelaine, No. 175), and were often set into gold snuffboxes by the men (cf. No. 166). They represent a particularly intimate aspect of English art—one which flourished till the later 19th century but is now almost extinct, having been replaced by the photograph.

PETER OLIVER (1594?–1647),
after Hans Holbein

16 *Edward, Prince of Wales, Later King Edward VI* (1)

Rectangular, 3×2 in. (7.6×5 cm.)
Signed in a monogram *PO*
Inscribed: *Edwardus Princeps Filius Henrici Octavi Regis Angliae*

A copy by Oliver after the painting by Holbein in the National Gallery, Washington.

By or after SAMUEL COOPER (1609–1672)

17 *Oliver Cromwell, Lord Protector of England* (24)

Rectangular, 4×3¼ in. (10.1×8.25 cm.)

Unfinished; none of the dress or armor appears except a broad linen collar. Close to the unfinished oval

portrait of Cromwell (1599–1658) in the Duke of Buccleuch's collection. There are copies elsewhere by Bernard Lens and Christian Richter.

JOHN HOSKINS(?) (d. 1665)

18 *Thomas Hobbes* (29)

Oval, 2¾×2¼ in. (7×5.7 cm.)
Inscribed: *Aetatis 81.1661.I.H.*

For the sitter see No. 133. Traditionally a portrait of Hobbes, and from comparison with known paintings of him there can be little doubt of this, but there is a discrepancy in the dates. Possibly by an artist other than Hoskins, although it bears his initials (*I.H.*).

LAWRENCE CROSSE (d. 1724)

19 *William Cavendish, 4th Earl and 1st Duke of Devonshire* (40)

Oval, 2×1 in. (5×2.5 cm.)
Signed in a monogram: *LC*

The 4th Earl of Devonshire (1640–1707) was created 1st Duke in 1694 by William III in reward for his loyal service. He was proud, high-minded and fiercely patriotic, and although the Cavendish family had been prominent adherents to the Royalist cause in the Civil War, he was in sympathy with neither the extravagant style of Charles II's court, following the Stuart Restoration, nor the King's connivance with France and the agents of Roman Catholicism. He played little overt part in the politics of James II's reign, but was one of the peers instrumental in effecting the Glorious Revolution of 1688, by which William of Orange took the throne of England. This event, the culmination of all the 1st Duke stood for, lay at the root of the strong Whig tradition of politics maintained by the Cavendish family throughout the 18th and 19th centuries. For the part he played in the building of Chatsworth, which became the material expression of his ducal status, see Introduction, p. 14.

CHRISTIAN RICHTER (1678–1732), after Charles Jervas

20 *Dorothy Savile, Countess of Burlington* (46)

Oval, 2×1½ in. (5×3.8 cm.)
Signed and dated on the back: *C.R. 1719*

Lady Dorothy Savile (1699–1758) was the daughter of William, 2nd Marquess of Halifax, and in 1721 became Countess to the 3rd Earl of Burlington (No. 4). Their daughter, Charlotte (No. 21) married William, later 4th Duke of Devonshire, and following her premature death in 1754 Countess Dorothy took over the care of the Duke's four children. She was known for the caricature portraits she made of friends and members of the family, and several of these are now preserved at Chatsworth in the same albums that contain the sketches of William Kent.

After a portrait at Chatsworth attributed to Charles Jervas.

Attributed to JOHN COMERFORD (1770?–1832), after George Knapton

21 *Lady Charlotte Boyle, as a Child* (53)

Oval, 1⅝×1¼ in. (4.1×3.2 cm.)

Lady Charlotte (1731–1754), daughter and heiress of the 3rd Earl of Burlington (No. 4), married William, eldest son of the 3rd Duke of Devonshire, in 1748. She never lived to be Duchess, dying at the age of 23 one year before her husband became 4th Duke. Their children appear in a portrait by Zoffany (No. 8).

After a pastel portrait at Chatsworth by George Knapton.

HENRY BONE (1755–1834), after Sir Joshua Reynolds

22 *William Cavendish, 5th Duke of Devonshire* (63)

Oval, painted in enamels, 2×1¾ in. (5×4.4 cm.)
Signed: *H.B.*

For the sitter, see No. 14. After the portrait by Reynolds in the collection of Earl Spencer at Althorp.

RICHARD COSWAY (1742?–1821)

23 *Lady Georgiana Spencer, Duchess of Devonshire* (71)

Oval, $3\frac{1}{2} \times 2\frac{5}{8}$ in. (8.9×6.6 cm.)

For the sitter see No. 11.

THOMAS PEAT (active 1791–1805)

24 *Lady Georgiana Spencer, Duchess of Devonshire*

Oval, $2 \times 1\frac{3}{4}$ in. (5×4.4 cm.)
Signed: *Peat* and inscribed: *Duchess of Devonshire.*

For the sitter, see No. 11. Bought by the present Duke.

ENGLISH SCHOOL, late 18th century

25 *Lady Elizabeth Foster* (77)

Oval, $3\frac{1}{4} \times 2$ in. (8.2×5 cm.)

Lady Elizabeth (1760–1824) is depicted as Melpomene, the muse of tragedy. For the sitter see No. 13.

HORACE HONE (1756–1825) after Sir Thomas Lawrence

26 *William Spencer Cavendish, 6th Duke of Devonshire* (93A)

Oval, painted in enamels, $2\frac{1}{8} \times 1\frac{3}{4}$ in. (54×4.4 cm.)
Signed and dated: *H.H. 1813.*

For the sitter, see No. 15. After the portrait by Lawrence in the collection of Lord Dormer at Grove Park.

Old Master Paintings
Italian School

SEBASTIANO RICCI (1662–1734)

27 *The Presentation of Christ in the Temple* (542)

Canvas; 33×43 in. (84×109 cm.)
Signed: *Riccius fecit 1713.*
Literature: J. Daniels, *Sebastiano Ricci*, London, 1976, p. 3, No. 10.

Possibly painted for the 3rd Earl of Burlington, for whom Ricci later executed an important series of compositions for the Earl's London house in Piccadilly (now the home of the Royal Academy). The composition is based on the organ-shutters painted by Paolo Veronese for the Church of S. Sebastiano, Venice, for which Ricci had frescoed the dome over the choir some thirteen years earlier.

SEBASTIANO RICCI

28 *The Flight into Egypt* (541)

Canvas; $33 \times 44\frac{1}{2}$ in. (84×113 cm.)
Literature: J. Daniels, *Sebastiano Ricci*, London, 1976, p. 3, No. 9.

Usually said to be a pendant to the *Presentation* (see No. 27), but the pictures are so different in character that this is doubtful.

The idea of showing the Holy Family about to cross a river is relatively rare in painting. It has been suggested that in such representation the river was the Styx and the boatman Charon and that this constituted a reference to the Passion of Christ, but in Ricci's version the presence of a girl in the bow of the boat beside the boatman makes such an interpretation unlikely.

VENETIAN SCHOOL, second half of the 18th century

29 *An Allegory of Justice* (658)

Canvas; $13 \times 12\frac{1}{2}$ in. (33×31.7 cm.)

A sketch for a ceiling painting, no doubt made as a *modello* to present to a potential patron. The subject is not easy to interpret because the figures are only roughly, though vigorously, indicated. To the right is Justice, blindfolded and holding the scales, and below her is Clemency, leaning on a lion which is her attribute according to the *Iconologia* of Cesare Ripa, a handbook of iconography first published in 1593 and used by artists all over Europe for two centuries. The winged figure at the top left, who cannot be precisely identified but certainly represents a force of evil, is hurling a thunderbolt—apparently at Justice; but Innocence, accompanied by a lamb, holds up his shield to protect her, and deflects it. Instead it strikes Discord (holding a torch and a dagger) and another vice who is not clearly identifiable by any attribute but is likely to be Envy, and they are thrust out of the space of the painting into the world below.

This lively sketch is typical of the North Italian—probably Venetian—artists of the mid- and later 18th century who specialized both in complicated allegories and in the art of steep perspective views, with figures in sharp foreshortening, often bursting out of the picture space. So far no satisfactory name for the author has been suggested, but he was certainly a near contemporary of the great Giambattista Tiepolo.

French School

SIMON VOUET (1590–1649)

30 *An Allegory of Peace* (698A)

Canvas; 61½×62¼ in. (156×158 cm.)
Provenance: At Chatsworth by 1715.
Literature: W. R. Crelly, *The Paintings of Simon Vouet*, New Haven, 1962, p. 156.

The arms are those of Anne of Austria, Queen of Louis XIII, for whom it was presumably painted. It may refer to the Peace of Westphalia signed in 1648 between the Emperor and his Protestant opponents, who had been supported by France under the guidance of Cardinals Richelieu and Mazarin.

NICOLAS POUSSIN (1594–1665)

31 *The Shepherds in Arcadia* (501)

Canvas; 39¾×32¼ in. (101×82 cm.), with a strip about 3¼ in. (8 cm.) added on the left
Provenance: Cardinal Camillo Massimi; Madame du Housset; Loménie de Brienne; at Devonshire House in 1761 (Dodsley, II, p. 227).
Literature: A. Blunt, *Nicolas Poussin*, London, 1966–67, p. 114, No. 119.

The picture is often called "*Et in Arcadia ego*," from the inscription which the shepherds decipher on the tomb of another shepherd who had also lived in the ideally happy country of Arcadia but had been struck down by death. This is one of Poussin's most poetical inventions, painted about 1630, when he was still deeply influenced by the study of Titian. A later less vehement and more contemplative version of the same subject is in the Louvre.

NICOLAS POUSSIN

32 *The Holy Family with St. John, St. Elizabeth and Six Putti* (502)

Canvas; 39¾×53 in. (100×132 cm.)
Provenance: At Devonshire House, 1761 (Dodsley, II, 226)
Literature: A. Blunt, *Nicolas Poussin*, London, 1966–67, No. 58.

A typical example of Poussin's later and more considered manner, when his style was dominated by his admiration for Raphael and ancient sculpture.

CLAUDE GELLÉE, called Claude Le Lorrain (1600–1682)

33 *Landscape with Mercury and Battus* (240)

Canvas; 29×43½ in. (74×110.5 cm.)
Painted in 1663 for an unidentified patron in Antwerp.
Provenance: At Devonshire House, 1761 (Dodsley, II, p. 225).
Literature: *Liber Veritatis*, No. 159; M. Röthlisberger, *Claude Lorrain: The Paintings*, New Haven and London, 1961.

Battus was a shepherd who betrayed Mercury's trust in him and broke his promise not to reveal the fact that the god had stolen the cattle of Apollo; as a punishment Mercury turned him into a touchstone (the story is told by Ovid, *Metamorphoses*, II, 685).

Claude, a contemporary of Poussin (see Nos. 31, 32) was the greatest painter of "ideal" landscapes in the 17th century. He was much admired by English collectors of the 18th century and had a great influence on the landscaping of parks, of which Capability Brown's remodelling of the Park at Chatsworth for the 4th Duke is a notable example.

GASPARD DUGHET, called GASPARD POUSSIN (1615–1675)

34 *Landscape with Cephalus Hunting* (160)

Canvas; 27½×66 in. (70×168 cm.)
Provenance: Probably in the collection in 1725, when John Vandervaart was paid half a guinea for stretching and varnishing "A Long Landskip G. pousin." At Devonshire House, 1761 (Dodsley, II, p. 228).

The painting has, since the 18th century, been said to represent the story of Cephalus, a great hunter whose jealousy of his wife Procris led to his killing her unintentionally (the story is told by Ovid, *Metamorphoses*, VII, 675), but nothing in the painting points precisely to this theme. Gaspard Dughet was the brother-in-law of Nicolas Poussin and took his name after learning from him the art of landscape painting, in which this is one of his most beautiful productions.

Spanish School

Attributed to DIEGO RODRIGUEZ DA SILVA Y VELÁZQUEZ, called VELASQUEZ (1599–1660)

35 *Portrait of a Lady in a Mantilla* (684)

Canvas; 38½×19 in. (98×48 cm.), a strip 2 in. wide added at the bottom.
Provenance: 3rd Earl of Burlington; at Chiswick in 1761 (Dodsley, II, p. 119); 4th Duke.

Literature: Lopez Rey, *Velasquez: A Catalogue Raisonné of his Oeuvre*, London, 1963, p. 378, No. 600; P. M. Bardi, *L'opera completa di Velázquez*, Milan, 1969, No. 95A; E. Harris, "The Cleaning of Velázquez' Lady with a Fan," *Burlington Magazine*, CXVII, 1975, p. 316.

The painting is unusual in its tall, narrow shape and has almost certainly been cut down. A drawing at Chatsworth, in an album which belonged to Lady Burlington and contains sketches by her and her daughters, seems to show the portrait in its original form, with the lady depicted at full length, standing in a landscape, with a view of a town in the background. The sitter, whose identity has not been established, appears to be the same as the lady represented in the portrait by Velasquez in the Wallace Collection, London, the *Lady with a fan*, in which, however, she is shown wearing a low-cut bodice. This probably indicates that the Wallace portrait was painted before 1639, when a decree was issued by the King of Spain forbidding the wearing of such décolleté dress. The Chatsworth portrait was probably painted after that date to conform to the new regulation, though not many years later, as the lady's age does not seem to be much different in the two portraits.

The traditional attribution to Velasquez has been challenged, but when it was shown at the exhibition of the artist's work in Madrid in 1960, many critics declared themselves convinced that it was by him, and Lopez Rey, the author of the latest catalogue of Velasquez' paintings, accepts it as being certainly by him. Others, however, including Enriqueta Harris, the leading English authority on Spanish painting, and P. M. Bardi, are still doubtful and believe that it may be the artist's son-in-law and assistant Juan del Mayo (1610–1687).

BARTOLOMÉ ESTEBAN MURILLO (1616–1682)

36 *The Holy Family* (455)

Canvas; 38×27 in. (96.5×68.5 cm.)
Literature: A. Mayer, *Murillo*, Stuttgart, 1923, p. 58; J. A. Gaya Nuño, *L'opera completa di Murillo*, Milan, 1978, No. 174.

The painting probably contains allegorical allusions. The Virgin's gesture of uncovering the Christ Child symbolizes his revelation to humanity (a theme borrowed from Raphael) and the wooden block which Joseph is cutting stands for the wood of the Cross.

Dutch and Flemish Schools

CORNELIS DE VOS (c. 1585–1651)

37 *Portrait of a Little Girl* (696)

Canvas; 40¾×30½ in. (103×77 cm.)
Provenance: 3rd Earl of Burlington; 4th Duke of Devonshire.

This portrait, traditionally ascribed to Velasquez, is a charming and characteristic work of de Vos and may actually represent one of his own daughters.

SIR PETER LELY (1618–1680)

38 *Portrait of a Man* (357)

Canvas; 40⅛×32½ in. (102×82.5 cm.)
Provenance: Recorded at Devonshire House in 1761 (Dodsley, II, p. 229).
Literature: O. Millar, Catalogue of the exhibition *Sir Peter Lely*, National Portrait Gallery, London, 1978, No. 5.

Traditionally described as a portrait of a sculptor, but the presence of the bust in the background is more likely to indicate a collector. The bust has been identified as a version of the Eros by Lysippus. Probably painted about 1646–47.

REMBRANDT VAN RIJN (1606–1669)

39 *Portrait of an Old Man* (550)

Canvas; 30¾×26 in. (78×66 cm.)
Signed and dated: *Rembrandt f. 1651*
Provenance: 3rd Earl of Burlington; at Chiswick in 1761 (Dodsley, II, p. 121); 4th Duke.
Literature: Hofstede de Groot, *Catalogue . . . of Dutch*

Painters, London, 1907–16, VI, No. 399; Bredius, *The Paintings of Rembrandt*, London, 1937, No. 266; Bredius revised by H. Gerson, London, 1969, No. 266 and pl. 204; H. Gerson, *Rembrandt*, London, 1968, No. 299.

This masterly portrait, in its static pose seen in a rigidly frontal view, is typical of Rembrandt's style in the early 1650s. The figure is brought to life by the vigorous brush strokes with which the artist delineates not only the face and hands but also the varied textures of the furred robe and frilled shirt which the sitter wears—features which Rembrandt painted all his life, but most imaginatively in this phase. The sitter cannot be identified but is almost certainly a member of the artist's circle of friends from whom he mainly drew his models after the 1640s.

THOMAS WYCK (1616–1677)

40 *View of London* (716)

Canvas; 23½×34½ in. (59.5×87.5 cm.)
Provenance: 3rd Earl of Burlington.
Literature: Catalogue of exhibition *London and the Thames*, Somerset House, London, 1977, No. 2.

One of the most vivid views of London before the Great Fire of 1666 which destroyed the greater part of the city. In the foreground is Southwark Cathedral, behind it old London Bridge, still built over with houses. On the far (north) bank can be seen, on the right, the Tower of London with its four turrets and, to the left, old St. Paul's.

Inigo Jones shows a somewhat similar view of London at an earlier date in one of his masque designs (No. 117).

Modern

LUCIAN FREUD (b. 1922)

41 *Large Interior, London, W.9.*

Oil on canvas; 35½×35½ in. (90.2×90.2 cm.)

The seated woman is the artist's mother. Painted in 1973 and bought by the present Duke in 1974.

There are several paintings by Lucian Freud at Chatsworth, nearly all of members of the present Duke's family, and painted over the past three decades. They are not portraits in the traditional sense, but reflect what the artist has said is his central theme: "My work is purely autobiographical . . . I work from the people that interest me . . . I use them to invent my pictures with." He has also spoken of his "horror of the idyllic," providing a clue to the disturbing effect of *Large Interior, W.9*.

LUCIAN FREUD

42 *Portrait of a Man: Andrew Cavendish, 11th Duke of Devonshire*

Oil on canvas; 23¼×23¼ in. (59.1×59.1 cm.)

Commissioned by the present Duke in 1971/2.

LUCIAN FREUD

43 *Woman in a White Shirt: Deborah, Duchess of Devonshire*

Oil on canvas; 17½×15½ in. (44.4×39.4 cm.)
Commissioned by the present Duke in 1956/7.

LAWRENCE STEPHEN LOWRY
(1887–1976)

44 *Harbour Scene*

Oil on canvas; 17½×23½ in. (44.4×59.7 cm.)
Signed and dated: *L. S. Lowry 1957*
Purchased by the present Duke.

The seaside subject adds a more cheerful note to the artist's lifelong theme of the cities and towns of England's industrial north. Lowry died in 1976, shortly before the opening of a major retrospective exhibition of his work in London, which became a great critical and popular success.

SUSAN CRAWFORD (b. 1941)

45 *Assessing the Field: The Mare Park Top with Lester Piggott*

Oil on canvas; oval, 19½×15½ in. (49.5×39.4 cm.)
Signed: *S. L. Crawford*
Purchased by the present Duke.

Park Top was the most successful racehorse owned by the present Duke of Devonshire and won many important races in England and France between 1967 and 1970, including the 1969 King George VI and Queen Elizabeth Cup at Ascot (No. 164). Many of the books and works of art collected by the Duke in recent years were purchased with the prize money won by the mare.

Drawings

One of the greatest glories of Chatsworth is the collection of Old Master drawings. This was mainly formed by the 2nd Duke and has remained intact till the present day except for two items: the *Liber Veritatis* of Claude Lorrain and the Italian Sketchbook of Van Dyck, which were handed over to the Treasury in part payment of duties on the death of the 10th Duke in 1950 and are now in the British Museum.

The 2nd Duke almost certainly began collecting before he succeeded to the title in 1707 and he was no doubt the purchaser of the drawings now at Chatsworth which came from the collections of Sir Peter Lely and P. H. Lankrink, sold in London between 1688 and 1694. It was in 1723, however, that he made his most spectacular acquisition: some 225 drawings from the collection of Nicolaes Anthoni Flinck, son of Govaert Flinck, a pupil of Rembrandt. These included not only superb groups of drawings by Dutch and Flemish artists, notably Rembrandt, Rubens and Van Dyck, but also many by major Italian artists, including Raphael, Mantegna, Barocci and Annibale Carracci.

By the time of his death in 1729 the 2nd Duke had built up a collection of drawings unequalled at the time in England (the Royal Collection did not attain its full amplitude till the early 1760s, with the acquisitions of George III) and surpassed by few in other countries. It was further enlarged by the drawings which came to the 4th Duke from his father-in-law, the 3rd Earl of Burlington, from whom he inherited the unique collection of architectural drawings by Palladio—now on loan to the Royal Institute of British Architects—and the drawings by Inigo Jones for the masques given at the English court during the reigns of James I and Charles I (see Nos. 108–119).

Most of the drawings shown here were included in two exhibitions circulated in 1962–63 and in 1969, both entitled *Old Master Drawings from Chatsworth*. The reader will find further information and fuller bibliographies for the drawings in the catalogues of these exhibitions, which are referred to in the entries below as "Chatsworth Drawings, 1962–63"[1] and "Chatsworth Drawings, 1969."[2] Unless otherwise stated, all drawings have been in the collection since the time of the 2nd Duke.

1. A. E. Popham and Felice Stampfle, *Old Master Drawings from Chatsworth*, catalogue of the exhibition circulated by the Smithsonian Institution, 1962–63.
2. James Byam Shaw, *Old Master Drawings from Chatsworth (II)*, catalogue of the exhibition circulated by the International Exhibitions Foundation, 1969.

Italian School

FLORENTINE SCHOOL, early 15th century

46 *Pilate Washing His Hands, and Study of Four Dogs* (963)

Pen and brown ink.
11½ × 14¾ in. (29.2 × 37.6 cm.)
Provenance: Giorgio Vasari (1511–1574).
Literature: Chatsworth Drawings, 1969, No. 8.

The attribution of the drawing is uncertain, but the names of Nanni di Banco and Donatello have been proposed for the *Pilate* and that of Francesco Pesellino for the *Four dogs*. The sheet is of particular interest because it was made up by Giorgio Vasari, the great biographer of Renaissance artists, who was also the first person to collect drawings systematically. These he set into sheets—in this case taking care that the drawing of Pilate, which has another drawing of

Christ Carrying the Cross on the *verso*, should be visible on both sides—and himself drew the ornamental frames in which the individual drawings are set. The woodcut portrait of Nanni di Banco from Vasari's *Lives of the Painters, Sculptors and Architects*, with a brown wash added by hand, also appears on the *verso* of the sheet.

ANONYMOUS, ITALIAN SCHOOL

The following five drawings come from a group of 131 watercolors and drawings of animals, birds and plants which were first hung by the 6th Duke in the "Sketch Gallery" at Chatsworth, were later moved to Compton Place, Eastbourne, and now once again hang at Chatsworth. They are remarkable examples of the interest shown by Italian artists of the Renaissance in natural history, but it is difficult to ascribe any of them to specific painters; in many cases it is also impossible to date them accurately, since artists devoted primarily to the study of nature often continued to use for several generations a technique which had long gone out of fashion with those concerned with figure painting.

47 *A Duck in Flight*

Pen, brown ink and watercolor.
$7\frac{7}{8} \times 11\frac{7}{8}$ in. (20×30.3 cm.)
Literature: Chatsworth Drawings, 1969, No. 2.

Probably by a north Italian artist of the first half of the 15th century.

48 *Periwinkles and Violets*

Watercolor and body color.
$7 \times 11\frac{1}{2}$ in. (17.8×29.3 cm.)

It has been suggested that this watercolor is by a follower of Giovanni Bellini, but the curvilinear forms of the stems and leaves seem to point to a somewhat earlier period when the elegance of the International Gothic style was still felt in northern Italy.

49 *A Monkey*

Watercolor with body color.
$15\frac{3}{4} \times 11\frac{1}{2}$ in. (40.2×29.3 cm.)
Literature: Chatsworth Drawings, 1969, No. 6.

This drawing, which is one of the most impressive and monumental of the whole series, is in a hatched technique which almost recalls fresco. It must date from the 15th century but cannot be attributed to any specific artist.

50 *A Snake*

Watercolor and body color.
$5\frac{7}{8} \times 16$ in. (15×40.5 cm.)

Probably dates from the late 15th century.

51 *A Hawfinch*

Watercolor over black chalk.
$11 \times 8\frac{3}{8}$ in. (28×21.5 cm.)
Dated 1540.
Literature: Chatsworth Drawings, 1969, No. 4.

This watercolor has been attributed to Giovanni da Udine, who collaborated with Raphael in the painting of the Loggie in the Vatican and was a specialist in the drawing of birds.

ANDREA MANTEGNA (1431–1506)

52 *Battle of the Sea-Gods* (897)

Pen and brown ink.
$10\frac{1}{4} \times 15$ in. (25.7×38 cm.)
Provenance: N. A. Flinck; bought in 1723 by the 2nd Duke.
Literature: E. Tietze-Conrat, *Mantegna*, London, 1955, p. 204; Chatsworth Drawings, 1962–63, No. 37; catalogue of the exhibition *Andrea Mantegna*, Mantua, 1961, p. 168, No. 125.

The drawing corresponds so closely to the left-hand plate of the engraving of the same subject (see No.

100), which is in the same direction, that it has been suggested that it may be a copy after the latter by an artist very close to Mantegna, but A. E. Popham, Tietze-Conrat, and most other modern critics believe it to be from the artist's own hand. The inscription *INVID*, an abbreviation of *invidia* ("envy"), gives the theme of the composition. It has been suggested that it specifically represents the sea storm raised by the envious Juno to destroy Aeneas, as described in the first book of Virgil's *Aeneid* (lines 147–152). The composition is inspired by a relief from an ancient sarcophagus in the Villa Medici, Rome, but is in the actual style and technique of the engraving. Mantegna was clearly influenced by the Florentine artist, Antonio Pollaiuolo, whose engraving, *Battle of the Nudes*, is similar in general character.

DOMENICO GHIRLANDAIO (1449–1494)

53 *Head of a Woman* (885)

Black chalk, the outlines pricked for transfer.
14⅜×8¹¹⁄₁₆ in. (36.6×22.1 cm.)
Literature: B. Berenson, *The Drawings of the Florentine Painters* (amplified edition), Chicago, 1938, II, p. 91, No. 866; Chatsworth Drawings, 1962–63, No. 24.

This is the full-size cartoon for the head of a woman standing by the steps on the left in the fresco of the *Birth of the Virgin* in the chapel of the Tornabuoni family in S. Maria Novella, Florence, commissioned by Giovanni Tornabuoni in 1485. Like most of the figures in the frescoes in this chapel the drawing is a portrait, probably of a member of the Tornabuoni family.

LEONARDO DA VINCI (1452–1519)

54 *Leda and the Swan* (717)

Pen and brown wash over black chalk.
6⅝×5½ in. (16×13.9 cm.)
Inscribed: *Leonardo da Vinci*
Literature: Chatsworth Drawings, 1962–63, No. 32.

The composition shows Leda, who was seduced by Jupiter disguised as a swan, and the infants Castor and Pollux and Helen and Clytemnestra being hatched from the eggs which resulted from the union. Leonardo was much occupied with the subject of Leda, to which he was probably attracted as a symbol of fertility, during his first stay in Milan just before 1503, and after his return to Florence in that year. His only painted version of the subject, which was in the French Royal Collection but vanished about 1700, and is only known from copies, showed Leda standing; but he also designed a composition showing her kneeling as in the present drawing. Another drawing showing her kneeling is in the Boymans-van Beuningen Museum, Rotterdam. In all the versions of the design the theme of fertility is emphasized by the luxuriant plants which surround the figures.

Follower of LEONARDO DA VINCI

55 *Heads of a Woman and Child* (893)

Metal-point on green prepared paper.
11¾×8⅝ in. (29.7×22 cm.)
Literature: Chatsworth Drawings, 1962–63, No. 33.

The head of the child corresponds closely to that of the infant St. John in the *Virgin of the Rocks* and is apparently based on a drawing by Leonardo himself in the Louvre. The head of the woman is like the head of the Virgin in a Virgin and Child in a private collection by a close follower of the artist (reproduced in W. Suida, *Leonardo und sein Kreis*, Munich, 1929, pl. 46).

The present drawing, which is an accomplished example of the style of Leonardo's best followers during his second Milanese period (1508–13), has been attributed to Giovanni Antonio Boltraffio (1467–1516) but without adequate reason.

VITTORE CARPACCIO (active 1486–c. 1525)

56 *A Scene of Presentation* (739)

Pen and brown ink over red chalk.
6⅝×7¾ in. (16.6×19.7 cm.)
Literature: J. Lauts, *Carpaccio. Paintings and Drawings*, London, 1962, p. 266, No. 7; Chatsworth Drawings, 1962–63, No. 10.

The subject of the drawing has not been certainly identified, but it has been suggested that it represents Cardinal Bessarion presenting a reliquary containing a fragment of the True Cross to the representative of the Scuola della Carità, Venice, whom he met at Bologna in 1472.

The composition is a fine example of the vivid, almost "shorthand" manner of drawing employed by Carpaccio and some other Venetian artists of the late 15th century.

RAFAELLO SANTI, called RAPHAEL
(1483–1520)

57 *Studies for the Madonna of the Meadow* (723)

Pen and brown ink.
9¾×7⅝ in. (25×19.4 cm.)
Provenance: Sir Peter Lely; 2nd Duke.
Literature: O. Fischel, *Raphaels Zeichnungen*, Berlin, 1913–72, III, No. 117 (who suggested, apparently without reason, that the drawing was touched up by another hand); Chatsworth Drawings, 1969, No. 57.

A preliminary study for the *Madonna of the Meadow*, painted in 1505 and now in the Kunsthistorisches Museum, Vienna. On the *verso* is a slight drawing after Michelangelo's *tondo* of the *Holy Family* now belonging to the Royal Academy, London.

RAFAELLO SANTI, called RAPHAEL

58 *Woman Reading to a Child* (728)

Metal-point on grey prepared paper, heightened with white.
7½×5½ in. (19×14 cm.)
Provenance: Sir Peter Lely; 2nd Duke.
Literature: Fischel, *op. cit.*, No. 375; Chatsworth Drawings, 1962–63, No. 57.

The drawing was engraved by Marcantonio Raimondi or one of his pupils, probably during Raphael's lifetime or soon after his death (Bartsch, XIV, p. 54, No. 48). It seems to be a study from life, as the figures are in contemporary dress, but it may have been made

as a preliminary for a painted composition, since somewhat similar figures occur in the fresco of the *Mass of Bolsena* in the Vatican, painted between 1511 and 1514. A closely similar drawing is in the Ashmolean Museum, Oxford (No. 561). For a note on the technique, see No. 59.

RAFAELLO SANTI, called RAPHAEL

59 *Studies for the Conversion of St. Paul* (905)

Red chalk over a sketch with the stylus.
12⁵⁄₁₆×9½ in. (31.3×24.1 cm.)
Literature: Fischel, *op. cit.*, Part IX, No. 447; Chatsworth Drawings, 1962–63, No. 60; J. Shearman, *Raphael's Cartoons in the Collection of Her Majesty The Queen*, London, 1972, pp. 101f.

Studies for a soldier running and two others on horseback for the composition of the *Conversion of St. Paul*, designed by Raphael for the series of tapestries commissioned by Leo X to decorate the lower part of the walls of the Sistine Chapel and woven in Brussels. Most of the cartoons are in the Royal Collection (on loan to the Victoria and Albert Museum, London) but in this case the cartoon is lost and the composition is only known from tapestries, in which the figures appear in reverse, owing to the fact that they were woven by the low warp process. In this drawing Raphael used a technique, which was habitual with him, of making the first sketch with a stylus, or metal-point, which left simply an indented line on the paper. This allowed him to make any changes in the design that he wished without leaving any clear marks; he then went over the lines finally arrived at in this way with red chalk.

A copy of this drawing exists in the Teyler Museum, Haarlem, which is of such quality that it has been claimed—but without real justification—as an original.

RAFAELLO SANTI, called RAPHAEL

60 *Three Men in Attitudes of Terror* (20)
Black chalk.
9¼×14½ in. (23.7×36.8 cm.)

Provenance: N. A. Flinck; bought in 1723 by the 2nd Duke.

Literature: Fischel, *op. cit.*, Part VIII, No. 394; Chatsworth Drawings, 1962–63, No. 55.

Study for a composition of the Resurrection, on which Raphael was working in the last years of his life, but of which he never made a painting. Other studies for it are in the British Museum; the Ashmolean Museum, Oxford; the Royal Library, Windsor Castle; and the Musée Bonnat, Bayonne. Raphael has here followed a practice common with him of drawing the figures in the nude to fix the poses and the anatomical details more clearly. In the painting, draperies —or in this case, probably armor—would have been added.

RAFAELLO SANTI, called RAPHAEL

61 *Studies of a Man's Head and Hand* (66)

Black chalk.

14⅜×13⅝ in. (36.3×34.6 cm.)

Literature: K. Oberhuber, "Vorzeichnungen zu Raphaels Transfiguration," *Jahrbuch der Berliner Museen*, N.F. IV, 1962, p. 127ff.; Chatsworth Drawings, 1962–63, No. 56.

Studies for the head and hand of the man on the left of the *Transfiguration* (see No. 62).

RAFELLO SANTI, called RAPHAEL

62 *Study for the Transfiguration* (904)

Red chalk over drawing with the stylus, squared.

9⅝×13¾ in. (24.6×35 cm.)

Literature: Oberhuber, *op. cit.*, p. 142; Chatsworth Drawings, 1969, No. 58.

A preparatory drawing for the painting in the Vatican, commissioned from Raphael in 1516 for the church of S. Pietro in Montorio, Rome, by Cardinal Giulio de' Medici, later Pope Clement VII. This work, Raphael's last altarpiece, has been the subject of endless discussion by historians of Italian painting. It used to be maintained that the painting was left unfinished

by Raphael at his death in 1520 and was completed by his assistants, of whom the most important was Giulio Romano, and some of the preparatory drawings, including the composition exhibited here, have been ascribed to him. The painting has recently been cleaned, however, and it is now generally agreed that it is in all essentials from the hand of Raphael himself. The preparatory drawings have also been reinstated and critics no longer doubt the authenticity of the Chatsworth drawing.

It represents only the upper half of the composition with the figures of Christ flanked by Moses and Elijah and below the Apostles, who show their astonishment at the vision. All the figures are drawn in the nude, a device frequently used by Raphael to define the actions and poses of the figures in his compositions, and it is an example of his brilliance in drawing the human figure in complicated poses.

Attributed to GIULIO ROMANO (1485–1546)

63 *Head of Pope Leo X* (38)

Black chalk.

18¾×11¾ in. (48×29 cm.), irregularly cut.

Provenance: P. H. Lankrink; 2nd Duke.

Literature: Chatsworth Drawings, 1962–63, No. 69; "The King's Good Servant," Sir Thomas More, catalogue of exhibition at the National Portrait Gallery, London, 1977, No. 75.

Giovanni de' Medici (1475–1521), second son of Lorenzo de' Medici (Lorenzo the Magnificent), was made a cardinal in 1489 and was elected pope in 1513 in succession to Julius II. He was a great patron of the arts, and in particular commissioned Raphael to complete the decoration of the Stanze in the Vatican begun by his predecessor. This drawing was used as a model for the figure of Pope Clement I in the last of the rooms to be decorated, the Sala di Costantino, which was commissioned shortly before Raphael's death in 1520 and completed by members of his studio under the leadership of Giulio Romano.

This drawing has sometimes been attributed to Sebastiano del Piombo, but it is now generally held

by scholars to be by Giulio Romano. Professor John Shearman, however, is convinced that it is from the hand of Raphael himself and not by his pupil.

Attributed to TIZIANO VECELLI, called TITIAN (c. 1485–1576)

64 *Pastoral Landscape* (750)

Pen and brown ink, touched with body color.
7⅝×11¾ in. (19.5×29.8 cm.)
Inscribed: *Titiano*
Literature: Chatsworth Drawings, 1969, No. 68; catalogue of exhibition *Disegni di Tiziano*, Fondazione Giorgio Cini, Venice, 1976, No. 46.

This drawing, which is an exceptionally fine example of Venetian landscape drawing in the early 16th century, was traditionally ascribed to Domenico Campagnola, but James Byam Shaw, in his catalogue of the Chatsworth drawings shown in the United States in 1969, put forward the view that it is an early work by Titian, when he was still under the influence of Giorgione. This was accepted by Oberhuber in his catalogue of the 1976 Venice exhibition, where it made a strong impression in the context, for the first time, of other drawings by Titian and his circle.

FRANCESCO MAZZOLA, called
IL PARMIGIANINO (1503–1540)

65 *Design for the Vault of the Steccata, Parma* (788)

Pen and ink and watercolor.
9³⁄₁₆×6¹¹⁄₁₆ in. (23.5×17 cm.)
On the *verso* studies of a woman fondling a horse.
Literature: A. E. Popham, *The Drawings of Parmigianino*, London, 1953, No. 718; Chatsworth Drawings, 1962–63, No. 43.

An elaborate colored study for the painted vault of the choir in the church of the Steccata at Parma on which Parmigianino was engaged from 1531 to 1539. The decoration was one of the most elaborate and ingenious schemes of illusionism of the time, with the figures appearing to stand against gilt coffered

relief panels. It is also typical of Parmigianino in the elegant elongation of the figures.

FRANCESCO MAZZOLA, called
IL PARMIGIANINO

66 *A Bearded Figure Sleeping* (806)

Red chalk.
7½×10¾ in. (19.1×27.3 cm.)
Provenance: Sir Peter Lely; 2nd Duke.
Literature: Popham, *op. cit.*, No. 734; Chatsworth Drawings, 1962–63, No. 46.

This drawing has been identified as a study for a sleeping soldier in a composition of the Resurrection, but it seems more likely that it represents one of the sleeping apostles in an Agony in the Garden.

PAOLO CALIARI, called VERONESE
(c. 1530–1588)

67 *The Martyrdom of St. Justina* (279)

Pen and brown ink, touches with the point of the brush and wash on grey-blue prepared paper; squared for transfer.
18½×9½ in. (47×24 cm.)
Provenance: P. H. Lankrink; 2nd Duke.
Literature: Chatsworth Drawings, 1962–63, No. 72.

A highly finished drawing for the painting over the High Altar in the church of S. Giustina, Padua, no doubt intended to be shown to the authorities of the church, who commissioned the altarpiece.

The painting corresponds closely to the drawing in its general composition, but one or two of the most picturesque details in the latter are omitted: the dog is moved across to the right-hand part of the foreground, where he is led by a soldier in armor in a full mannerist *contrapposto* (twisted pose) who replaces the piper who appears at this point in the drawing. Veronese, however, added vividness to the painting by increasing the number of saints and angels in the heavenly zone at the top of the composition and by inserting in the landscape background the dome of the church of S. Antonio, the most holy shrine of the city of Padua.

FEDERICO BAROCCI (1526–1612)

68 *Head of a Boy* (355)

Black, red and white chalk.
7⅝ × 8 in. (20.6 × 19.4 cm.)
Provenance: N. A. Flinck; bought in 1723 by the
2nd Duke.
Literature: Chatsworth Drawings, 1969, No. 15; *Mostra di Federico Barocci* (catalogue), Bologna, 1975, No. 129.

A study for a figure in the *Martyrdom of S. Vitale* in the Brera Gallery, Milan, dated 1583. The drawing is a fine example of Barocci's use of colored chalks, a technique employed by many artists of his generation but never with such subtle fluency.

ANNIBALE CARRACCI (1560–1609)

69 *Shepherd Boy Piping* (446)

Black chalk.
15½ × 10½ in. (39.3 × 26.6 cm.)
Inscribed: *Antonio da Correggio*.
Provenance: N. A. Flinck; bought in 1723 by 2nd Duke.
Literature: Chatsworth Drawings, 1962–63, No. 14;
D. Posner, *Annibale Carracci*, London, 1971, II, No. 16.

A lively study from nature made at an early date in the artist's career, when he was deeply influenced by the study of Correggio, to whom this drawing was once ascribed. It was probably made about 1585 in connection with a painting of a fête champêtre, now at Marseilles, which contains a group of peasants playing instruments like recorders.

GIOVANNI BENEDETTO CASTIGLIONE (c. 1610–1665)

70 *Tobit Burying the Dead* (622)

Brush and oil colors.
16¼ × 11⅜ in. (41.4 × 28.9 cm.)
Provenance: P. H. Lankrink; 2nd Duke.
Literature: A. Blunt, "A Poussin-Castiglione Problem," *Journal of the Warburg Institute*, III, 195, pp. 143ff.; Chatsworth Drawings, 1969, No. 29; A. Percy, *G. B. Castiglione*, Catalogue of the exhibition held at the Philadelphia Museum of Art, 1971, p. 68, No. 16.

The story is taken from the Book of Tobit (I, 18ff.) which tells how Tobit, in defiance of the orders of Sennacherib, buried the bodies of the Jews killed by the king outside the walls of Nineveh. It is rarely treated in art but was a favorite with Castiglione and his associates.

This is a brilliant example of the technique of drawing with a brush and oil paints on paper, characteristic of Castiglione, who probably learnt it from seeing similar sketches by Rubens and Van Dyck, which he could have known either in his native Genoa or during his visits to Rome.

GIOVANNI FRANCESCO BARBIERI, called GUERCINO (1591–1666)

71 *The Madonna del Carmine Offering the Scapular to S. Albert* (519)

Pen and brown wash with some body color.
16⅛ × 10⅝ in. (41.2 × 26.9 cm.)
Literature: D. Mahon, Catalogue of the Guercino exhibition at Bologna, 1968, *Disegni*, No. 8; Chatsworth Drawings, 1969, No. 38.

A preliminary study for the altarpiece painted about 1615 for the church of Sta. Maria Annunciata and now in the Gallery at Cento. The composition shows the Virgin giving the scapular—the symbol of membership of a religious order—to St. Albert, founder of the Carmelite Order.

French School

JACQUES CALLOT (1592–1635)

72 TWO SCENES FROM THE PASSION:
 A. *The Taking of Christ* and
 B. *Christ Before Pilate*

Brown wash over black chalk.
Each 4 × 8½ in. (10 × 21.5 cm.)
Provenance: In a collection in Paris in 1684; P. J. Mariette sale, 1775, part of lot 1185; Tersan; probably acquired by the 6th Duke and added to the

volume of Callot drawings acquired by the 2nd Duke. Literature: D. Ternois, *Jacques Callot: Catalogue complet de son oeuvre dessiné*, Paris, 1961, p. 98; Chatsworth Drawings, 1969, Nos. 111a, 111b.

These are two from a group of thirteen drawings at Chatsworth for the *Grande Passion* series of prints, only seven of which were etched by Callot, probably between 1619 and 1624. They are among the artist's most dramatic drawings.

CLAUDE GELLÉE, called LE LORRAIN (1600–1682)

73 *Moses and the Burning Bush* (872)

Pen and brown wash.
6¼×8⅛ in. (15.5×20.7 cm.)
Literature: M. Röthlisberger, *Claude Lorrain, The Drawings*, Berkeley, 1968, No. 921.

A study for the painting, now on loan from the Duke of Sutherland to the National Gallery of Scotland, painted in 1660 for Louis Anglure de Bourlemont, Archbishop of Toulouse (*Liber Veritatis*, No. 161). This is Claude's first study for the painting and at this stage he has not actually drawn the Burning Bush, which he later introduced on the rock to the left of the composition.

CLAUDE GELLÉE, called LE LORRAIN

74 *The Disembarkation of Cleopatra at Tarsus* (870)

Pen and brown wash.
5½×8 in. (13.8×20.5 cm.)
Literature: M. Röthlisberger, *op. cit.*, No. 505.

In B.C. 41, after the death of Caesar, whose mistress she had been, Cleopatra was summoned by Mark Anthony to Tarsus. It was here that the celebrated love affair between the two began, and the moment of her landing is the subject of the famous speech in Shakespeare's *Antony and Cleopatra* beginning: "The barge she sat in, like a burnish'd throne / Burn'd on the water. . . ." The drawing is a study for a painting

made for Monsignor Giorio (*Liber Veritatis* 63), now in the Louvre.

CLAUDE GELLÉE, called LE LORRAIN

75 *Jupiter and Callisto* (945)

Pen and brown and grey wash over black chalk heightened with body color.
10⅛×13⅛ in. (25.7×33.5 cm.)
Signed: *CLAUDIO INVFEC.*
Literature: M. Röthlisberger, *op. cit.*, No. 950; Chatsworth Drawings, 1969, No. 118.

Jupiter seduced Callisto, one of the nymphs of Diana, by disguising himself as the goddess. Callisto was transformed into a bear by the jealous Juno, and her son by Jupiter, Arcas, unknowingly hunted and nearly killed her; but Jupiter intervened and transformed them both into constellations: Callisto into the Great Bear; Arcas into Arctophylax (see Ovid, *Metamorphoses*, 2, 405ff.). No painting is known exactly based on this drawing.

CLAUDE GELLÉE, called LE LORRAIN

76 *Ascanius Shooting the Stag* (943)

Pen with brown and black wash, heightened with white.
10×12½ in. (25.3×32.6 cm.)
Inscribed in the artist's hand: *Libro settimo di Virgilio foglio 16 Come Ascanio saetta il cervo de Silvia. Figliuola di Tirro Claudio IV. Roma 16178* [sic].
Literature: M. Röthlisberger, *op. cit.*, No. 1127.

As the inscription indicates, the drawing illustrates an episode from the story of Ascanius, son of Aeneas and leader of the Trojans who had landed in Italy and were about to found Rome. He was tricked by the Fury Alecto into shooting a favorite tame white stag which belonged to Silvia, daughter of Tyrrhus, king of one of the tribes of Latium, who therefore attacked the Trojans. The story is told by Virgil in the 7th book of the *Aeneid*.

The inscription illustrates the difficulty which Claude had in dealing with figures: he wrote 16178 instead of 1678, a mistake which occurs on other drawings.

The drawing is a preparation for Claude's last painting, executed in 1682 for Prince Colonna and now in the Ashmolean Museum, Oxford. Both the painting and the drawing are among the most poetical works of Claude's last period.

Flemish School

JAN GOSSAERT, called MABUSE
(c. 1478–1533/36)

77 *Adam and Eve* (935)

Pen and black ink on grey prepared paper, heightened with white.
13¾×9⅜ in. (34.8×23.9 cm.)
Provenance: N. A. Flinck; bought in 1723 by the 2nd Duke.
Literature: Chatsworth Drawings, 1962–63, No. 87; *Jan Gossaert, dit Mabuse*, catalogue of exhibition, Boymans-van Beuningen Museum, Rotterdam, 1965, No. 60.

A highly finished drawing in a technique much used in the early 16th century.

PIETER BRUEGEL THE ELDER
(1525/30–1569)

78 *View of the Ripa Grande, Rome* (841)

Pen and brown ink.
8⁹⁄₁₆×11⅛ in. (20.8×28.3 cm.)
Inscribed: *a rypa*
Literature: Chatsworth Drawings, 1962–63, No. 77; *Pieter Bruegel der Aeltere*, catalogue of exhibition at the Kupferstichkabinett, Berlin, 1975, No. 26.

The inscription refers to the Ripa Grande, the main port of Rome in the 16th century, on the right bank of the Tiber near the Porta Portese. The drawing, which was presumably made when Bruegel was in Rome in 1553, shows the old Customs House and the Romanesque tower of the church of S. Maria de Turri. All the buildings shown were destroyed in the 18th century to make way for the vast Ospizio di S. Michele.

The drawing was traditionally ascribed to Jan Bruegel the Elder ("Velvet Bruegel") but there can be no doubt that it is by his father, Pieter.

SIR PETER PAUL RUBENS (1577–1640) or
SIR ANTHONY VAN DYCK (1599–1641)

79 *A Wolf-Hunt* (982)

Black and red chalk and watercolor.
9⅝×14⅛ in. (24.7×36 cm.)
Provenance: N. A. Flinck; bought 1723 by the 2nd Duke.
Literature: Chatsworth Drawings, 1969, No. 98.

The drawing corresponds closely in composition with a painting by Rubens in the Metropolitan Museum, New York, but the elaborate use of watercolor suggests that it may be a variant from the painting rather than a study for it, which would probably have been in brown wash only. The brilliance of the draughtsmanship suggests that it may be by Van Dyck and this is confirmed by certain technical devices, such as the indication of the animals' muscles by dots instead of lines which is to be found in his *Study of Cows* (No. 86).

SIR PETER PAUL RUBENS

80 *Woman Churning* (984)

Black and red chalk.
13⅛×10 in. (33.3×25.5 cm.)
Literature: J. Held, *Rubens. Selected Drawings*, London, 1959, No. 95; J. Burchard and R. A. d'Hulst, *Rubens Drawings*, Brussels, 1963, No. 177; Chatsworth Drawings, 1962–63, No. 101.

A study from the life, which Rubens did not apparently use in a painting. It was probably made in the first half of the 1630s.

SIR PETER PAUL RUBENS

81 *Tree Trunk and Brambles* (1008)

Red and black chalk, pen and brown ink, some color.
13¾×11¾ in. (35.2×29.8 cm.)
Inscribed in Rubens' hand: *afgevallen bladern ende op*

sommighe plaetsen schoon gruen grase door kyken ("fallen leaves and in some places green grasses peep through"). Literature: J. Burchard and R. A. d'Hulst, *op. cit.*, No. 105; Chatsworth Drawings, 1962–63, No. 102.

The drawing, which is one of Rubens' most subtle studies from nature, is related in style to one in the Louvre which the artist used for the *Boar Hunt* at Dresden; the latter was probably painted between 1615 and 1620, which suggests a similar dating for the drawing.

SIR ANTHONY VAN DYCK (1599–1641)

82 *The Marriage of St. Catherine* (989)

Pen and brown ink with brown and grey wash over black chalk.
7¼×11 in. (18.2×28 cm.)
Provenance: N. A. Flinck; bought in 1723 by the 2nd Duke.
Literature: H. Vey, *Van Dyck Zeichnungen*, Brussels, 1962, Nos. 52–56; Chatsworth Drawings, 1969, No. 81.

A study for a painting in the Prado, Madrid (1544), for which four other drawings are known. The drawings and the painting are unusual in that they show not only the Virgin, St. Joseph and the Christ Child who places the ring, symbolizing spiritual marriage, on the finger of St. Catherine, but also other saints, including St. George, and in the Chatsworth drawing a pope who is probably Gregory the Great. St. Catherine is shown much older than is usual in representations of this subject, and her hair is braided in the fashion which was current in Flanders in the late Middle Ages.

SIR ANTHONY VAN DYCK

83 *Horatius Cocles Defending the Bridge over the Tiber* (992)

Pen and brown ink with grey wash.
7⅞×12⅛ in. (20×30.9 cm.)
Provenance: N. A. Flinck; bought in 1723 by the 2nd Duke.
Literature: Vey, *op. cit.*, No. 39; Chatsworth Drawings, 1969, No. 83.

The drawing represents the famous story of Horatius who single-handedly held back the Etruscans while his Roman comrades broke down the bridge behind him, leaving him to swim, wounded, to the other bank, but saving Rome. No painting of the subject by Van Dyck is known.

SIR ANTHONY VAN DYCK

84 *Inigo Jones* (1002A)

Black chalk.
9½×7¾ in. (24.1×19.7 cm.)
Inscribed on the mount: *Van Dyck's original drawing, from which the Print by van Voerst was taken in the book of Van Dyck's Heads. Given me by the Duke of Devonshire. / Burlington.*
Provenance: N. A. Flinck; bought in 1723 by the 2nd Duke; given by him to the 3rd Earl of Burlington, the owner of the masque drawings by Inigo Jones and inherited by the 4th Duke who married Burlington's daughter and heiress.
Literature: Vey, *op. cit.*, No. 271; Chatsworth Drawings, 1962–63, No. 82.

The portrait was engraved by Robert van Voerst in Van Dyck's *Iconography* (cf. H. Mauquoy-Hendrickx, *L'Iconographie d'Antoine van Dyck, Catalogue raisonné*, Brussels, 1956, p. 235, No. 72).

SIR ANTHONY VAN DYCK

85 *Head and Forequarters of a Horse* (1009)

Black and white chalks.
13¼×12⅜ in. (33.7×31.4 cm.)
Literature: Vey, *op. cit.*, No. 18; Chatsworth Drawings, 1962–63, No. 85.

A study for the painting of *St. Martin dividing his cloak with a beggar*, known in several versions, of which the one nearest to the drawing is in the church of Saventhem, Belgium. Drawing and painting both belong to the early period of Van Dyck when his style was close to that of Rubens, to whom the version of the painting in the Royal Collection at Windsor Castle was for many years attributed.

SIR ANTHONY VAN DYCK

86 *A Study of Cows* (964)

Pen and brown ink with a little brown wash.
12½×20¼ in. (31.8×51.5 cm.)
Inscribed: *Ant. van Dyck*
Provenance: N. A. Flinck; bought 1723 by the 2nd Duke.
Literature: J. Held, *Rubens Selected Drawings*, London, 1959, I, pp. 12, 133 (as probably by Rubens); Chatsworth Drawings, 1969, No. 79 (as Van Dyck); K. Prenger, *Kunstchronik*, XXXI, 1978, p. 135 (as Rubens); J. Rowlands, *Rubens Drawings and Sketches*, Exhibition, British Museum, 1977, No. 200 (as Van Dyck).

The drawing is related, though not very closely, to a painting of a *Landscape with Cows* in the Alte Pinakothek, Munich, by Rubens, to whom this drawing has sometimes been attributed, but most modern scholars prefer the traditional attribution—indicated in the old inscription—to Van Dyck, with whose style it corresponds closely.

SIR ANTHONY VAN DYCK

87 *A Clump of Trees by a Country Road*

Pen and watercolor.
10¾×13¼ in. (27.4×34 cm.)
Provenance: N. A. Flinck; bought in 1723 by the 2nd Duke.
Literature: Vey, *op. cit.*, No. 305; Chatsworth Drawings, 1969, No. 85.

One of Van Dyck's freshest renderings of an English landscape, probably done between 1635 and 1640, which looks forward to the work of native English watercolorists of the 18th century.

German School

ALBRECHT DÜRER (1471–1528)

88 *The Virgin and Child with the Infant St. John* (830)

Pen and brown ink.
11¼×8⅛ in. (28.6×20.5 cm.)
Signed with the monogram *AD*.

Literature: Winkler, *Dürers Zeichnungen*, III, 1938, No. 538; Chatsworth Drawings, 1969, No. 107.

Closely related in style and type to Dürer's woodcut of 1518, the *Virgin with many angels* (Bartsch 101), and almost certainly of the same date. The child holds up to the Virgin a carnation which is a symbol of the Passion.

HANS BURGKMAIR (1473–1531)

89 *Portrait of a Man* (933)

Black chalk.
13¾×10⅝ in. (35.2×27 cm.)
Dated MDXVIII.
Literature: Chatsworth Drawings, 1962–63, No. 103.

The sitter has been tentatively identified as Wolfgang von Maen, who was chaplain to the Emperor Maximilian and probably accompanied him in 1518 to the Imperial Diet at Augsburg where Burgkmair was working.

HANS HOLBEIN THE YOUNGER (1497–1543)

90 *Portrait of a Scholar or Cleric* (835)

Drawn with the point of the brush and black ink over black chalk on pink prepared paper.
8½×7¼ in. (21.7×18.4 cm.)
Inscribed: *HH*
Literature: Chatsworth Drawings, 1962–63, No. 105; *Between Renaissance and Baroque*, City Gallery, Manchester, 1965, No. 321.

The drawing is in the technique used by Holbein during his second stay in England, from 1532 till his death in 1543. It probably represents one of the powerful and not usually overscrupulous members of the Court of Henry VIII, possibly a supporter of Thomas Cromwell, the executant of the suppression of the monasteries, to whose clientele many of Holbein's sitters belonged.

HANS HOLBEIN THE YOUNGER

91 *Portrait of a Youth* (836)

Black and red chalk.
9⅝×8 in. (24.5×20.2 cm.)
Literature: Chatsworth Drawings, 1962–63, No. 106.

The sitter does not appear to be English and the drawing was probably made in Basle, either before Holbein's first visit to England in 1527 or during the years 1529 to 1532 when he was in Basle again.

Dutch School

REMBRANDT VAN RIJN (1606–1669)

92 *Isaac Blessing Jacob* (1015)

Pen and brown ink.
7×8 in. (17.5×20.1 cm.)
Provenance: N. A. Flinck; bought by the 2nd Duke in 1723.
Literature: O. Benesch, *The Drawings of Rembrandt*, London, 1954–57, No. 891; Chatsworth Drawings, 1969, No. 90.

The drawing was probably made about 1652.

REMBRANDT VAN RIJN

93 *An Actor in his Dressing Room* (1018)

Pen and brown ink.
7½×6 in. (18.3×15 cm.)
Literature: Benesch, *op. cit.*, No. 120; Chatsworth Drawings, 1962–63, No. 88; H. van de Waal, *Steps towards Rembrandt*, Amsterdam-London, 1974, p. 73ff.

The drawing is traditionally called *St. Augustine in his Study*, but de Waal has pointed out that the figure does not look a bishop, and that the casual way in which the mitre and cape are hung upon a kind of clothes peg is inconsistent with any representation of the saint. He suggests—very convincingly—that the drawing represents an actor in his dressing room, about to perform the part of Bishop Gozewije in a tragedy entitled *Gijshecht van Aemstel* by the famous

Dutch poet Joos van den Vondel. The play was written in 1637 and first produced in 1638, and the drawing was probably made at that time. Rembrandt is known to have been in touch with Vondel and may well have attended rehearsals of the play and visited the actors in their dressing rooms. Other drawings by Rembrandt show individual actors and scenes from the play.

REMBRANDT VAN RIJN

94 *View on the Amstel* (1022)

Pen and brown wash with some body color on brown prepared paper.
5×8½ in. (13×21.7 cm.)
Provenance: N. A. Flinck; bought by the 2nd Duke in 1723.
Literature: Benesch, *op. cit.*, No. 1218.

The view is taken near the Trompenburg estate, outside Amsterdam. The drawing is to be dated about 1649–50.

This and the following three drawings are superb examples of Rembrandt's style as a landscape draughtsman. They represent with the frankest naturalism parts of the dull, flat countryside near Amsterdam, but the artist's vibrant line gives life to the trees, thatched cottages, reflections on the water and even a rowboat.

There are altogether twenty-nine landscape drawings by Rembrandt at Chatsworth, without doubt one of the chief glories of the collection, although they may, ironically, have been acquired almost by accident. If the collection of prints made by the 2nd and 3rd Dukes at the same time is an accurate indication of their tastes, they appear to have shown little interest in the artist, for very few etchings by him are included. It may be, therefore, that this incomparable series of his drawings only came to Chatsworth because it formed part of the Flinck collection, which was prized above all for the works of the great Italian masters it contained. Rembrandt came to be appreciated generally in England only later in the 18th century.

REMBRANDT VAN RIJN

95 *View on the Bullewijk with a Rowing Boat* (1033)

Pen and brown wash with some body color.
5¼×7⅞ in. (13.3×20 cm.)
Provenance: N. A. Flinck.
Literature: Benesch, *op. cit.*, No. 1231; Chatsworth
Drawings, 1969, No. 94.

The view shows in the distance the Ouderkerk, Amsterdam.

REMBRANDT VAN RIJN

96 *Two Thatched Cottages* (1038)

Pen and brown ink with some body color.
5⅜×8 in. (13.7×20 cm.)
Provenance: N. A. Flinck; bought by the 2nd Duke
in 1723.
Literature: Benesch, *op. cit.*, No. 796; Chatsworth
Drawings, 1969, No. 96.

Drawn about 1640–41.

REMBRANDT VAN RIJN

97 *View over the Nieuwe Meer with a Sailing Boat* (1034)

Pen and brown wash on slightly toned paper.
3½×7¼ in. (8.8×18.1 cm.)
Provenance: N. A. Flinck; bought by the 2nd Duke
in 1723.
Literature: Benesch, *op. cit.*, No. 847.

The site is probably the Nieuwe Meer, a reclaimed
area of water near Amsterdam. Probably drawn about
1649–50.

SAMUEL PALMER (1805–1881)

98 TWO ILLUSTRATIONS TO MILTON'S *Il Penseroso*:
 A. *The Bellman*
 B. *Morning*

Watercolor with some body color.
Each 20×28 in. (51×70 cm.)
Provenance: Commissioned by the artist's friend, C. R.

Valpy; A. W. Dunn (sale Christie's, 18th June 1892, lots
47, 48); R. Dunthorne; J. D. Fletcher; anon. sale, Christie's,
8th June 1976, lots 188, 190; bought by the present Duke
1977.
Literature: *The Letters of Samuel Palmer* (ed. R. Lister),
London, 1974, pp. 696–700, 732, 764, 813, 1068; R. Lister,
A Vision Recaptured, London, 1978, pp. 70–74.

The drawings illustrate two passages from *Il Penseroso*:
 "And the Bellman's drowsy charm
 To bless the doors from Nightly harm"
 [ll. 83, 84]
and:
 "Not trickt and frounct, as she was wont
 With the Attic Boy to hunt;
 But kerchieft in a comely cloud,
 While rocking winds are piping loud,
 Or usher'd with a shower still
 When the gust hath blown his fill,
 Ending on the rustling leaves,
 With minute drops from off the eaves"
 [ll. 123–130]
In 1864 Palmer wrote to his friend C. R. Valpy
that he was beginning work on a series of designs
illustrating Milton's shorter poems, including *L'Allegro* and *Il Penseroso*. He intended to make etchings of
all of them, but only two were executed, including
one of *The Bellman*. However, between 1864 and his
death in 1881 he made many drawings and a set of
eight large and finished watercolors, of which these
are two. They are among the most remarkable of
his later works, in which he recaptured some of the
imaginative power which he had displayed in his
early works painted at Shoreham in the 1820s.

According to the catalogue of the Dunn sale, *Morning* was painted in 1869 but *The Bellman* was only
executed in 1881, the year of the artist's death.

HILAIRE-GERMAIN-EDGAR DEGAS
(1834–1917)

99 *Study of a Horse*

Pencil.
7×10 in. (18×25.5 cm.)
With the stamp of the Degas Sale (1919).
Provenance: Bought by the present Duke in 1968.

Prints

The Library at Chatsworth contains a magnificent collection of engravings and woodcuts, mainly formed by the 2nd and 3rd Dukes. Unlike the Old Master drawings collected during the same period, which have all been separately mounted in the course of this century, the prints for the most part remain in the albums originally made for them, providing a rare sense of the rich scope that lay behind the 18th-century concept of a library. The collection includes sets of fine impressions of works by the great masters in the field, notably Mantegna, Dürer, Callot and Van Dyck; but since it would be impossible to represent its true resources in the space available in the exhibition, a choice has been made of a few items, each now separately mounted, of exceptional beauty or rarity.

ANDREA MANTEGNA (1431–1506)

100 *The Battle of the Sea-Gods*

Engraving in two plates.
12³⁄₈×33³⁄₈ in. (31.4×84.7 cm.)
Literature: J. A. Levenson, K. Oberhuber, J. L. Sheehan, *Early Italian Engravings from the National Gallery of Art*, Washington, D.C., 1973, Nos. 75, 76.

An unrivalled impression of one of the finest examples of the art of engraving on copper in the early, draughtsmanlike stage of its development. The right-hand plate was copied by Dürer in a well-known drawing of 1494. The German artist remained faithful to the composition's outlines but replaced Mantegna's slanting lines of shading with more meticulous surface modelling, thereby suppressing the clear, sculptural quality of the Italian print. For the drawing of the same subject by Mantegna, see No. 52.

FEDERICO BAROCCI (1526–1612)

101 *The Annunciation*

Etching printed on yellow silk.
17×12 in. (43.8×31.3 cm.)
Signed: *Federicus Barocius. Urb. Inventor excudit*
Provenance: Sir Peter Lely.
Literature: Another impression of this etching is discussed in the catalogue of the exhibition, *The Graphic Art of Federico Barocci*, Cleveland and Yale, 1978, No. 75.

One of the four compositions which Barocci treated in etching. It was based on the painting which he executed for Francesco Maria II, Duke of Urbino, for his chapel in the Basilica of Loreto in 1582–84, with a view of the ducal palace of Urbino through the window.

This is a unique example of the etching printed on yellow silk, a technique occasionally used in the late 16th and early 17th centuries to produce prints of exceptional luxury and also subtlety, since the silk gave a particular softness to the lines.

GIOVANNI BENEDETTO CASTIGLIONE (c. 1610–1665)

102 *Noah and the Animals Entering the Ark*

Monotype.
9³⁄₄×13¹⁄₂ in. (24.7×35 cm.)
Literature: Ann Percy, *Giovanni Benedetto Castiglione*, Catalogue of exhibition at the Philadelphia Museum of Art, 1971, p. 152, M. 10.

The technique of monotype was invented by Castiglione and little used by other artists till it was revived in the 19th century. The process consists of painting the composition on a warm copper plate in printer's ink and then taking a single pull from it on paper.

Sometimes the lines are drawn with the brush in black on the plate, but in this and several other examples Castiglione began by covering the whole plate with black ink and then drawing the outlines—probably with a piece of wood sharpened to a point—so that they stand out white against it. In either case the pull can be touched up in ink with a brush. Castiglione made an etching of the same subject in which a similar group of animals appear. Both date from a late period in the artist's life, probably 1650–55. Only about twenty monotypes by Castiglione are known.

HERCULES SEGHERS (1589–c. 1635)

103 *Lamentation over the Dead Christ*

Colored etching.
6¼×14 in. (16×15.5 cm.)
Literature: Haverkamp-Begemann, *Hercules Seghers*, Amsterdam, 1968.

Hercules Seghers was a highly inventive artist who experimented in the technique of etching and color printing. Some scholars have maintained that the color in the *Lamentation* was printed from the metal plate, but very careful examination seems to show that only the blue outlines were printed in this way and that the other colors were added directly in watercolors.

SIR ANTHONY VAN DYCK (1599–1641)

The portrait etchings made by Van Dyck were never published in his lifetime, as their appearance by contemporary standards was considered unfinished, but they marked a tremendous advance in sensitivity and brilliance of handling over any previous etched or engraved work in portraiture. As such they would naturally have guided the parallel progress of the series of engraved portraits of famous men known as the *Iconography*, a publication entrusted wholly to professional engravers working from Van Dyck's designs. The preparatory etching (No. 106) made by

the engraver Peter de Jode of a plate he went on to complete as a full engraving (No. 107) in the *Iconography* series is different in intention from Van Dyck's own etching of the same subject (No. 105). Uniformly pale as a deliberate result of light biting, it also includes traces of grey "surface tone" where parts of the plate's surface were allowed to retain a thin film of ink, a way of avoiding etching in stronger areas of cross-hatching at this early stage. The etching by Van Dyck, by contrast, is full-blooded and self-sufficient, and may well have been employed to set a standard of refinement for his engraver to emulate, especially in the sitter's face. The two plates were in any case brought further into line by the touches of brown wash which Van Dyck added with the brush to de Jode's proof, thereby controlling key accents in the final engraving. Neither Van Dyck's own etchings, however, nor the original sketches he made in black chalk (Nos. 84, 104) served as basic models for his engravers to follow. Instead, keeping to a procedure established by his master Rubens, he or an assistant would normally provide a monochrome painting in oils. This set out in a much clearer form the overall scale of light and shade for the engraver to translate into his own specialized conventions of lines, cross-hatching and dots.

Literature: M. Mauquoy-Hendrickz, *L'Iconographie d'Antoine Van Dyck, Catalogue raisonné*, Brussels, 1956; Catalogue of the exhibition *Van Dyck: Drawings and Etchings from Chatsworth*, Graves Art Gallery, Sheffield, 1978.

SIR ANTHONY VAN DYCK

104 *Jan Snellinck* (996)

Black chalk.
11½×7¾ in. (29.5×19.6 cm.)
Provenance: N. A. Flinck.
Literature: Vey, *op. cit.*, No. 245.

The sitter (1544–1638) was an Antwerp painter of history and battle pictures. The drawing was made some time between 1627 and 1635 and is related to the following three prints (Nos. 105, 106, 107).

SIR ANTHONY VAN DYCK

105 *Jan Snellinck*

Etching, fourth state.
9¾×6⅛ in. (24.2×13.3 cm.)

PETER DE JODE (1601–1674) and
SIR ANTHONY VAN DYCK

106 *Jan Snellinck*

Etching, first state of a plate afterwards completed as an engraving (No. 107); trial proof with some surface tone and retouched in brown wash.
9⅝×6⅛ in. (24.6×15.6 cm.)
Provenance: P. H. Lankrink.

PETER DE JODE

107 *Jan Snellinck*

Engraving, second state, before the engraver's name was added.
9⅛×6 in. (23.3×15.2 cm.)

Designs for Court Masques by Inigo Jones

The "masque," a theatrical performance with fantastic costumes and elaborate stage settings, was the most remarkable manifestation of the taste of the Stuart court under James I and Charles I, at a moment when this court was perhaps the most sophisticated in Europe.

The masques were the result of a rare collaboration between the dramatist Ben Jonson and the architect-designer Inigo Jones, whose drawings constitute this section of the exhibition; but they were essentially devised to express the ideas of the sovereigns for whom they were performed. The earlier masques, produced in the reign of James I, were based on complicated allegories embodying semi-philosophical ideas, but the later ones, designed for Charles I, had a quite specifically political content, glorifying the idea of the Divine Right of Kings. The masques were danced by the King, the Queen and members of the court, and they were given in the palace of Whitehall —first in the old Banqueting House, and then for a short time in the new Banqueting House. The latter, built by Inigo Jones between 1619 and 1622, was one of the first manifestations of the new classical and Palladian style of architecture which Jones introduced into England as a result of his visit to Italy in 1613–14. When about ten years later the huge canvases painted by Rubens for the ceiling of the Banqueting House were set in place, masques were no longer performed there for fear that the candles would damage the paintings. In 1638 a new temporary "Masquing House" was constructed in the courtyard near the Banqueting House and it was here that the last masques of Charles I's reign were performed. By this time Jonson and Jones had quarrelled irreconcilably and other authors —of slighter talent—were employed to write the libretti; but Jones' talent had flowered and the success of these masques was almost entirely due to his invention.

In Italy Jones must also have seen some of the festivals given at the courts of the Italian princes and these greatly influenced his designs for masques—

both for the costumes and for the stage-settings, in which he was the first English designer to use architectural perspective and ingenious machines for changing the scenes, introducing storms and sea effects, and allowing figures to appear suspended as if coming down from the sky.

The drawings by Inigo Jones at Chatsworth, which constitute almost all the surviving works of this kind, probably passed after his death to his pupil John Webb, and were acquired by the 3rd Earl of Burlington, one of the creators of the Palladian movement in English architecture. They were inherited by his daughter, who married the 4th Duke of Devonshire, and so came into the collection.

A full account of the drawings and a history of the masque at the Stuart court will be found in S. Orgel and R. Strong, *Inigo Jones. The Theatre of the Stuart Court*, London, 1973.

The Masque of Blackness by Ben Jonson

This masque, given at the Old Banqueting House, Whitehall, on 6th January 1605, was the first in which Inigo Jones and Ben Jonson collaborated in the service of Anne of Denmark, Queen of James I.

A scene was concealed by a curtain, "a Landtschap, consisting of small woods, and here and there a void place fill'd with huntings." When the curtain fell "an artificall sea was seene to shoote forth" filled with tritons, mermaids and sea horses. The masquers, who were the daughters of Niger, arrived in a concave shell and presented their fans to James I, gave "their own single dance," took partners for general revels and later departed in their shell again.

The masque evoked hostile comment, as the Queen and her ladies blacked their faces, "a very lothsome sight," and the banquet "was so furiously assaulted, that down went table and tresses before one bit was touched."

Literature: S. Orgel and R. Strong, *Inigo Jones. The Theatre of the Stuart Court*, London, 1973, I, p. 89.

108 *A Masquer as a Negro Nymph,*
Daughter of Niger

Watercolors with gold and silver.
11⁵⁄₁₆×6⁵⁄₁₆ in. (29×15.5 cm.)
Literature: Orgel and Strong, *op. cit.*, I, p. 96, No. 1.

"The attyre of (the) *Masquers* was alike, in all, without difference: the colours, *azure*, and *siluer*; (their hayre thicke, and curled vpright in tresses, lyke *Pyramids*), but returned on the top with a scroll and antique dressing of feathers, and iewells interlaced with ropes of pearle. And, for the front, eare, neck, and wrists, the ornament was of the most choise and orient pearle; best setting off from the black."

This drawing is not from Jones' own hand, but was certainly copied from an original by him, probably for the use of the tailor or another member of the designer's staff.

109 *A Torchbearer as an Oceania*

Body colors with silver and gold.
11¼×7⅞ in. (28.5×19 cm.)
Literature: Orgel and Strong, *op. cit.*, I, p. 98, No. 4.

"For the *light-bearers*, *sea-greene*, waued about the skirts with gold and siluer; their hayre loose, and flowing, gyrlanded with sea-grasse, and that stuck with branches of corall."

The Masque of Queens by Ben Jonson

Given at the old Banqueting House on 2nd February 1609, for the Queen, who danced in it with her ladies, disguised as the great Queens of ancient history. The stage at first showed an "ougly Hell," but this was soon transformed into the House of Fame.

Literature: Orgel and Strong, *op. cit.*, I, p. 131.

110 *The House of Fame*

Pen and ink washed with grey.
11×7¾ in. (28×19.5 cm.)
Inscribed: *la Tribuna ninta (montata?) In vna nugola. . . .*
pieno dell lume con la fame dirutto (dietro?)
Literature: Orgel and Strong, *op. cit.*, I, p. 138, No. 15.

"There rests, now that We giue the description (we promist) of the *Scene*, which was the House of FAME. The structure and ornament of which (as is profest before) was intierly *Mr Jones* his Invention, and Designe. First for the lower Columnes, he chose the statues of the most excellent *Poëts*, as *Homer*, *Virgil*, *Lucan* & c. as beeing the substantiall supporters of *Fame*. For the vpper, *Achilles*, *Aeneas*, *Caesar*, and those *Heroës*, which those *Poets* had celebrated. All which stood, as in massy gold. Betwene the Pillars, vnderneath, were figured *Land-Battayles*, *Sea-Fights*, *Triumphes*, *Loues*, *Sacrifices*, and all magnificent Subiects of Honor: In brasse, and heightend, with siluer. In which he profest to follow that noble description, made by *Chaucer*, of the like place. Aboue, were plac'd the *Masquers*, ouer whose heads he deuis'd two eminent Figures of *Honor*, & *Vertue*, for the *Arch*. The *Freezes*, both below, and aboue, were fill'd with seuerall-coloured Lights, like *Emeralds*, *Rubies*, *Saphires*, *Carbuncles*, & c."

The twelve Queens are seen sitting in a triangle of light in an alcove about the door. This was a *machina versatilis* which revolved revealing Fame, and allowing the masquers to descend and enter through the doors below in their chariots.

111 *Penthesileia*

Pen and black ink washed with greenish grey.
10¾×6⅛ in. (27.5×15.5 cm.)
Inscribed: *The Countess of bedford. Penthisilea Queen of the Amasons Depe pinkcolor Deep morrey Skie color*
Literature: Orgel and Strong, *op. cit.*, I, p. 139, No. 36.

Design for a costume worn by Lucy Harington (1581–1627), daughter of John, first Lord Harington and wife of the Earl of Bedford.

112 *Berenice*

Pen and black ink washed with greenish grey.
11⅝×7 in. (30×17.7 cm.)
Inscribed: *Lady An Clifford Berenice Q of the AEgiptians Green (Skie Color crossed through) Carnation Whit'*
Literature: Orgel and Strong, *op. cit.*, I, p. 142, No. 22.

Design for a costume worn by Anne Clifford (1590–1676), heiress of George Clifford, Earl of Cumberland; married Richard Sackville, Earl of Dorset and secondly Philip Herbert, Earl of Pembroke and Montgomery.

The Lords' Masque by Thomas Campion

Staged at the Banqueting House at Whitehall on 14th February 1613, in honor of the marriage of James I's eldest daughter Elizabeth to Frederick, Elector Palatine of the Rhine.

The scene was divided into two parts, an upper and a lower. The latter was "a wood in perspective, the innermost part being of relief, or whole round, the rest painted." Later "the upper part of the scene was discovered by the sudden fall of a curtain; then in clouds of several colours . . . appeared eight stars of extraordinary bigness." The stars "moved in an exceeding strange and delightful manner" and the scene changed to "an element of artificial fires, with several circles of lights, in continual motion, representing the house of Prometheus." The masquers descended in a transparent cloud which "brake in twain" and made their entry attended by pages as Fiery Spirits. Meanwhile the lower scene was transformed, revealing silver statues of women set in niches of gold adorned with jewels, and later "a prospective with porticos on each side . . . in the middle . . . an obelisk, all of silver."

Literature: Orgel and Strong, *op. cit.*, I, p. 241.

113 *A Star Masquer*

Pen and black ink with watercolors, silver and gold.
12⅜×6⅞ in. (31.5×17.5 cm.)
Literature: Orgel and Strong, *op. cit.*, I, p. 247, No. 79.

"The ground of their attires was massie cloth of siluer, embossed with flames of Embroidery; on their heads, they had Crownes, Flames made all of Gold-plate Enameled, and on the top a Feather of Silke, representing a cloud of smoake."

114 *A Fiery Spirit Torchbearer*

Pen and ink with watercolors.
11⅜×6¼ in. (29×16 cm.)
Literature: Orgel and Strong, *op. cit.*, I, p. 247, No. 81.

"Sixteene Pages, like fierie spirits, all their attires being alike composed of flames, with fierie Wings and Bases, bearing in either hand a Torch of Virgine Waxe."

Perhaps the most beautiful and accomplished of all the designs produced by Jones prior to his Italian visit.

Unidentified Play

115 *Border and Scene with a Stag Hunt*

Border in pen and black ink, scene in pen and brown ink washed with sepia, squared for enlargement and splashed with scene-painters' distemper.
17¼×18⅛ in. (44×46 cm.)
Literature: Orgel and Strong, *op. cit.*, I, p. 322, No. 110.

One of the largest and most splendid of Inigo's late designs. It is not clear to which production it relates, but the style suggests a date of about 1620.

Florimène

A French pastoral acted on 21st December 1625 by Henrietta Maria, daughter of Henry IV of France and Queen of Charles I. The author is not known.

Literature: Orgel and Strong, *op. cit.*, II, p. 631.

116 *Border and Standing Scene*

Pen and brown ink.
11¾×13⅞ in. (30×35 cm.)
Literature: Orgel and Strong, *op. cit.*, II, p. 648, No. 326.

"The ornament inclosing the Scoene was made of a Pastorall invention, proper to the subject, with a figure sitting on each side, representing a noble shepheard and sheapeardesse, playing on Rurall instruments, over them Garlands held up by naked Boyes, as the price of their Uictory. Above all, ranne a large

Freese, and in it children in severall postures, imitating the Pastorall Rights and sacrifices, in the midst was placed a rich compartment, in which was written *FLORIMENE* . . . the scoene was discovered consisting of Groves, Hils, Plaines, and here and there scattering, some shepheards cottages, and a far off, to terminate the sight, was the mayne *Sea*, expressing this place to be the Isle of Delos."

Britannia Triumphans by
Sir William Davenant

Danced on 7th January 1638, this was the first masque to be staged for three years owing to fear of damaging the Rubens ceiling paintings in the Banqueting House with smoke from the candles. A new temporary masquing house was erected in the courtyard near the Banqueting House and it was in this that the last Stuart masques were staged.

The masque was led by Charles I, who was celebrated as "Britanocles, the glory of the western world." In its political statements it was overt in its belief in the divinity of the King's rule and its denunciation of "the great seducers of this Isle."

Literature: Orgel and Strong, *op. cit.*, II, p. 661.

117 *London Afar Off*

Pen and brown ink.
10⅝×14⅛ in. (27×36 cm.)
Inscribed: *1 sceane with Londen farr off.*
Literature: Orgel and Strong, *op. cit.*, II, p. 668, No. 334.

"A curtain flying up discovered the first Scene wherein were English houses of the old and newer forms, intermixt with trees, and afar off a prospect of the City of London and the river of Thames, which, being a principal part, might be taken for all Great Britain."

The view of London, which may be compared with the painting by Thomas Wyck (No. 40), shows in the middle Old St. Paul's, destroyed in the Great Fire of 1666, and other churches, and in the foreground the south bank near Southwark.

Salmacida Spolia by
Sir William Davenant

The masque was danced on 21st January 1640 in the presence of Henrietta Maria's mother, Marie de' Medici, in exile from the French court. *Salmacida Spolia* means literally the spoils of the fountain Salmacis in Caria and it was the last masque performed before the outbreak of the Civil War. The masque is overt in its references to the political scene, to those "Malignant spirits" who threaten the King's peace, and is important as the last great artistic statement of the ideas of Divine Right before the Civil War, which broke out two years later.

Literature: Orgel and Strong, *op. cit.*, II, p. 729.

118 *The King as Philogenes*

Pen and brown ink, corrected in places with white chalk or paint.
11¼×6½ in. (28.5×16.5 cm.)
Inscribed: *for yᵉ kinge 1640.*
Literature: Orgel and Strong, *op. cit.*, II, p. 774, No. 432.

"The habit of his Majesty and the Masquers was of watchet, richly embroidered with silver, long stockings set up of white; their caps with scrolls of gold, and plumes of white feathers."

119 *A Lady Masquer in Amazonian Habit*

Fine pen and brown ink washed with grey.
10½×6½ in. (26.5×16.5 cm.)
Literature: Orgel and Strong, *op. cit.*, II, p. 784, No. 442.

"The Queen's Majesty and her ladies were in Amazonian habits of carnation, embroidered with silver, with plumed helms, bandrickes with antique swords hanging by their sides, all as rich as might be, but the strangeness of the habits was most admired."

Architecture and Views of Houses

Chiswick House

In 1682 the first Earl of Burlington bought a property at Chiswick, some ten miles west of London, with a Jacobean house (visible on the right in No. 123A), which had belonged to the Wardour family. In 1725 the 3rd Earl decided to build a "villa," linked to the old house by a narrow gallery, which was primarily designed to house his collection of works of art and to be a setting for entertaining rather than for living. He chose as his model the Villa Rotonda by Palladio, of whose buildings he had become an ardent admirer during his second visit to Italy in 1719. On his return he set about convincing the English that Palladio was the model whom architects should follow. He succeeded in imposing his taste and so created the Palladian movement which dominated English architecture in the first half of the 18th century. Burlington's choice of Palladio as a model was well judged, because in addition to the elegance of his style, which appealed to 18th-century English taste, his villas were designed as centers of an agricultural community, with stables and storehouses attached, and so could easily be adapted to the needs of the English country gentleman.

At Chiswick Burlington was his own architect, but for the decoration of the interior he employed William Kent, whom he had met in Rome. As can be seen from No. 120B, Kent's treatment of the interior was much richer than Burlington's rather austere external architecture.

A new layout of the gardens, centered on the old house, was begun about 1715, but the whole was transformed and given a much freer, more informal character in the 1720s and 1730s by Kent, who designed many of its most remarkable features, includ-

ing the Rustic Grotto (No. 122C) and the Exedra (No. 122B).

HENRY FLITCROFT after Lord Burlington

120 TWO DRAWINGS OF CHISWICK VILLA

A. *Chiswick Villa: Rear Elevation*
Pen and grey wash.
14½×19¼ in. (37×49 cm.)

B. *Chiswick Villa: Section*
Pen and grey wash.
15×20 in. (38×51 cm.)
Provenance: 3rd Earl of Burlington; 4th Duke.
Literature: Catalogue of the exhibition *Apollo of the Arts. Lord Burlington and his Circle*, Nottingham University Art Gallery, 1973, Nos. 32, 33.

Both these drawings were engraved in William Kent's *Designs of Inigo Jones*, London, 1727, pls. 72, 73.

LORD BURLINGTON and HENRY FLITCROFT

121 TWO DRAWINGS OF CHISWICK

A. *The Orangery at Chiswick House, by Lord Burlington*
Pen and grey wash.
6×7½ in. (15×19 cm.)
Inscription in Burlington's hand.

B. *The Orangery at Chiswick House, by Henry Flitcroft*
Pen and grey wash.
7¾×11¼ in. (19.5×29.5 cm.)
Provenance: 3rd Earl of Burlington; 4th Duke.
Literature: *Catalogue of the Drawings Collection of the Royal Institute of British Architects*, vol. B, p. 99, Nos. 2, 3.

The Orangery, which was destroyed in the 19th century, stood in the northern part of the garden. Drawing A shows Burlington's own sketch; Drawing B is a fair copy by his amanuensis, Henry Flitcroft.

WILLIAM KENT (1685–1748)

122 THREE DRAWINGS OF CHISWICK

A. *Chiswick Villa from the Southwest*

Pen and brown wash over pencil.
10×13¾ in. (26×36 cm.)

B. *Chiswick: The Exedra*

Pen and brown wash over pencil.
11½×15¾ in. (29×40 cm.)

C. *Chiswick: The Cascade*

Pen and brown wash over pencil.
14×18½ in. (35.5×47 cm.)
Provenance: 3rd Earl of Burlington; 4th Duke.

Drawing A shows the Villa from the southwest; Drawing B shows the Exedra, a semicircle composed of clipped hedges enclosing statues and urns evoking the atmosphere of an ancient Roman garden. In the distance is a column, crowned with a copy of the Medici Venus. Drawing C shows the Grotto, finished in 1738, which was one of the earliest examples of this type of "rustic" grotto to be made in England.

JACQUES RIGAUD (1681–1753)

123 TWO DRAWINGS OF CHISWICK

A. *Chiswick Villa*

Pen and grey wash.
14×27½ in. (36×70 cm.)

B. *The Gardens of Chiswick*

Pen and grey wash.
11×20 in. (27.9×50.8 cm.)
Provenance: 3rd Earl of Burlington; 4th Duke.
Literature: Catalogue of exhibition at Nottingham University Art Gallery, 1972, Nos. 80, 81.

Two drawings from a series commissioned by Burlington about 1734 from Rigaud, a French draughtsman and engraver who had recently come to England. Drawing A shows the Villa seen from the southeast with the old house on the right. Drawing B shows the gardens with three structures at the end of the three avenues: to the left, a pavilion near the Rustic Bridge (destroyed); in the middle, a domed pavilion (also destroyed); to the right, the Rustic House.

WILLIAM KENT

124 *Design for a Cascade at Chatsworth*

Pen and brown wash over pencil.
15¾×12½ in. (40×32 cm.)
Provenance: 3rd Earl of Burlington; 4th Duke.

An unexecuted project to transform the cascade constructed by the 1st Duke into the "rustic" style which Kent displayed in the Grotto at Chiswick (No. 122C).

WILLIAM HUNT (1790–1864)

125 *The Gallery, Chiswick Villa*

Watercolor.
12¾×10 in. (32.5×25.5 cm.)
Signed: *Wm. Hunt 1828.*

This and the following three watercolor paintings show interiors in houses belonging to the Dukes of Devonshire. They were either executed for or purchased by the 6th Duke in the early 19th century. They are of particular interest because they illustrate the decoration and arrangement of these rooms at that time, and especially because they include items of furniture which are now preserved at Chatsworth.

This painting represents what was known as the "Gallery fronting the garden." It shows the pedimented doorway on the right leading into the saloon, flanked on either side by large rectangular mirrors and richly carved console tables. In the recess, beneath the statues, stand a pair of mahogany hall chairs with rectangular backs and pedimented cresting. These are now at Chatsworth and are exhibited here (No. 178).

The pair of carved and gilt pedestals are also now at Chatsworth. The carpet dates from the early 19th century but the room appears otherwise to be much as it was in Lord Burlington's day.

WILLIAM HUNT

126 *The Saloon, Devonshire House*

Watercolor.
10½×12¼ in. (26.5×31 cm.)
Signed: *Wm. Hunt 1822.*
Literature: John Cornforth, "Chatsworth, Derbyshire – vii," *Country Life*, 1st August 1968, pp. 29–31.

Devonshire House was built for the 3rd Duke by William Kent, following a fire which destroyed the old house in 1733. The house was entirely redecorated in the early 19th century for the 6th Duke. This view shows the console tables and wall brackets from the original Kent interior, but the ceiling, draperies, cornices and the splendid suite of black and gold chairs and settees are all part of the early 19th-century redecorating and refurnishing. The seat furniture was very probably supplied by Morant and Seddon who also supplied similar suites to George IV. It was subsequently moved to the library at Chatsworth (No. 127).

WILLIAM HUNT

127 *The Library, Chatsworth*

Watercolor.
10×11¼ in. (25.5×28.5 cm.)
Signed: *Wm. Hunt 1827.*
Literature: William Spencer, 6th Duke of Devonshire, *Handbook to Chatsworth and Hardwick*, 1844, pp. 17, 114.

The library at Chatsworth, on the first floor of the East front, was built by the 1st Duke in the last years of the 17th century. At that time it was not a library but was intended for use as a gallery, replacing the old Elizabethan gallery. In 1815 the 6th Duke decided to turn this 17th-century room into a library and in so doing he left the ceiling, with its rich plasterwork and circular paintings by Antonio Verrio,

in its original state, as indeed it remains today. He also left the cornice and architrave, the plain deal floor and, of more importance, the marble chimney-piece carved by Nadauld, a Huguenot protégé of the 1st Duke. This view of the library shows the room as it appeared after the 6th Duke's first alterations had taken place in 1816. It is furnished with a set of oval-backed chairs and settees ordered in the 1780s by the 5th Duke. These are still at Chatsworth but are no longer in the library. In the right foreground is a single chair from a set provided by Morant and Seddon for the 6th Duke, of very similar design to the suite supplied by the same firm for the saloon at Devonshire House (see No. 126). In 1829 the Duke decided to make further alterations along the East front at Chatsworth, and Wyatville was brought in as architect to equip the library with new mahogany bookcases from floor to ceiling, necessitating the removal of the cornice and architrave and Nadauld's marble chimney-piece, and the replacement of the deal floor by an oak floor which was carpeted to accord with the colors in the 17th-century ceiling. The appearance of the room today is as Wyatville left it, and it now also contains the fine black and gold suite of settees and chairs from Devonshire House from the workshop of Morant and Seddon.

DAVID COX (1783–1859)

128 *The Long Gallery, Hardwick Hall*

Watercolor.
30¼×42½ in. (77×107.5 cm.)

Hardwick Hall was begun in 1590 by Elizabeth Hardwick, widow of the 6th Earl of Shrewsbury, who had also been the builder of the first Chatsworth. The Long Gallery was an essential feature of Elizabethan houses, intended as a portrait gallery where those living in and visiting the house could take exercise and refresh their minds in the contemplation of worthy ancestors or noble historical characters. This view shows the Hardwick portraits, very much as they hang today, placed closely together and set against the tapestries which line the walls. It was

probably painted in about 1830 and reflects, in the figure of a man with his dog, the Romantic revival of the first half of the 19th century in which the Elizabethan age was much admired. It is interesting to note, however, how conservative were the long-established land-owning families; despite the "Elizabethan" craze of the second quarter of the 19th century when this picture was painted, the Gallery was furnished along the whole length of the inner wall with a splendid set of carved mahogany and partly gilt armchairs, dating from about 1740 and purchased by the 3rd Duke. These chairs are now in the state rooms at Chatsworth.

WILLIAM TURNER ("TURNER OF OXFORD") (1789–1862)

129 *Bolton Abbey from the River Wharfe*

Oil on canvas.
23×31½ in. (57.5×78.7 cm.)
Provenance: Purchased by the present Duke.

This picturesque ruin, painted by Turner much as it appears today, has long been known as Bolton Abbey although it was, in fact, an Augustinian Priory, first established in the 12th century. Its buildings were altered and extended over five centuries right up until its suppression in 1539 by Henry VIII, when they were stripped and fell into decay. The estate belonged to the Earls of Cumberland and passed to the Boyle family through the marriage of Elizabeth Clifford, daughter and heiress of the last Earl of Cumberland, to Richard Boyle, 2nd Earl of Cork and 1st Earl of Burlington. His grandson, the 3rd Earl (see No. 4), converted the surviving gatehouse into a residence in 1720, and in 1843, long after Bolton had passed into the hands of the Dukes of Devonshire, Joseph Paxton carried out extensive alterations and additions to this house at the direction of the 6th Duke. It was always called a "shooting box," for use in the summer months only, and survives as such today.

Manuscripts, Letters and Books

The French soldier and man of letters St. Evremond, in a letter to the poet Edmund Waller, recounted a conversation he heard during a visit to Chatsworth in the 1670s, between Thomas Hobbes and the 3rd Earl of Devonshire:

"My Lord Devonshire has more than ten thousand volumes in his house: I entreated his lordship to lodge me as far as possible from that pestilential corner: I have but one book, and that is Euclid, but I begin to be tired of him; I believe he has done more harm than good; he has set fools a-reasoning."

"There is one thing in Mr. Hobbes's conduct," said lord Devonshire, "that I am unable to account for: he is always railing at books, yet always adding to their number."

"I write, my lord," answered Hobbes, "to shew the folly of writing. Were all the books in the world on board one vessel I should feel a greater pleasure than that Lucretius speaks of in seeing the wreck."

"But should you feel no tenderness for your own productions?"

"I care for nothing," added he, "but the *Leviathan*, and that might possibly escape by swimming."

Even if, as seems likely, St. Evremond (or Hobbes) was exaggerating the number of books then at Chatsworth, there can be no doubt that in his younger days Hobbes, despite his mischievous irony on this occasion, must have felt he had been given the run of a private university, so rich and wide was the store of literature at his disposal. The next two centuries were to see the library he helped form for the Earls of Devonshire become far greater and more celebrated, and despite the losses sustained during the present century, commencing with the migration of the John Kemble theatrical collection together with all the Caxtons, to the Huntington Library at San Marino in 1912, and culminating in the record-making sales at Christie's in 1958 and 1974, the Chatsworth Library remains truly great. It owes most to William Spencer Cavendish, 6th Duke of Devonshire (1790–1858), who succeeded to the title in 1811. Although outstripped by his uncle, the 2nd Earl Spencer, who was by far the greatest book collector of the age, the 6th Duke added profusely to the varied library he inherited, seeking out incunabula, manuscripts, books on vellum and fine bindings at all the important sales of the period, most notably the famous Roxburgh sale of 1812. On that occasion he was for once able to outwit his uncle, employing a French agent to bid secretly on his behalf, having first sent shivers round the saleroom with a rumor that the stranger was acting for Napoleon Bonaparte, no less! Two entire libraries were acquired by him outright, one by purchase and the other by gift: that of Thomas Dampier, Bishop of Ely, abundant in early editions of the Greek and Latin classics; and the large and important collection made by his kinsman, the scientist Henry Cavendish (see No. 135). There are still well over five hundred incunabula at Chatsworth, most of them acquired by the 6th Duke.

In addition to the books and manuscripts in the library proper, including most of the surviving autograph writings of Thomas Hobbes and Henry Cavendish, there are important archival papers of the 18th and 19th centuries, when members of the family were deeply involved in the politics of the day. Of particular interest to historians are the letters and journals of the 3rd and 4th Dukes of Devonshire, both of whom served as Lord Lieutenant of Ireland, and the latter also briefly as Prime Minister of England. A great deal of research has centered upon the extensive body of correspondence produced in the Victorian period by the 8th Duke, who was for some years leader of the Liberal Party in succession to Gladstone, and who indeed himself turned down the offer to

be premier no less than three times. Since 1935, all the papers and muniments from the many estates throughout England and Ireland, held by various branches of the family over the centuries, have been concentrated at Chatsworth, providing a unique source of information on economic and social history.

The library at Chatsworth continues to grow. The present Duke has built upon the botanical foundations laid by the 6th Duke, his renowned gardener, Sir Joseph Paxton, and the 7th Duke, who between them purchased so many of the great works of Humboldt, Audubon and Gould. To these he has added several of the spectacular flower books of Redouté, Thornton, Curtis and others working in the golden age of botanical illustration at the end of the 18th and the beginning of the 19th centuries (see Nos. 145, 146, 147). The heart of the collection remains in the old Long Gallery, transformed by Wyatville for the 6th Duke into a library most visitors acknowledge to be the most beautiful room at Chatsworth; but there are few rooms or galleries throughout the house that its arteries of books and papers have not now reached.

130 *Roman de Gillion de Trazegnies*

Bruges, c. 1470
Illuminated manuscript on vellum, 237 leaves, 14⅗×10¹/₁₀ in. (37.5×26 cm.)
Provenance: Louis de Gruuthuse; Louis XII of France; Duke of Roxburgh; bought by the 6th Duke in 1812.
Literature: E. B. Ham, *Le Manuscrit de Gillion de Trazegnies à Chatsworth, Romania*, 229, 1952, pp. 66–77; catalogue of exhibition *La Miniature Flamande*, Brussels, 1959, No. 160; catalogue of exhibition *Medieval and Early Renaissance Treasures*, Whitworth Art Gallery, Manchester, 1976, No. 51.

The text, a romance recounting the adventures of an imaginary crusading knight called Gillion de Trazegnies in the Holy Land, was written originally about 1450 and dedicated to Philip the Good, Duke of Burgundy. The present manuscript has a preface dedicated to Louis de Gruuthuse of Bruges (1422–1492) with the date 1464, but the script has been attributed to a famous professional scribe, David Aubert, who seems to have worked for Louis in Bruges from about

1469. The eight miniatures, including some highly animated battle scenes on both land and sea, and their ravishing, colorfully embroidered borders of flowers, birds, beasts and droll figures, are by the artist formerly identified as Philip de Mazarolles, now believed to be Liévin van Lathem. There are also a considerable number of historiated initials, almost equally detailed, with the scenes they enclose more minutely scaled.

It was with Louis de Gruuthuse that Edward IV stayed in Bruges when he was forced to flee England in 1470. On his return the King created him Earl of Winchester, as a mark of gratitude. Louis' emblem, the "bombard" (a cannon firing), and his motto, *"plus est en vous,"* occur in the book, but his arms have been everywhere painted out, and on folio 9 those of Louis XII of France are inserted.

131 *Vengeance de Notre Seigneur*

Bruges, c. 1465–68
Illuminated manuscript on vellum, volume I, 137 leaves; volume II, 167 leaves, 14⅗×10¹/₁₀ in. (37.5×26 cm.)
Provenance: Philip the Good, Duke of Burgundy; Chrétien de Lamoignon; Duke of Roxburgh; bought by the 6th Duke, 1812.
Literature: Catalogue of exhibition *La Miniature Flamande*, Brussels, 1959, Nos. 154–155; catalogue of exhibition *Medieval and Early Renaissance Treasures*, Whitworth Art Gallery, Manchester, 1976, No. 50.

This anonymous mystery-play purports to narrate events of the 1st century A.D., culminating in the destruction of Jerusalem by the Romans, which is interpreted as "Our Lord's vengeance" for the killing of Christ by the Jews. The manuscript was written for Philip the Good, Duke of Burgundy, by the scribe Yvonnet le Jeune. It is recorded in the surviving ducal accounts that he was paid for writing the thirty-eight gatherings in July 1468, and the same source reveals that the twenty *histoires*, or "miniatures," are by the Bruges miniaturist Loyset Liédet. Yvonnet wrote the date 1465 in the table of contents. The manuscript is now bound in two volumes but was originally one, and is a typical example of the deluxe

copies of the Burgundian library. The scenes of ancient history are seen in contemporary terms of 15th-century Flanders and reflect the domestic customs, costume and architecture of that period.

Lord Burlington recorded in a note inside the back cover that the book was presented to him by General George Wade, for whom the Earl designed a Palladian house in 1723.

132 *Book of Hours, According to the Use of Sarum (Salisbury)*

Flemish, c. 1500
Illuminated manuscript on vellum, 187 leaves, with a contemporary stamped leather binding, 8×5½ in. (20.5× 14 cm.)
Provenance: Henry VII of England; Queen Margaret of Scotland, Henry's daughter; Archbishop of St. Andrews; Monsieur Le Pin, a magistrate of Bruges, 1717; 3rd Earl of Burlington; 4th Duke.
Literature: Catalogue of exhibition *Medieval and Early Renaissance Treasures*, Whitworth Art Gallery, Manchester, 1976, No. 55.

A prayer book used for the private devotions of Queen Margaret, wife of James IV of Scotland, and given to her by her father, Henry VII, as we learn from two inscriptions in his hand: *Remembre yo^r kynde and lovyng fader in yo^r prayers. Henry Ky*, and *pray for your lovyng fader that gave you thys book and I geve you att all tymes godds blessȳg and myne. Henry Ky* (ff. 14 recto and 32 verso). The first of these occurs after the opening section of the book, a calendar with border scenes of the twelve months, and the second after a miniature of St. George of England in a series of twelve saints. The Hours of the Virgin follow, with a principal sequence of six large miniatures, beginning with the Annunciation and ending with the Flight into Egypt, interspersed with many historiated initials. Most of the illumination is by an anonymous Flemish miniaturist known as the "Master of the Prayer-books," and is in a different, later style from that of the two Burgundian manuscripts (Nos. 130, 131). The borders are given flat, opaque grounds and painted in *trompe l'oeil* with flowers, birds and insects, seemingly scattered on the surface of the page, providing a mock foil to the space and perspective of the scenes within.

133 *Elements of Law*, by Thomas Hobbes

Manuscript, pp. xviii+290, bound in brown Russia, re-backed. Collation: pp. [i–xviii], *Order* and *Contents*; pp. 1–289, text; p. [290], blank.
Devonshire Mss., Hobbes Group, no. A2a.
Provenance: 3rd Earl.

The life and fortunes of Thomas Hobbes (1588–1679), one of England's greatest and most original political philosophers, were inseparably linked to the Cavendish family (see No. 18). At the age of twenty, in 1608, he was recommended by the principal of his college, Magdalen Hall, Oxford, to be tutor to the son of William Cavendish, Baron Hardwick, afterwards 1st Earl of Devonshire. More than seventy years later, on 4th December 1679, he died at Hardwick Hall, a much loved and respected member of the household of the 3rd Earl, whose own education, many years before, had in turn been entrusted to Hobbes' care. In the intervening years Hobbes' position with the Cavendish family had not only provided him with access to the highest intellectual circles of the day, but also with the use of the exceptionally large library then being formed at Chatsworth. He made European tours successively with both his noble charges, first in 1610 and again from 1634 to 1637.

The manuscript of *Elements of Law* appears to be in Hobbes' own hand and to be his own original copy of the work with emendations and insertions by the author; the monogram *TH* is found at the head of page one. It lacks the dedication to William Cavendish, 1st Earl of Newcastle, which Hobbes supplied in his own hand, signed and dated 9th May 1640, to a copy of the manuscript later made by an amanuensis. This is also at Chatsworth (no. A2b). Further copies of the whole work were later made, of which there is one example at Chatsworth (A2c) as well as a number in the British Library. After circulating for

some years in manuscript, the work was eventually published in two parts in 1650 under the titles *Humane Nature* and *De Corpore Politico*. Publication of the former was not authorized by Hobbes, but a revised edition that appeared in 1651 was approved by him. The first version of Hobbes' political philosophy in print, the *De Cive* of 1642, was an enlarged version of *Elements of Law* with a section on religion added. This was subsequently enlarged again to form Hobbes' masterpiece, *Leviathan*, the English version of which was published in 1651, followed by one in Latin in 1668. Fair claim can be made that *Leviathan* is the greatest work of political philosophy in the English language.

134 *Of Taste. An Epistle to the Right Honourable Richard Earl of Burlington,* by Alexander Pope, with the author's covering letter

Manuscript, 3 leaves, bound with the published version of the poem, 1731. 15⅝×9⅝ in. (38.6×24.5 cm.)
Letter dated April 4th (1731).

Provenance: 3rd Earl of Burlington; 4th Duke.
Literature: Sherburn, the *Correspondence of Alexander Pope*, Oxford, 1976, vol. III, pp. 187–188; catalogue of exhibition *Apollo of the Arts: Lord Burlington and his circle*, Nottingham University, 1973, Nos. 67, 68.

Twikenham Ap. 4ᵗʰ
My Lord

I send you the enclosed with great pleasure to myself. It has been above ten years on my conscience to leave some Testimony of my Esteem for yʳ Lordship among my Writings. I wish it were worthier of you. As to yᵉ Thought wᶜʰ was just suggested when last I saw you, of its attending yᵉ Book, I would have your Lᵈship think further of it; & upon a considerate perusal, If you still think so, the few Words I've added in this paper may perhaps serve two ends at once, & ease you too in another respect. In short tis all submitted to yʳ own best Judgment: Do with it, & me, as you will. Only I beg your Lᵈs.p will not show the thing in Manuscript, till yᵉ proper time: It may yet receive Improvement, & will, to the last day it's in my power. Some lines are added towᵈ yᵉ End on yᵉ Common Enemy, the

Bad Imitators & Pretenders, wᶜʰ perhaps are properer there, than in your own mouth. I am with all truth,
My Lᵈ
Your most obedᵗ & affectionate Servant
A. Pope
I hope Lady B. thinks me as I am, her most faithful Servant.

The manuscript of Pope's famous poem on taste, a fair copy not in the poet's own hand, is the enclosure referred to in the covering letter. Its full title as published continues: "occasioned by his publishing Palladio's Designs of the Baths, Arches, Theâtres, etc. of Ancient Rome," suggesting that the book Burlington thought the poem might "attend" was a projected second volume, never published, of his *Fabbriche Antiche* of the previous year, which contained plates after Palladio's drawings of Roman baths. Pope (1688–1744) was an intimate friend of Lord Burlington and shared and influenced his ideas about architecture and especially landscape gardening. The poem affirms the principles behind Burlington's mission to redirect the course of English taste, which should be governed above all by sense and decorum, whether in collecting, building or gardening, and thus purge the nation of the baroque extravagance of previous decades. However, the best remembered lines are not affirmative but satirical, and directed against the "Common Enemy, the Bad Imitators and Pretenders" who, Pope warns, will undo the Earl's best efforts through the corrupting process of fashion:

"... yet shall your noble Rules
Fill half the land with imitating Fools
Who random drawings from your sheets shall take,
And of one Beauty many Blunders make."

135 *White Book No. 1*, by Henry Cavendish

A volume of notes and experiments, 1786–99, 139 pp., with many loose ff. inserted, Ms., bound in white vellum. Open at a diagram and notes for an experiment *On the absorbtion* (sic) *of deph(logisticated) air by grass in drying.*
Provenance: Lord George Cavendish; Lord Chesham; present Duke 1969.

Henry Cavendish (1731–1810), one of the greatest discoverers in the history of science and "the man who weighed the earth," was born 10th October 1731 at Nice, France, and died 24th February 1810, at Clapham, London. His original experiments and findings, many of which remained unpublished during his lifetime, were of far-reaching importance in chemistry, physics, mechanics, heat, electricity and meteorology, but his popular fame came to center upon the "Cavendish Experiment," by which he was able to determine the density of the earth. He was the son of Lord Charles Cavendish, a younger son of the 2nd Duke of Devonshire and Lady Anne Grey, the fourth daughter of Henry, Duke of Kent. Shy and reticent to the point of eccentricity, he lived with his father until the latter's death in 1783, and thereafter led a solitary existence devoted to research at his house near the British Museum or at his villa in Clapham.

The principal share of Henry Cavendish's very considerable fortune, amassed through a lifetime of material self-denial, was bequeathed to Lord George Cavendish, the son of his first cousin, who presented Cavendish's famous library, comprising some 12,000 volumes, to the 6th Duke of Devonshire. It remains a major element in the Library at Chatsworth today. It seems likely that Henry Cavendish's own scientific notes and manuscripts were kept in the possession of Lord George's family, and rejoined the books at Chatsworth upon the succession of Lord George's grandson to the title of 7th Duke of Devonshire in 1858. The *White Book No. 1*, however, was amongst a small group of original manuscripts separated at an early date from the collection and only acquired by the present Duke of Devonshire in 1969 from Lord Chesham, a direct descendant of Lord George Cavendish. It appears to be the only known Cavendish manuscript in volume form and is devoted to chemical experiments on specimens of inorganic materials, the fruit of several geological tours between 1785 and 1793 made by Henry Cavendish and Dr. (later Sir) Charles Blagden, his friend and assistant, and Secretary of the Royal Society.

136 *Letter from David Garrick to William, 4th Duke of Devonshire, 25th June 1764*

Literature: *The Letters of David Garrick* edited by David M. Little and George M. Kahrl, London, 1963, vol. I, No. 334, pp. 418–420.

> Abano near
> Padua
> June 25th
> 1764.

My Lord.

I had the honour of Yr Grace's letter at Venice, where I was enjoying the magnificent Entertainments which were given by the State to the Duke of York. The *Regate* they gave him was all a Dream & fairy Vision, & more than answer'd our Expectations, tho they were sufficiently rais'd by the various reports; & the great preparations: It is said that this visit of his Royal Highness has cost the State & ye four Noble *deputed* Venetians, more than a hundred & twenty thousand Sequins. They were very solicitous (indeed too solicitous) to entertain him; for they would have overlaid him with ceremony & their great wigs, had not He broke from them sometimes to prevent suffocation— His Royal Highness has been most gracious to Me—I am greatly oblig'd to Your Grace for the very delicate manner of excusing Yourself about Pictures & Statues, and I am thoroughly convinc'd that it is owing to Your Grace's *want of Money* & not to my want of taste, that I have not an immediate commission. I shall execute that of the Prints to the best of my power. I am at this moment in treaty for no less than two Pictures by Tempesto, two Bassan's, a Vandyke, a Rubens, a Paul Veronese &c. I have a little money to throw away & I don't see why I should not be a little ridiculous as well as My betters. Mrs Garrick & I are retir'd to this Place to try the Mud of ye hot springs upon her very disagreeable & obstinate complaint: She has undergone the operation Eight times & thinks herself the better for it—the People here give such an Account of Its Efficacy, that I have withstood the urgent calls of my Brother, & my own impatience to go to England, in hopes of finding some relief for her, if not a Cure. Should we fail here too, our Journey to England will be as Melancholy as it is long—We are in a very pleasant house, well situated, & built by Palladio— it belongs to a Count Seco, who has most politely lent it to us wth Every Convenience, but that of getting good beef & Mutton, till ye 15th of the next month. The imprudent Step of Lady S. S. has sorely vex'd me; I always thought she had a foolish liking for ye Drama, & ye dramatis personae, but

I could not have imagin'd yᵗ the flesh wᵈ have overpower'd her Spirit, when there was a good understanding to have help'd in the Struggle—'tis a most deplorable Business indeed! Lord and Lady Spencer left us more than a fortnight ago, & my Pleasures & Spirits are gone wᵗʰ them, his Lordᵖ has made no great purchases in virtû—he is in treaty about yᵉ famous Magdalen of Guido in yᵉ Barberini Palace at Rome, & I believe he will succeed. He has bought two very famous pictures of Salvator Rosa at florence, & gave two hundred pounds less than yᵉ late Lord Leicester once offer'd for them; these & a famous Ring, which was Prince Eugene's, & bought of Count Zanetti at Venice, are all his treasure from Italy: I forgot a Woman's head by Raphael, as they say, & a very good Sketch of a Picture by Baroche. We liv'd in the same house wᵗʰ Mʳ Howard and Mʳ Langdale—I think it was lucky they travell'd togeather—the first is a very worthy good natur'd Young Man, I don't know a better Sort of Man than the last—He is prudent & sensible & what he wants in learning is better supply'd by discretion & an Understanding in Spite of his bigottry—I'll answer for it, that Norfolk House is not mistaken in him. Your Grace's trouble, & my Impertinence is at an End—

Mʳˢ Garrick joins with me in Duty to Your Grace & in Respects to Lady Dorothy & all the Lords.

<div align="right">

I am

Your Grace's

Most faithfull

humble Servant

D Garrick

</div>

PS. We Expect to be
in England yᵉ beginning
or rather yᵉ 2ᵈ Week in
August—we shall go by
Ausburgh, Stratsburgh, Nancy &c
Mʳ Garrick
June 25 1764

David Garrick (1717–1779), the famous actor and manager of the Drury Lane Theatre Company, left to posterity an extensive body of correspondence, remarkable for the fresh and lively insights it provides into the theatrical, literary and social circles of 18th-century England. His friends and correspondents included Dr. Johnson, Edmund Burke, William Hogarth and Richard Sheridan, as well as three principal connections of the Cavendish family: the 3rd Earl and Countess of Burlington, the 4th Duke of Devon-

shire, and Countess Spencer, the mother of the 5th Duke's Duchess, Georgiana. The Burlingtons were early patrons of a celebrated Viennese ballet dancer, Eva Maria Veigel, known by her stage name as Violette, whom David Garrick married in 1749. Later, following the death in 1754 of the Burlingtons' daughter Charlotte, Garrick developed a deep friendship with William, 4th Duke of Devonshire, who had married Charlotte in 1748. As Lord Lieutenant of Ireland in Dublin throughout 1755 and 1756, the Duke was kept informed by Garrick of London and family gossip, and especially news of his children, who after their mother's death were cared for by their grandmother, Lady Burlington.

Between September 1763 and April 1765, Mr. and Mrs. Garrick made a Grand Tour of Europe, principally in France and Italy, which lasted longer than intended owing to Mrs. Garrick's painful attack of rheumatism, referred to in this letter. This inconvenience fails to dim the brilliance of the picture Garrick paints of the life of a Grand Tourist. It was during these travels that Garrick's friendship with Lord and Lady Spencer began to deepen. The "Lady S.S." to whom he refers was Susan Strangways, the eldest daughter of Lord Ilchester, who had distressed her father by eloping with an actor named O'brien.

137 *Letter from William Makepeace Thackeray to the 6th Duke of Devonshire, 1st May 1848, with a Pencil Portrait of Becky Sharp*

Literature: G. W. Ray, *The letters and private papers of William Makepeace Thackeray*, London, 1945, vol. II, p. 375, No. 466; L. Stevenson, *The Showman of Vanity Fair*, 1947, reissued New York, 1968, p. 172.

<div align="right">Kensington. May 1. 1848.</div>

My Lord Duke

Mʳˢ Rawdon Crawley whom I saw last week and whom I informed of your Grace's desire to have her portrait, was good enough to permit me to copy a little drawing made of her "in happier days" she said with a sigh by Smee the Royal Academician.

Mʳˢ Crawley now lives in a small but very pretty little house in Belgravia: and is conspicuous for her numerous

charities wᶜʰ always get into the newspapers, and her un-affected piety. Many of the most exalted and spotless of her own sex visit her and are of opinion that she is a *most injured woman*. There is no *sort of truth* in the stories regarding Mʳˢ Crawley & the late Lord Steyne. The licentious character of that nobleman alone gave rise to reports from wᶜʰ alas! the most spotless life and reputation cannot always defend themselves—

The present Sir Rawdon Crawley (who succeeded his late uncle Sir Pitt 1832, Sir Pitt died on the passing of the Reform Bill) does not see his Mother, and his undutifulness is a cause of the deepest grief to that admirable lady. "If it were not for *higher things*," she says how could she have borne up against the worlds calumny, a wicked husbands cruelty and falseness, and the thanklessness (sharper than a serpent's tooth) of an adored Child?. But she has been preserved mercifully preserved to bear all these griefs and awaits her reward *elsewhere*. The italics are Mʳˢ Crawleys own.

She took the style and title of Lady Crawley for some time after Sir Pitts death in 1832, but it turned out that Colonel Crawley Governor of Coventry Island had died of fever three months before his brother, whereupon Mʳˢ Rawdon was obliged to lay down the title wᶜʰ she had prematurely assumed.

The late Jos. Sedley Esqʳᵉ of the Bengal Civil Service left her two lakhs of rupees on the interest of wᶜʰ the widow lives in the practices of piety and benevolence before mentioned. She has lost what little good looks she once possessed, and wears false hair & teeth (the latter give her rather a ghastly look when she smiles) and—for a pious woman—is the best crinolined lady in Knightsbridge district.

Colonel & Mʳˢ W. Dobbin live in Hampshire near Sir R. Crawley: Lady Jane was godmother to their little girl: and the ladies are exceedingly attached to each other. the Colonels "History of the Punjaub" is looked for with much anxiety in some circles.

Captain & Lᵗ Colonel G. Sedley-Osborne (he wishes he says to be distinguished from some other branches of the Osborne family and is descended by the mothers side from Sir Charles Sedley) is I need not say well, for I saw him in a most richly embroidered cambric pink shirt with diamond studds) bowing to Your Grace, at the last party at Devonshire House—He is in Parliament: but the property left him by his Grandfather has, I hear, been a good deal overrated.

He was very sweet upon Miss Crawley Sir Pitt's daughter who married her cousin the present Baronet, and a good deal

cut up when he was refused. He is not however a man to be permanently cast down by sentimental disappointment. His chief cause of annoyance at the present moment is that he is growing bald, but his whiskers are still without a grey hair, and the finest in London.

I think these are the latest particulars relating to a number of persons about whom Your Grace was good enough to express some interest. I am very glad to be enabled to give this information and am

> Your Graces very much obliged Svt
> W. M. Thackeray.

P.S. Lady O'Dowd is at O'Dowdstown *arming*. She has just sent in a letter of adhesion to the Lord Lieutenant wᶜʰ has been acknowledged by his Excellency's Private Secretary Mʳ Corray Connellan—Miss Glorvina O'Dowd is thinking of coming up to the Castle to marry the last named gentleman.

P.S.2. The India Mail just arrived announces the utter ruin of the Union Bank of Calcutta in wᶜʰ all Mʳˢ Crawleys money was. Will Fate never cease to persecute that suffering Saint?

Vanity Fair, like several other great Victorian novels, first appeared in serialized installments, which by May 1848 were nearing their conclusion. The lives of the characters had taken a strong hold of the public's curiosity, and when the 6th Duke asked the author for a portrait of the heroine, Becky Sharp—by then Mrs. Rawdon Crawley—he was rewarded not only with the supposed sketch after Smee R.A., "made in happier days," but with an indulgent account in detail of the various characters and their latest doings, playfully couched in terms of current gossip. The final installments, nos. 19 and 20, appeared as a double issue in July, two months later, and differed in several minor details from the account given in the letter.

Thackeray (1811–1863) had first been introduced to the Duke by the poetess Mrs. Caroline Norton, better known to the public for her beauty and a politically contrived scandal involving the Prime Minister, Lord Melbourne. Melbourne's wife had been Lady Caroline Lamb, the Duke's cousin. Like Dickens (No. 138), Thackeray later visited Chatsworth, in September 1851, where he was received as an honored guest and shown round the house by his host.

138 *Letter from Charles Dickens to the 6th Duke of Devonshire, 1st June 1851*

Broadstairs
Sunday First June 1851.

My Dear Lord Duke.

It is quite delightful to me to have something to say to you, and a real solid reason for writing. Not that I can ever want one while I remember (as I always must) your extraordinary kindness and generosity and while I feel (as I ever shall) faithfully devoted to you with a strong attachment; but that I know you are too noble in your favours to bear with a hundreth part of the use I *could* make of that pretext for inflicting my tediousness upon you.

I have decided to postpone the first night at the Hanover Square rooms, until the originally contemplated second night—Wednesday the 18th of June! The booksellers who have the tickets in charge unanimously declare that for next Tuesday the notice is too short—that it is impossible to expect a good house—that they can do nothing in the time after the two Devonshire House performances. And the Honorary Secretary coming down to me express last night, to tell me so, I immediately changed the evening.

I hope you will think I did right, and that you will have leisure to look in upon us on the 18th—I really believe the actors will go all wrong and want all heart, if they don't see you in your box.

I am in a favorite house of mine here, perched by itself on the top of a cliff, with the green corn growing all about it and the larks singing invisible all day long. The freshness of the sea, and the associations of the place (I finished Copperfield in this same airy nest) have set me to work with great vigor—and I can hardly believe that I am ever a Manager, and ever go about with a painted face, in gaslight.

When I first had the happiness of seeing you in the room where we have since held so many Councils, you gratified me very much by your affectionate remembrance of Copperfield. I am having him put into a decent suit of morocco, and when he comes home in his new dress, shall entreat you to give him a place on your shelves for my sake.—You see how dangerous it is to give me encouragement!

When I saw you last, I was quite full of the melancholy of having turned a leaf in my life. It was so sad to see the curtain dropped on what you had made so bright and interesting and triumphant, that something of the shadow of the great curtain which falls on everything seemed for a little while to be upon my spirits. I have an indescribable dread of leave-takings, and the taking leave of such a gracious scene made me almost miserable.

—Which I acknowledge here, because it was certainly and undoubtedly your fault.

With the utmost earnestness of my heart, I am ever My Dear Lord Duke—

Yours faithfully and obliged
Charles Dickens

Apart from an affectionate allusion to the writing of *David Copperfield*, the subject of Dickens' letter is the second performance by the novelist's own amateur company of Bulwer-Lytton's play, *Not so bad as we seem*. The first had taken place two weeks before on the 16th May 1851 at the Duke's London home, Devonshire House, Piccadilly, in the presence of Queen Victoria and Prince Albert, and had raised £1000 for the charitable "Guild of Literature and Art," which Dickens and Lytton had founded in 1850 to raise money for writers and artists. On that occasion, the Duke's famous gardener, Joseph Paxton, fresh from his triumph as the architect of the Crystal Palace, built to house the Great Exhibition of that year, had designed the stage used by the players, specially constructed not to damage either the floor or the walls of the drawing room that served as an auditorium. The Duke had taken a strong interest in the Guild from its inception, and as a result formed a close friendship with Dickens, who in October 1851 accepted an invitation to visit Chatsworth, where, as we learn from a later letter, he enjoyed himself immensely.

139 *Hypnerotomachia Poliphili*, by Francesco Colonna

Folio, printed on vellum by Aldus Manutius, Venice, 1499.
Provenance: almost certainly bought by the 6th Duke.
Literature: A. M. Hind, *Introduction to the History of the Woodcut*, 1935 (Dover reprint 1963), vol. II, pp. 489–493.

Only two other copies on vellum are known, one in the British Library and the other in the New York Public Library. The *Hypnerotomachia* is one of the most beautifully printed and illustrated books to come off any early Italian press. It contains 171 woodcuts executed in a classic and timeless style, but the identity

of the artist who designed them remains a mystery. In spite of the difficulty of the language used in the text—a mixture of Latin and Italian—the book was widely read, partly for its romantic love story, but even more for its imaginary descriptions of ancient ruins and sculpture and for its ingenious hieroglyphics. In the words of the preface, "Poliphilo, the hero and lover of Polia, falls asleep and in his dream and pursuit of Polia sees many antiquities worthy of remembrance and describes them in appropriate terms with elegant style." A French translation with new illustrations, probably after Jean Cousin and Jean Goujon, was published in 1546, and the book was still read in France and used by French artists as a source of themes for their paintings for at least another hundred years. In 1592 a truncated version also appeared in English under the title *Hypnerotomachia, or the Strife of Love in a Dream*.

140 *De Serpentibus*, by Nicolo Leoniceno

Quarto, Joan. Ant. de Benedictis, Bologna, 1518. 8⅖× 5⁷⁄₁₀ in. (21.5×14.8 cm.)
Brown calf, gold-tooled binding by Claude de Picques for Jean Grolier.
Lettered: *IO. GROLIERII ET AMICORUM*
Provenance: Jean Grolier; Le Camus de Limare sale, 1786; 6th Duke of Devonshire.
Literature: C. Shipman, *Researches concerning Jean Grolier*, New York, Grolier Club, 1907, No. 269; H. M. Nixon, catalogue of exhibition, *Bookbindings from the Library of Jean Grolier*, British Museum, 1965, No. 52.

Fine binding, more often than not, is by its nature an anonymous craft, and the best bindings have always been known by the names of the collectors who commissioned them. Among these, no name stands higher than that of Jean Grolier (1479–1565), who was born at Lyons into a family that came originally from Italy. He succeeded his father as treasurer of the Duchy of Milan, then under French control, in 1509, a post he kept until 1520, and afterwards occupied various financial positions in the royal service within France. In Italy he formed close relations with the leading humanists, especially members of the Aldus family (see No. 139), and achieved wide fame as a patron of

Renaissance scholarship and a great collector of books.

The style of binding particularly associated with Grolier consists of geometric patterns impressed in gold leaf into the surface of the leather with variously shaped brass dies. The binder of the Leoniceno has been identified as Claude de Picques, who received all Grolier's commissions from about 1538 until 1548 when he became binder to King Henry II. The elegance and poise of his design contrast with the sturdier mannerism of the Jovius binding (No. 141), which is by the "Cupid's Bow" binder, so-called from his most distinctive tool, who did work for Grolier from about 1548 until 1554.

141 *Descriptio Britanniae*, by Paulus Jovius

Quarto, Mich. Tramezino, Venice, 1548, 8¾×5¼ in. (22.2×15 cm.)
Brown marbled morocco, gold-tooled binding by the "Cupid's Bow" binder for Jean Grolier.
Lettered: *IO. GROLIERII ET AMICORUM* and stamped with the arms of Pétau.
Provenance: Jean Grolier; Pierre Séguier, Chancellor of France; N. J. Foucault; Alexander Pétau sale, 1722; 2nd Duke of Devonshire.
Literature: C. Shipman, *Researches concerning Jean Grolier*, New York, Grolier Club, 1907, No. 245; H. M. Nixon, catalogue of exhibition, *Bookbindings from the Library of Jean Grolier*, British Museum, 1965, No. 122.

142 *The First and Chief Grounds of Architecture*, by John Shute, London, 1563

Folio, with four full-page engravings and one full-page woodcut.
Provenance: 3rd Earl of Burlington; 4th Duke.
Literature: *The First and Chief Grounds of Architecture by John Shute*, facsimile edition with an introduction by Laurence Weaver, London, 1912; Sir John Summerson, *Architecture in Britain 1530–1830*, 1953, pp. 17, 20–23 and pl. 12; Rudolf Wittkower, *Palladio and English Palladianism*, London, 1974, pp. 73, 100 and pl. 125; S.T.C. 22464.

Although this very rare book, one of only seven known copies, is recorded in the 1742 catalogue of Lord Burlington's library at Chiswick, by that time

it would already have appeared an extreme curiosity, even on the shelves of what was then the finest collection of architectural books and drawings ever assembled in England. The numerous editions of Vitruvius, Alberti, Serlio, Palladio and other architects in the classical tradition which Burlington collected were primary means of instruction in his mission to restore architecture to what he considered to be its true principles. John Shute, however, remembered then as now only for his book, the first ever written by an Englishman on architecture, was an amateur from an age and a society to whom the very word "architect" was strange, who in 1550 was sent by the Duke of Northumberland to Italy to study both contemporary buildings and Roman monuments. On his return he thought it would be profitable to others, as he says in the preface, to publish his findings, "wherein I do followe not onelye the writinges of learned men but also do ground my selfe on my owne experience and practise, gathered by the sight of ye monumentes in Italie." The "learned men" include Alberti, whose *Ten Books on Architecture* first published in 1485 is the principal source of Shute's text, Serlio and Philander; but the charm and chief originality of the book lie in the engravings, which reflect the fanciful myths Shute recounts of the origins of the five classical orders of architecture, to the exclusion of any strict attention to scale and proportion. Indeed, if Shute engraved the plates himself, as seems likely from their vigorous, scratchy style, these alone constitute a considerable achievement and are among the very earliest English engravings known. The book remained the only English work on architecture right up to Burlington's own time; the comprehensive treatise planned by Inigo Jones in the 17th century was never published because of the Civil War.

143 *De Magnete*, by William Gilbert

Small folio, London, printed by P. Short, 1600.
Provenance: Henry Cavendish; Lord George Cavendish; 6th Duke.
Literature: P. G. Mottelay, *Bibliographical History of Electricity and Magnetism*, London, 1922; D. H. Roller, *The De Magnete of William Gilbert*, Amsterdam, 1959.

This book by William Gilbert (1540–1603) is considered the first great scientific work published in England. It exerted a strong influence on 17th- and early 18th-century thought and was discussed by the great discoverers and philosophers of the period, including Galileo, Francis Bacon and Kepler. Gilbert's findings also offered a practical means of determining position at sea. His work in the second chapter of the second book established a new science—electricity—and his discoveries furnished a broad foundation for further experiments, including, ultimately, those of Henry Cavendish himself, from whose library the book comes (see No. 135). It is interesting to note that Gilbert's intense interest in electrical phenomena was principally to eliminate them so that he could pursue his primary studies in magnetism.

144 *A Declaration of the State of the Colony and Affaires in Virginia. With the Names of the Adventurers and Summes Adventured in that Action*

Quarto, printed by Thomas Snodham for the Virginia Company, London, 1620.
Provenance: 1st Earl of Devonshire.
Literature: S. M. Kingsbury, *The records of the Virginia Company of London*, 1906–35; S.T.C. 24841.4 made up with part of 24841.6.

A company report setting out for the information and encouragement of English investors, or "adventurers," the rewards of their previous investment in Virginia, and the good prospects for further profit if they put up more. By 1620 the colony had weathered its worst setbacks and was embarking upon a more businesslike plan of settlement and plantation. Among the natural resources claimed for Virginia in the report are furs, timber, silk, potash, flax, iron, fruit, salt, dyestuffs, oils, cotton, sugar, corn, cattle and fish; and this wealth of produce is reflected in the wide variety of trades represented by the 800 new settlers to be sent out in 1620 and 1621. These also include "one hundred young maides to make wives for these tenants as the former 90 which have been lately sent."

There is a choice collection of early Americana at Chatsworth associated with the 1st Earl of Devonshire and his son, Lord Cavendish, later 2nd Earl, who were both prominent members of the Virginia Company and its offshoot, the Somers Islands or Bermuda Company. Their names occur on the list of Adventurers in the *Declaration*, where they are credited with £137:10s and £25 respectively, with a further £50 put up by Lord Cavendish at a later date. As immediate heirs to the great fortune in land and commerce built by the 1st Earl's mother, Bess of Hardwick, they had much capital to invest, and their account books reveal large sums laid out on ventures in Russia, the East Indies and the West Indies, in addition to the colony in Virginia.

145 *Horti Medici Amstelodamensis Rariorum Plantarum Descriptio et Icones,* by Jan and Caspar Commelin

Folio: 2 volumes, P. and J. Blaeu for A. van Someren, Amsterdam, 1697 and 1701.
Provenance: Thomas Wentworth 1712; William Charles de Meuron, 7th Earl Fitzwilliam; bought by the present Duke.
Literature: Wilfrid Blunt, *The Art of Botanical Illustration,* London, 1950, pp. 137–138; C. Nissen, *Die botanische Buchillustration,* Stuttgart, 1966, No. 389.

Jan Commelin (1620–1692) was director of the Botanic Garden in Amsterdam established in 1682, and introduced many plants there that had been brought back from Holland's colonial territories overseas. Chief among the artists he employed to paint the new plants were Johan and Maria Monincks, whose original paintings survive in the present library of the Amsterdam Botanic Garden, including those made for the illustration of the *Descriptio et Icones.* Jan Commelin, who wrote the descriptions himself, died before the book was published, and the work was completed by his nephew Caspar (1667–1731). It contains elaborate heraldic title pages, and over two hundred hand-colored engravings of the plants themselves.

146 *Les Roses,* by Pierre-Joseph Redouté

Large folio in three volumes, large paper copy, first edition, Paris, Firmin-Didot, 1817–24.
Provenance: G. M. T. Foljambe; bought by the present Duke, 1968.
Literature: Wilfrid Blunt, *The Art of Botanical Illustration,* London, 1950, pp. 177–180; C. Nissen, *Die botanische Buchillustration,* Stuttgart, 1966, No. 1599.

Redouté's most famous work, here in a copy that juxtaposes two separate impressions of each of the 169 plates: one printed in color and finished by hand, the other printed uncolored on brown paper. The technique perfected by Redouté and his team of professional engravers was to print the illustrations in color from stipple-engraved plates, working from the original watercolor paintings he made on vellum. Stipple-engraving favored extremely delicate gradations of tone, rendered by dots rather than lines or cross-hatching. All the main colors were meticulously dabbed onto a single plate before each impression was taken, and the resulting color print was finished off by hand, usually by Redouté himself. The process was a very elaborate and costly refinement of the earlier method of illustration (see No. 145) in which orthodox line-engravings or etchings were printed in black and afterwards colored by hand.

Pierre-Joseph Redouté (1759–1840), the most celebrated of all flower painters and illustrators, numbered among his patrons five royal ladies of France, including Marie Antoinette and the Empress Josephine. During the Empire period especially, the course of botanical science was gracefully deflected by princely patronage and taste to produce in his work publications of unprecedented luxury and beauty.

147 *The Beauties of Flora,* by Samuel Curtis

Title page and ten colored plates, unbound, S. Curtis, Gamston, Nottinghamshire, 1820.
The plates now separately framed.
Provenance: bought by the present Duke, 1974.
Literature: G. Dunthorne, *Flower and Fruit Prints of the 18th and early 19th centuries,* New York, 1938, No. 84;

C. Nissen, *Die Botanische buchillustration*, Stuttgart, 1966, No. 436.

A sumptuous production, conceived as a rival to Robert Thornton's famous *Temple of Flora*, and the only other flower book besides that work to illustrate life-sized flowers dramatically set in front of a landscape background. The undertaking was extremely expensive and led Curtis, like Thornton before him, into bankruptcy. He had published an equally beautiful—and equally rare—*Monograph on the Genus Camellia* a year before, and both works consist of hand-colored stipple-engravings and aquatints after original paintings by Clara Maria Pope (d. 1838), the wife of the artist Francis Wheatley. Samuel Curtis (1779–1860) was a cousin of William Curtis, the founder of the *Botanical Magazine*.

Gold, Silver, Firearms, Gems and Jewelry

Whereas the visitor to a great English house is usually able to see and enjoy at close quarters the pictures, furniture and general appearance of its rooms, often there is little opportunity to study those works of art which, by nature of their intrinsic worth in precious metals or jewels, have for the most part been stored away in a strongroom or in the owner's bank, rarely to see the light of day.

Following a familiar pattern in England, the wealth of silver at Chatsworth is partly the result of rich additions to the mainstream of possessions, brought in by heiresses on marriage or bequest. For example, the earliest piece in the collection, the important mid-17th-century gilt bowl and cover bearing the Savile crest, can scarcely have arrived until the 4th Duke's marriage to Charlotte Boyle, the daughter of Dorothy Savile, in 1748. However, there is no doubt that the real concentration of splendor is in the great display pieces made by refugee Huguenot goldsmiths in London, protected by William III's anti-French policy and therefore likely to have been favored by the 1st Duke, the King's close supporter. There is, furthermore, a most important item that must spring directly from this association, the superb Royal French toilet service bearing William and Mary's arms and presumably a wedding gift to the latter in 1677. The Dutch "pilgrim" bottles, likewise, may have come from the King.

Another recurrent source of fine plate in noble families is what is known as "Office Plate"—that is, silver engraved with the Royal arms issued to ambassadors and high officers of state who represent the sovereign, and which, by custom, comes to be regarded as a perquisite of the holder at the end of his term and is not returned to the Royal Jewel Office, whence it came. At Chatsworth there are a number of such plates and dishes acquired by one or another of the Dukes in the capacity of Lord Steward of the Household, or later Lord Chamberlain.

Apart from the silver, one also expects to find family treasures of snuffboxes, miniatures and other "objets de vitrine" as well as, of course, jewelry. As examples of these the exhibition includes some fine French gold snuffboxes, the beautiful diamond Châtelaine, the astonishing Kniphausen "Hawk," and the even more astonishing Devonshire Parure.

Literature: J. F. Hayward, *Huguenot Silver*, London 1959; A. G. Grimwade, *London Goldsmiths 1697–1837: Their Marks and Lives*, London, 1976.

Gold and Silver

148 *Savile Cup and Cover*

Silver gilt; H. 13¾ in., D. 10⅝ in. (34.9×26.9 cm.)
No date letter; London, c. 1650.
Maker's mark: a hound sejant.

The arms are those of Savile, later Halifax, and Coventry. Sir William Savile married Anne, daughter of Thomas, Lord Coventry. Their son William became Marquess of Halifax in 1668, and was the grandfather of Dorothy Savile, the wife of the 3rd Earl of Burlington.

The maker of this important cup, as yet unidentified, is probably the most outstanding London goldsmith of the mid-17th century. Patronized by Royal and High Church circles, his work survives for the twenty years from 1646–66 at Gloucester Cathedral, Winchester and Wadham Colleges, Fulham Palace and elsewhere, and often shows Dutch influences in its style, as in the present piece.

149 *Toilet Service*

Silver gilt; 23 pieces: a mirror, a pair of candlesticks, a pair of powder flasks, an ewer and basin, a pair of caskets, a small bowl and cover, a mug, a pair of oval salvers, a circular salver, a jewel casket, a pair of octagonal boxes, a pair of circular boxes, two small oval boxes and a snuffer tray and snuffers.
Pierre Prévost, Paris, 1670.

Unquestionably the most important surviving toilet service in Western Europe. It was probably acquired by purchase or gift for the marriage in 1677 of William, Prince of Orange, to the Princess Mary. The maker's mark, where legible, is that of Pierre Prévost (b. 1640), who became a Master goldsmith in 1672. He was working in Paris till 1716, in 1689 at the rue de la Haute Vannerie and from 1694 at the Quai des Orfèvres. One of the octagonal boxes, presumably a replacement for one that had been damaged or lost, bears the mark of Hans Coenrat Brechtel, a German who was at The Hague from 1640 until his death in 1675. The pieces are all richly decorated with embossed flowers and foliage and are embellished with the applied arms and monogram of William and Mary.

150 *Ewer*

Silver gilt, H. 12½ in. (31.7 cm.)
Ralph Leake, London, c. 1685.
Engraved with the arms of the 4th Earl of Devonshire and his Countess, Mary Butler.

This maker, whose mark is *RL*, may be either Ralph Leake I, a Freeman of the Goldsmiths' Company in 1656, or his probable cousin, Ralph Leake II, who became a Freeman twenty years later. Whichever the case, he was a leading maker of the 1680s, responsible for the plate of St. James' Church, Piccadilly, and the Royal Hospital, Chelsea, as well as the Rutland Wine Cooler, 1681, and Winchester College Cup, 1682.

151 *Rosewater Dish*

Silver gilt; D. 26 in. (66 cm.), one of a pair.
London, 1683–84.

Engraved with the arms in a mantling of the 4th Earl of Devonshire and his Countess, Mary Butler.

The maker's mark is illegible, but the dish is associated with the ewer by Ralph Leake (No. 150).

152 *Pair of Pilgrim Bottles*

Silver gilt; H. 18½ in. (46.9 cm.)
Maker's mark: *AL* (probably Adam Loots), The Hague, 1688.
Engraved with the arms of the 1st Duke of Devonshire within the Garter.

These bottles were probably a gift from the Prince of Orange, later King William III, to the 1st Duke. They are called "pilgrim" bottles after their presumed derivation from the traditional leather water-bottle of the medieval pilgrims. Large silver flasks of this form survive from the 16th century in French and English examples, in the Louvre and the Kremlin and in a few great English families. The present pieces are believed to be the only Dutch survivals. Adam Loots was goldsmith to Prince William of Orange.

153 *Perfume Burner*

Silver; H. 34½ in. (87.6 cm.)
No date letter; probably London, c. 1690.
Maker's mark: *P.R.* in a shield.

Perfume burners, probably once common in brass or copper, have survived in silver only in a few great houses. This is the largest and heaviest English example yet recorded. The maker's mark, dating from before the commencement of the Goldsmiths' Hall registers, may possibly be that of the Huguenot Philip Rollos, known to have been in England by 1691, although not a Freeman of the Goldsmiths' Company till 1697.

154 *Pair of Wine Coolers*

Silver gilt; H. 9¾ in., D. 8¾ in. (24.7 × 22.2 cm.)
David Willaume, London, 1698–99.
Engraved with the arms of the 1st Duke of Devonshire.

Probably the earliest surviving single ice pails. David Willaume, born at Metz in 1658, was a leading Huguenot goldsmith who was working in London probably by 1686. He married Marie Mettayer, the sister of Lewis Mettayer, another Huguenot goldsmith, in 1690 and became a Freeman of the Goldsmiths' Company in 1693.

155 *Exchequer Seal Tazza*

Silver gilt; H. 3 in., D. 12½ in. (7.62×31.7 cm.)
No date mark; London, c. 1702.
Engraved with the Exchequer Seal of William III and the arms and crest of Boyle and signed *S.G.* for Simon Gribelin.

The piece bears no maker's marks, but it was made from the Seal of the Exchequer for Henry Boyle, third son of Lord Clifford of Londesborough, who held the office of Chancellor of the Exchequer from 1701 to 1708. From at least the reign of Elizabeth I, it became the custom for the holders of the great seals of the Kingdom to retain the seal itself on the death of a sovereign or if a new seal was to come into use, and to make a commemorative cup or salver from the silver of which it was made. The remarkable engraving of the present example is by the leading Huguenot engraver of plate in London at the end of the 17th century, Simon Gribelin.

156 *Ewer and Basin*

Gold; basin: oval, 10¾×7¾ in. (27.3×19.7 cm.), height of ewer: 7 in. (17.8 cm.)
Pierre Platel, London, 1701.
Engraved with the arms of the 1st Duke of Devonshire within the Garter.

Pierre Platel was a Huguenot from Lille, who arrived in England with his brother Claude as a page in the train of William III in 1688. He was made a Freeman of the Goldsmiths' Company in 1699 and his mark was entered with the address Pall Mall. He was "above 32 years" when he married in 1700, and he died in 1719. The basin is associated with an ewer which, sadly, was stolen in 1978; the two together constitute Platel's masterpiece.

157 *Engraved Table Top*

Silver; 35¾×25 in. (90.8×63.5 cm.)
Signed: *B. Gentot In Fecit*

The plaques at the four corners are engraved with a double monogram, *WCD*, for William Cavendish, Duke of Devonshire, and a Ducal coronet. The absence of the Garter from the arms in the center plaque proves that the table top was engraved for William, 2nd Duke of Devonshire, before his installation as a Knight of the Garter on 22nd December 1710.

Blaise Gentot was born at Lyons in 1658 and moved to Paris in 1700. He was known as a medallist as well as an engraver.

158 *Pair of Pilgrim Bottles*

Silver; H. 34 in. (86.4 cm.)
Anthony Nelme, London, 1715–16.
Engraved with the arms of Richard Boyle, 3rd Earl of Burlington and the Boyle motto *Vivit post funera virtus.*

Anthony Nelme, from Much Marcle in Herefordshire, was apprenticed in 1672 and made a Freeman in 1679–80. He was Warden of the Goldsmiths' Company in 1717 and 1722, and died in early 1723. For the "pilgrim" bottle form, see No. 152.

159 *Two Leaf-Pattern Fruit Dishes*

Silver gilt; 14×10 in. (35.6×25.4 cm.) and 13×8¼ in. (33×20.9 cm.)
No maker's mark.

The naturalistic form of these dishes appears possibly to be influenced by parallel examples in Chelsea porcelain, and an attribution has been made to Nicholas Sprimont, who began working in London as a goldsmith in 1742, and was later the founder of the Chelsea porcelain factory. On the other hand, it should be noted that a service of somewhat similar, if more elaborate, dishes in the collection of the Duke of Portland was made by Daniel Smith and Robert Sharp in 1764.

160 *Badge*

Silver; oval, 10×9 in. (25.4×22.9 cm.)
John Parker and Edward Wakelin, London, 1769–70.
Embossed with the arms of Cavendish and Boyle and a
Ducal coronet.

Perhaps used to designate the Duke's barge when he
travelled by water on the River Thames, although
no records of its use have survived. Silver badges of
this kind were displayed on the ceremonial barges
kept by the Lord Mayor, members of the royal family
and the great companies of London, but many private
barges are also known to have taken part in the great
regattas of the day. The badge was bought for the
collection earlier this century.

The firm of John Parker and Edward Wakelin
began production in 1758 and continued until 1776.

161 *Pair of Candelabra*

Silver, H. 40 in. (101.6 cm.)
Paul Storr, London, 1813–14.

Candelabra of this great size—here with ten lights
apiece, supported by three figures of Apollo and the
bases decorated with stags—were intended for ban-
quets, and are among the largest pieces of plate cre-
ated for the Prince Regent, later King George IV,
and a number of leading families of the period. They
frequently combine classical figures with arms and
heraldic supporters—in this example, the Cavendish
stag.

Paul Storr (1771–1844), the doyen of Regency
silver, was apprenticed to Andrew Fogelberg about
1785. His first mark was in partnership with William
Frisbee, in 1792, and he worked alone from 1793. He
was the principal executant of royal and family plate
to the order of Rundell and Bridge, the royal gold-
smiths, until 1819. Later he was joined by John Mor-
timer and his own nephew, John Hunt, and finally
retired in 1838.

162 *Pair of Soup Tureens*

Silver, oval H. 13¾ in. W. 20 in. (34.9×50.8 cm.)
Paul Storr, London, 1820–21.

Like the candelabra by Storr (No. 161) these massive
tureens, with eagle handles and feet and the applied
arms of Cavendish, were intended for banquets.

163 *Dog Collar*

Leather with silver plates, 9 in. diameter.
Robert Garrard II, London, 1832.
Twice engraved *Duke of Devonshire* and with an applied
Ducal coronet and the Cavendish crest, a snake.

A collar of great size made for the 6th Duke's mastiff,
whose name, "Hector," is inscribed on the key. The
Duke owned a number of pet dogs and in several
cases commissioned portraits of them. These do not
include a mastiff, but there are in the gardens at
Chatsworth two stone statues of mastiffs of the same
period.

Robert Garrard II succeeded in 1818 as senior part-
ner in the firm founded by his father and was ap-
pointed royal goldsmith in 1830. The firm has con-
tinued to hold this appointment until the present day.

164 *The King George VI and the Queen
Elizabeth Stakes Cup, Ascot, 1969*

Silver gilt, H. 10½ in. (26.7 cm.)
Carrington and Company, London, 1962.
Engraved with the Royal arms.

Won by the present Duke's racehorse, the mare "Park
Top" (see No. 45).

165 *Louis XV Gold Snuffbox*

Oval, 1⅛×3½ in. (2.8×8.9 cm.)
Paris, 1768.

The lid is chased and decorated with musical trophies
in golds of several colors.

166 *Louis XV Gold Snuffbox*

Oval, 1⅛×2¼ in. (2.8×5.7 cm.)
Paris, 1774.

The lid is inset with a small oval miniature of Duchess

Georgiana, by or after Richard Cosway (1742–1821) (see No. 23). All the outer surfaces of the box are decorated with panels of crystal enclosing hair interwoven with gold thread.

167 *Louis XVI Gold Snuffbox*

Oval, 2⅜×3¼ in. (6×8.2 cm.)
Pierre François Drais, Paris, 1776.

The lid has an enamelled border and is inset with a yellow egg-shaped quartz, probably from the mineral collection formed by Duchess Georgiana which survives at Chatsworth. The sides and base of the box are also enamelled.

The maker was born in 1726 and is recorded as working from 1763, receiving in 1776 the appointment of jeweller to Louis XVI. Examples of his work are in the Louvre, the Wallace Collection, London, and the Metropolitan Museum, New York.

168 *George IV Gold Snuffbox*

Circular, D. 3⅜ in. (8.5 cm.)
Alexander James Strachan, London, 1821.

The lid is inset with a cornelian intaglio bust of King George IV and is chased and engraved in two colors of gold with a wreath of oak leaves, a royal crown, and the badge and motto of the Royal Guelphic Order, instituted by George IV in 1815 when he was Prince Regent. The box may well have been a gift to the 6th Duke from the King at the time of his coronation.

The maker was responsible for the finest gold snuffboxes of the Regency period, and there are good examples of his work in the Wellington Collection, Apsley House, London. He entered his first mark in 1799 in Long Acre, London, and was made a Freeman of the Goldsmiths' Company in 1817.

169 *George IV Gold Snuffbox*

Circular, D. 3½ in. (8.9 cm.)
John Northam, London, 1827.

The lid is inset with a portrait medallion of the Tsar Nicholas I of Russia by V. A. Lerske, struck to commemorate his coronation in 1826. It is covered by a panel of crystal and encircled by the enamelled badge and chain of the Order of St. Andrew. The 6th Duke attended the coronation as Ambassador Extraordinary on behalf of George IV, and the medallion was no doubt a gift to him on that occasion from Nicholas, who also made him a Knight of the Order of St. Andrew. It seems likely that the 6th Duke had the medallion mounted in a snuffbox on his return.

The box bears the maker's mark *IN* for John Northam who is recorded from 1793 onwards. His work is comparable in quality with that of Strachan (No. 168).

170 *Enamel and Gold Snuffbox*

Oblong, 1⅛×2½ in. (2.8×6.3 cm.)
Carl Fabergé, St. Petersburg, c. 1900.

The box, which has an enamelled view of Chatsworth on the lid, was presented to Evelyn, Duchess of Devonshire, wife of the 9th Duke, by Queen Mary, to whom she was Mistress of the Robes. It bears the stamp of Henry Wigstrom, one of the best known of Fabergé's workmasters and a specialist in gold and enamel work. Fabergé worked from the 1890s right through the Russian Revolution and carried out a considerable number of commissions for English patrons, including Edward VII and Queen Alexandra.

Firearms

171 *Flintlock Fowling Piece*

L. 64¾ in. (164.5 cm.)
De Seret, London, c. 1690.
Literature: J. F. Hayward, "The Huguenot Gunmakers of London," *Proceedings of the Huguenot Society of London*, vol. XX, No. 6, 1965, p. 657.

The walnut stock is finely inlaid in silver with a classical warrior, demi-figures, birds and scrolling fo-

liage. The lock is chiselled with foliage and signed *De Seret*; the barrel, *De Seret Londini*. The steel butt plate is engraved with a sportsman between further scrolls of foliage.

Both Isaac de Seret, the maker of this piece, and Landreville, the maker of the following (No. 172), were Huguenot refugees working in England in the late 17th century.

172 *Flintlock Double Action Fowling Piece*

L. 63 in. (160 cm.)
Landreville, London, c. 1690.
Literature: J. F. Hayward, *op. cit.*, p. 657.

The revolving chambers are fired by a single lock. The barrel is plain and unstocked, and the walnut butt has steel furniture lightly engraved with scrolls, with the signature *Landreville London* on the lock plate.

173 *Pair of French Percussion Duelling Pistols*

L. 15⅜ in. (39 cm.)
Jean Le Page, Paris, c. 1840.

The pistols, which have browned octagonal barrels, are in a fitted mahogany case with a full complement of accessories, including bullets and a bullet mould, powder flask and powder gauge, and ramrods. The walnut stocks are carved with shells and the butts with oak wreaths.

Jean André Prosper Henri Le Page (1792–1854) was working in Paris from 1822 until 1840 at 13, rue de Richelieu.

Gems and Jewelry

174 *The Kniphausen "Hawk"*

Silver and silver-gilt, decorated with painted enamel, the body set with red garnets and amethysts, the feet with citrine quartzes (foiled to deepen their color); the base set with turquoises and other blue stones, amethysts, garnets, emeralds, citrines, blue sapphires and three onyx cameos.
Unmarked. Dated 1697.
H. 14¾ in. (36.5 cm.); Diam. of base: 9¾ in. (24.8 cm.)

The beaker: H. 6⅛ in. (15.5 cm.); Diam. of lip 3 in. (6.9 cm.)
Literature: *The Illustrated London News*, 26th July 1851; W. T. T. C. Bijleveld, *De Nederlandse Leew*, June 1935; *Oude Luister van het Groninger Land*, Exhib. in the Groningen Museum voor Stad en Lande 22 Jan. – 5 March 1961, cat. entry 144. For the Genealogy of the Kniphausen family: A. M. H. T. Stokvis, *Manuel d'histoire, de généalogie et de chronologie de tous les états du globe*, III (1966 reprint, p. 300).

The beaker and the underside of the base are silver-gilt; the rest of the surface is covered with painted enamel on an enamel base, and is densely set with gemstones in silver collets. The garnets on the body are rose-cut, the amethysts, emerald-cut; the turquoises on the base are *en cabochon*, and most of the remainder of the stones are emerald or table-cut. The head can be removed and the torpedo-shaped beaker unscrewed from within the body. A tube in the eagle's mouth allows liquid to be poured from it, although the object as a whole constitutes a thoroughly unwieldy pouring vessel and its function was of course largely decorative.

The beaker is engraved with the following inscription in Roman capitals:

GEORGIVS WILHELMVS S.R.I. COMES. A. KNIPHAUSEN IN NIENORTA AC TERRITORII VREDEWOLDIAE HANC AQVILAM GEMMIS DISTINCTAM AETERNAE SACRAVIT MEMORIAE ORDINAVITQVE VI CRATER ILLE RUTILIS RADIANS ALIS REFERENS INSIGNE PERVETUSTAE GENTIS ORTIAE QVAE NVNC NIENORTIA NVNCVPATVR PERPETVO MANEAT PENES ARCIS NIENORTII AC TERRITORII VREDEWOLDIAE PERILLUSTRES DOMINOS DEDICATVM INSIGNE HOC POCVLVM AN CIↃ. IↃ. CXCVII
IM

POCVLA CHRYSOLITHIS DISTINCTA ATQVE ASPERA SIGNIS QVAE IOVIS ARMIGERAM VASA IMITANTVR AVEM CVM NIENORTANAE REFERANT INSIGNIA GENTIS ARCI SACRA VIT POCVLA IVRE COMES.

(George William von Kniphausen, Count of the Holy Roman Empire, Lord of Nienort and of the territory of Vredewold, dedicated this eagle bespangled with gems to eternal remembrance, and ordained that this goblet, flashing with ruby wings and resembling the sign of the ancient family of

Ortia, which is now called Nienortia, should remain forever in the possession of the illustrious lords of the castle of Nienort and the territory of Vredewold. This cup was dedicated as a symbol in the year 1697 in memory. Since cups adorned with chrysoliths and studded with gems—cups shaped like the armor-bearing bird of Jove—resemble the sign of the Nienort family, the Count rightly dedicated such a cup to his castle.)

Nienort is a castle in the Eastern part of Holland, near Groningen, owned during the 16th and the early part of the 17th centuries by the van Ewsum family. The last van Ewsum, Anna, first married Carl Hieronymus von Inn- und Kniphausen who died in 1664, and second, in 1665, his half-cousin, Georg Wilhelm, Freiherr von Kniphausen. It was fortunate for the latter that he married an heiress because his father had earlier sold the lordship of Inn- und Kniphausen to the Aldenburg family, a fact worth bearing in mind as it may explain the later history of the eagle, traditionally referred to as the Kniphausen "hawk." At any rate, Georg Wilhelm made the most of his position as lord of Nienoord (as it is called in Dutch) and transformed the castle into the first grand baroque building to be seen in the neighborhood. In 1694 Emperor Leopold made him Count of the Holy Roman Empire and it is probable that simple pride in his position and family are sufficient explanation for the existence of this extraordinarily lavish display vessel. To create an inalienable family treasure was a well-established way of emphasizing a dynasty, perhaps the most famous example of which is the Treasury founded in 1565 by Duke Albrecht V of Bavaria. It has been suggested that the cup was made to commemorate the patching up of a territorial dispute between two nephews of Anna's first husband but this seems far-fetched, especially since no reference whatsoever is made to it in the inscription.

It is not known how the eagle came to be in the Devonshire collections. The jewel inventories make no mention of it, but there is a note in the Chatsworth records that the cup disappeared from Nienoord in the 18th century; it reappeared again on loan from the 6th Duke to the Great Exhibition of 1851. As mentioned earlier, however, there may be a dynastic

explanation for the eagle's translation from Holland to England. Georg Wilhelm had only one son, who died without issue in 1717, and it is possible that the eagle reverted to the Aldenburg line to whom Georg Wilhelm's father had sold the lordship of Kniphausen. This line in turn died out in the mid-18th century, and the heiress, Charlotte Sophia, married William Count Bentinck (d. 1773). From this match emerge two ways in which the eagle might have come to England: first, Charlotte Sophia's younger son, John Albert, founded the English line of Bentincks; secondly, William's brother was the 1st Duke of Portland and it was his grandson, William Henry Cavendish, who in 1766 married Dorothy, only daughter of the 4th Duke of Devonshire (see No. 8). Thus a connection, albeit a tentative one, can be made between the Kniphausens and the Devonshires; one can, for example, speculate about whether the eagle was perhaps a wedding present from Charlotte Sophia to her great-nephew on the occasion of his great match.

Be that as it may, the eagle was exhibited in the Netherlands Department at the Great Exhibition of 1851, and was described in the *Illustrated London News* as "being located not far from Mr. Hope's jewels, with which it divides the attention of the virtuosi." The eagle is however, not Dutch, but German. It could be contemporary with the inscription or might date from 20–30 years earlier, as this kind of densely gem-studded plate, often slightly naive, but ostentatiously splendid, was popular at all the German courts—but not in Holland—during the second half of the 17th century: examples from the Imperial Treasury can be seen in Vienna (Kunsthistorisches Museum), in Munich (Residenz), Dresden (Green Vaults) and elsewhere. Zoomorphic forms were also common among display plate from the beginning of the century onwards, and this eagle could have been made in a number of centers, of which Augsburg and Dresden are the most likely—Augsburg because it had the largest goldsmiths' trade in the whole of Germany and exported all over Europe, and Dresden because a group of goldsmiths there were catering to the especially lavish tastes of the Electors, shortly to become Kings of Poland.

175 *Watch and Châtelaine*

Gold and silver, diamond set throughout, with two oval plaques enclosing brown hair, two chalcedony seals, and a watch and watch key.

Early 19th century, maker unknown.

Provenance: Probably made for the Duchess Georgiana.

A châtelaine is the traditional emblem of the mistress of the house, originally designed to carry keys, scissors and other objects of utility, but here transformed into a most decorative and gracious means of wearing a watch and seals. It is arranged to hang from the waist belt in two parts, each with a hook and joined at the top by chains. The watch is suspended on one side, and a linked ensemble of the plaques, seals, watch key and diamond-set tassels on the other. Cupid appears on both seals, in one holding a letter with the inscription *Lisez et Croyez* ("Read and Believe me"), and in the other with a lovers' knot and the inscription *Dénouera qui Pourra* ("Untie it who Can"). The Cavendish crest of a snake and the cipher *GHC*, diamond set within each panel of hair, are repeated in a similar panel on the back of the watch, but although the châtelaine has been traditionally associated with the Duchess Georgiana, the precise meaning of the cipher remains to be discovered.

176 *The Devonshire Parure*

The Devonshire parure consists of seven pieces of jewelry made by C. F. Hancock (d. 1891) for Countess Granville to wear in Moscow at the coronation of the Tsar Alexander II in 1856, when her husband represented Queen Victoria. Set with 88 cameos and intaglios[1] from the Devonshire Gem Collection, and studded with diamonds, the parure is a masterpiece of Victorian design and craftsmanship and is the last in a long tradition of jewels expressing the theme of Imperial grandeur.

Since the time of Alexander the Great the owner-

1. Engraved gems are of two kinds: *intaglios*, where the design is cut out from below the surface of the stone, which means that impressions can be taken from it and it can be used as a seal; and *cameos*, where the design stands out in relief. The latter are usually made from stones with several colored layers, a favorite being sardonyx.

ship of engraved gems has represented magnificence and power, and throughout the ancient world the patronage of engravers was the prerogative of royalty. The materials used—agates, chalcedonies, rubies, emeralds and sapphires—were rare, and the art of carving them with miniature sculpture in relief or intaglio even more so. Medieval churchmen set them in their rings and croziers, gospel covers and reliquaries, such as the Shrine of the Three Kings at Cologne which contained 226 gems. In the 15th century, following the example of the humanist Pope Paul II (1417–1471), important collections were assembled at the courts of the Gonzaga, the Este and the Medici; indeed, so proud was Lorenzo de'Medici of his gems that some were inscribed with an abbreviation of his name: *LAU. R. MED.* This heightened interest led to a revival of the art of gem engraving, accompanied by a fashion for wearing gems in clothing, necklaces and headdresses. Most 16th-century monarchs shared a taste for engraved gems, but in England the first important collection was formed by a private individual, Thomas Howard, Earl of Arundel (1585–1646). English connoisseurs thereafter played a leading role in the formation of 18th-century collections and among them was the 2nd Duke of Devonshire (1672–1729), who bought both classical and later gems.

The funeral oration of the 2nd Duke, "that pattern of politeness and fine taste," describes his love of learning and his desire to revive the spirit of the Dukes of Ferrara and Urbino at Devonshire House. Some of his gems are illustrated in a rare book of plates engraved by M. Gosmund, a Frenchman, between 1724 and 1730, and there is an unpublished catalogue drawn up by the German engraver Lorenz Natter (1705–1763) in 1762 which lists 385 gems. By 1900 when Mrs. Eugénie Strong, then Librarian at Chatsworth, listed the collection it had increased to 560 items. This included a cameo portrait of the 6th Duke by the Roman engraver Giuseppe Girometti (1780–1851), and an interest in gems certainly relates to his patronage of Canova and Thorwaldsen.

The 6th Duke (1790–1858) was born into the Whig tradition and had inherited a respect for Napoleon.

He would have been familiar with the parures worn by the ladies of the Bonaparte family at the Coronation of the Emperor which the court jewellers Odiot and Nitot had set with engraved gems removed from the former French Royal Collection at the Cabinet des Médailles,[2] and he had also represented George IV at the coronation of the Tsar Nicholas I in 1825. When his nephew, Lord Granville,[3] was invited to lead the British Mission to Moscow for the coronation of 1856 he knew exactly what was required of a royal delegate. He offered money, and promised the loan of the Devonshire plate, diamonds and gems. With the Duke's agent, the architect Sir Joseph Paxton as intermediary, C. F. Hancock of Bruton Street was invited to create a parure incorporating this ancestral treasure.

C. F. Hancock was a pupil of the Regency silversmith Paul Storr, and had made his reputation with the design for the Victoria Cross and for racing trophies of a monumental kind.[4] It was entirely in keeping with the nostalgic mood of the Romantic period that he should look to the past for ideas to help meet the challenge of this splendid commission. Whereas Pugin had set the fashion for Gothic jewelry in the 1851 Exhibition, Hancock looked to the Renaissance for inspiration. The 16th-century jewellers had shown great virtuosity in their designs for cameo settings, many of which had survived, some even associated with the name of Benvenuto Cellini,[5] and there was the evidence of contemporary portraits. His adoption of the Renaissance style meant that the Devonshire gems were set in gold enriched with polychrome enamels, with diamonds used as points of contrast, organized round the two basic forms of pendant oval medallions and openwork linking chains, with scrollwork and arabesques, quatrefoils and hexafoils providing the ornamental motifs. Although the design of the settings is relatively uniform, being of 16th-

century origin, this does not apply to the shapes and outlines of the individual pieces, which show a wider-ranging eclecticism. The necklace with its important pendant cameos alternating with pairs of intaglios derives from Roman prototypes,[6] and yet, reversed to form the diadem, its curved shape repeats the becoming fashion set by the Empress Eugénie in court dress designed by Worth and painted by Winterhalter. The stomacher translates the foliate scrolls of Tudor embroidery into gold, enamel and precious stones, while the coronet and bandeau echo the medievalizing fashions of the early years of Queen Victoria's reign;[7] the bracelet design is a favorite of the Romantic period, though more often set with miniature portraits than with gems. In its entirety the parure presents a synthesis of many sources, and from them Hancock has produced a group of jewels that were not only the last word in fashionable taste, but equal to the splendor of the occasion for which they were designed. They represent Victorian England's interpretation of the theme which had last been taken up by the French Empire jewellers on behalf of the Bonaparte family, and for this reason they have an important place in the history of jewelry.

Countess Granville had an ancestry and background which matched the parure in distinction. She was the heiress of the ancient Rhineland family of Dalberg who claimed descent from a Roman soldier related to Jesus Christ. More recently both her uncle, Karl Theodor, Prince Bishop of Mainz, and her father, Baron Emeric, had aligned themselves with Napoleon, and the Baron had accompanied Talleyrand to the Congress of Vienna. On her mother's side, Brignole Sale, she was descended from one of the oldest Genoese families and her first husband, Sir Richard Acton, had a similarly impeccable international background. Her son John by this first marriage, the future Catholic historian and philosopher, Lord Acton, accompanied the Granvilles to Moscow together with a suite of young people representing the noblest Eng-

2. H. Vever, *La Bijouterie française au 19ème siècle*, p. 37ff.

3. George Leveson Gower, 2nd Earl Granville (1815–1891).

4. Sotheby's Mentmore Sale Catalogue, Vol. II, *Works of Art and Silver*, Nos. 1663 (the Doncaster Cup) and 1665 (the Brighton Cup).

5. E. Babelon, *Catalogue des camées antiques et modernes de la Bibliothèque Nationale*, Nos. 97 and 249.

6. Babelon, *op. cit.*, No. 367.

7. See Margaret Flower, *Victorian Jewellery*, p. 74, for an illustration of a print after a painting by A. E. Chalon showing Queen Victoria wearing a bandeau and coronet together.

lish families. From mid-August 1856 they were installed at the Graziano Palace and for the next month attended functions connected with the Tsar's consecration to his people—ceremonial entries, troop reviews, ritual offerings, gala performances of opera and ballet, banquets in the Riding School, state balls and embassy receptions. Since most of these events were accompanied by pageantry on a scale worthy of a Roman triumph, the contrast with the plains and vast forests surrounding the metropolis must have invested the occasion with a very special quality.

Representing Napoleon III was Count de Morny, his half brother, who had even brought a private railway carriage for the journey from St. Petersburg, and the German monarchy had sent the Crown Prince Frederick William. Perhaps the most dashing figure was Prince Esterhazy, who attended the coronation dressed in velvet hussar's uniform braided with pearls and sparkling with diamonds, and whose entourage included a gypsy orchestra to entertain his guests with wild and melancholy music. The rivalry between these diplomatic colleagues for imperial approval was intense, and of course the Russian nobility lived up to their extravagant reputation. In this atmosphere the Granvilles decided to make their mark by good taste and breeding rather than ostentation. One great coup was the delivery from London of a marquee designed by Paxton and made by Benjamin Edginton within two weeks of the Granvilles appeal for help when they realized that the reception rooms in the Graziano Palace were far too small. Even with the marquee outside the rooms became so crowded that the Scottish piper brought by the Marquis of Stafford was called upon to clear them at intervals.

Lady Granville's choice of items from the parure would have depended on the importance of the occasion, and her coiffure and dress would have been adapted accordingly. Under no circumstances could the entire parure have been worn together, for the four separate head ornaments could never have been combined. They are so impressive that they must be thought of in conjunction with formal court dress with trains and veils, and a deep décolletage for the necklace with its pendants and for the stomacher,

which she wore for the ball given for the Imperial family in Paxton's marquee.[8] Portraits of Lady Granville emphasize her chic and elegance, and certainly the correspondent of the *Illustrated London News* was impressed as she arrived for the coronation at the Cathedral of the Assumption ablaze with the Devonshire gems and diamonds. A later generation of Cavendishes removed the most important of the diamonds for setting in a more conventional tiara. For the present exhibition, however, they have been replaced by very fine paste imitations, so that once again the parure can be seen for what it is—a triumph of the jeweller's art.

Engraved Gems in the Parure

Because of the large number of cameos and intaglios it contains, the parure resembles a miniature gallery of classical art. Each gem represents some aspect of antiquity: heads of divinities such as Jupiter and Minerva; portraits of rulers and their families, or great thinkers such as Socrates; scenes from mythology and the Trojan War. The Renaissance gems illustrate how the 16th-century engraver reinterpreted these themes, among them court portraiture, which is exemplified by a group of cameos of the Tudor dynasty equalling in importance those in the Royal Collection at Windsor.

Note: All but the smallest diamonds have been replaced with paste.

A. *Bracelet*

Gold, enamel, diamonds, garnet and cornelian

The central gem is a cabochon garnet intaglio of a Muse tuning a lyre; the cameos to each side are of children's heads, both 16th century.

B. *Bandeau*

Gold, enamel, diamonds, rubies, sapphires, emerald, cornelian, plasma and jacinth

The ruby, sapphire and emerald intaglios and cameos are of a quality worthy of the importance of the

8. *Illustrated London News*, 18th October 1856, p. 391.

central gem, a cornelian intaglio signed in Greek letters DIOSKOURIDES, showing Diomedes clambering over the altar of Apollo at Troy with the sacred image of Athena in his hands. Dioskourides is mentioned by both Pliny (*Natural History*, Book XXXVII) and Suetonius (*Octavian* 50) as the maker of Augustus' own signet, and the quality of the Chatsworth gem explains the Imperial preference for this particular artist. Although small in size, it stands beside such works of art as the Ara Pacis in Rome as the expression of the artistic genius of the Augustan age. There is another fine rendering of the same subject in the Devonshire Collection, signed GNAIOS.

C. *Comb*

Gold, enamel, diamonds, onyx, sardonyx and amethyst
Literature: Prudence Oliver Harper, The Royal Hunter, catalogue of exhibition, Asia House Gallery, New York, 1978, No. 65.

The scrolled openwork lower section contains three large gems in oval enamelled medallions: two are Greco-Roman onyx cameos; the third (central) gem is an amethyst intaglio—an inscribed portrait of the Sassanian monarch Bahram I, before his imperial succession (273–276 A.D.).

D. *Coronet*

Gold, enamel, diamonds, jacinth, onyx, cornelians, amethyst and lapis lazuli

Most of the gems are portraits in the classical manner and date from the 16th century, but there is also a convex jacinth intaglio of a warrior on horseback, his cloak streaming out behind him. This vigorous Hellenistic representation of a warrior may be compared with the mounted horsemen on the monument erected at the command of the victorious Aemilius Paullus at Delphi after the battle between the Romans and the Macedonians at Pydna in 168 B.C.

E. *Stomacher*

Gold, enamel, diamonds, cornelian, onyx, garnet, jacinths, lapis lazuli, plasma and sardonyx

The stomacher tapers to a point set with a cornelian

intaglio of Venus and the Eagle. This important gem of the Roman Court School has an allegorical significance, for Venus Genetrix was the mythical ancestress of the Julio-Claudian dynasty, and she is shown here with a horn of plenty and the Roman eagle, symbolic of Imperial power. This theme is fairly common, and there is another version in the Devonshire Collection. The onyx cameo of the Rape of Europa, an animated composition which includes humans, animals, fish, hybrids, sea and landscape, exemplifies the highly pictorial style of some 16th-century engraving.

F. *Necklace*

Gold, enamel, diamonds, cornelians, sardonyx, onyx and garnets

The arrangement centers around an important Roman portrait cameo in sardonyx of the Emperor Tiberius (42 B.C. – A.D. 37). This is a major gem, presumably cut for a member of the imperial entourage, and it depicts the successor of Augustus wearing the aegis with snake, referring to Medusa, and eagle feathers, implying the correspondence between the earthly ruler and Jupiter in the heavens. The Kufic inscription round the rim gives the name of a later owner, a Mamluk prince of the 14th century. There is also a sardonyx cameo portrait of Edward VI as a child, wearing a baby's bonnet and facing front, and the style of the engraving in low relief compares with a gem in the Royal Collection at Windsor which, like this, has the front image repeated at the back as an intaglio. This group of early Tudor portraits has been attributed to Richard Astyll. A later work is the sardonyx cameo of Queen Elizabeth, in the detailed style—using all the colors of the stone to differentiate hair, flesh and costume—associated with the name of Julien de Fontenay, who was also employed by Henry IV of France.

G. *Diadem*

Gold, enamel, diamonds, sardonyx, onyx, cornelian, garnets and lapis lazuli

Foremost among the splendid gems in the diadem is the central sardonyx cameo depicting Eos, personification of the Dawn, wearing a long chiton and standing in her chariot, pulled by two fiery horses. This motif was extremely popular and later inspired a group of gems associated with 13th-century Hohenstaufen court art in Southern Italy. In the 16th century the back was engraved with a cameo of a river god. Also in the diadem is a sardonyx cameo portrait of Queen Elizabeth, and since it is set in a locket containing her miniature (now damaged) and that of Lord Leicester, it is possibly the jewel referred to among the gifts offered to Her Majesty in 1581 by eight masquers in Christmas week: "a flower of golde garnished with sparks of diamonds, rubyes and ophales with an agate of her Majesty's phisnamy and a perle pendant with devices painted on it" (*Progresses of Queen Elizabeth*, Vol. II, p. 389, ed. J. Nichols). Also of major historical interest is a group portrait of Henry VIII with his children, the father shown facing front, the others in profile. This miniature version of the dynastic group portrait seems unique, and stylistically it dates from the period of Julien de Fontenay's cameos of Queen Elizabeth. The Queen rewarded her ministers and ambassador with her portrait, and cameos like this were worn round the neck or in the hat as badges of loyalty; they can be regarded as the forerunners of the Royal Orders given by the monarchy in later periods to acknowledge devoted service.

Furniture and Woodwork

It is not possible, within the framework of the present exhibition, to represent adequately the wealth and range of the furniture at Chatsworth. Each generation of the Cavendish family contributed, in varying degrees, to the decoration and furnishing of this great house. The important items of furniture for the state rooms and private apartments were not "collected" as were pictures and sculptures, but they were expressly commissioned from leading, and often royal, cabinetmakers in order to realize particular decorative schemes. Their status, particularly as regards those pieces made by craftsmen of international repute, was that of a work of art.

A portrait of the 2nd Duke shows him, as a collector, beside his Boulle coin cabinet (No. 3). This little coffer, fitted with drawers, is one of a pair at Chatsworth which the 2nd Duke acquired from France and of which he was as proud as he was of his coin collection. The other contained his collection of gems. The pair, along with other examples at Windsor Castle and in the Wallace Collection, demonstrate the skill of the celebrated cabinetmaker André Charles Boulle (1642–1732), who held the appointment of *ébéniste du roi* to Louis XIV. Veneered with tortoiseshell and engraved brass in an arabesque design, the coffers are enriched with gilt bronze mounts and are an expression of European baroque taste so well represented in the splendid state rooms which the 1st Duke was creating in the late 17th century at Chatsworth. These rooms still display superb mirrors which were then a novel feature in the decoration of interiors, adding a new sense of space and light. They also contain fine lacquer and marquetry cabinets of which the small fall-front coffer is an example (No. 177).

The strength of the furniture collection now preserved at Chatsworth depends, however, not upon pieces from any single period but upon its extraor-dinary variety. This variety has been achieved as a result of the ownership enjoyed by the Dukes of Devonshire of a number of different properties, some of which came to the family by marriage, most notably by that of the 4th Duke to the daughter of the 3rd Earl of Burlington. This alliance brought into Cavendish hands Burlington House and Chiswick Villa, both furnished by William Kent, who had also designed the furniture and decoration of the Duke's own London house, Devonshire House in Piccadilly. A number of pieces by Kent originating from these sources, created by his own imaginative skill and inspired by his experiences in Italy, are included in the exhibition (Nos. 178–181).

The ownership of two houses in London so close to each other, in addition to the nearby villa at Chiswick —each splendidly decorated and furnished to accord with the fashionable Palladian taste, became a burden to the 5th Duke of Devonshire; and in 1770 he decided to let Burlington House and to move its furniture to Devonshire House. However, both Chiswick House and Devonshire House, which underwent alterations in the late 18th and early 19th centuries, remained occupied by the Dukes of Devonshire until the present century. Many of the pieces from the three houses are now preserved at Chatsworth and represent a unique and fascinating collection of superbly carved furniture of the second quarter of the 18th century, some emanating from the workshops of the royal cabinetmaker, Benjamin Goodison. Some chairs belonging to this group are illustrated in their earlier setting at Chiswick House in an early 19th-century watercolor included in this exhibition (No. 125).

It is not surprising that with a family so closely involved with Palladianism there should be hardly any furniture of a markedly rococo character at Chats-

worth. But it must have been the 3rd Duke who ordered, in about 1740, the superb set of mahogany and partly gilt armchairs which are carved on the knees and the feet with scrolling leaves in an incipient rococo style. These are now at Chatsworth but were evidently at one time in the great Elizabethan Long Gallery at Hardwick Hall, where they are shown in an early 19th-century watercolor (No. 128). From the 18th century until quite recent times there were frequent transfers of furniture in both directions between Hardwick and Chatsworth. As Lord Chamberlain at the time of the death of George II, it fell also to the 4th Duke to receive as a perquisite of office the state bed in which the monarch died and the furniture from his bedchamber. A poignant note in the Chatsworth archives records the despatch of the bed and furniture to Devonshire House, and the bed is now preserved at Chatsworth.

The 5th Duke, who has already been mentioned as having abandoned Burlington House as a family residence, was responsible for remodelling the withdrawing rooms in the private apartments at Chatsworth in about 1780, employing as his architect John Carr of York (1723–1807) to design elegant neoclassical pier-glasses and pier-tables. Sets of seat furniture were ordered from François Hervé, chairmaker to the Prince of Wales, and a number of pieces of marquetry furniture were ordered from London cabinetmakers. Among these pieces are the corner cupboards included in this exhibition which represent the fashion for light-colored woods and neoclassical motifs (No. 183).

The 6th Duke carried his father's enthusiasm further. He made sweeping alterations at Devonshire House, creating interiors in the grand Regency style which transformed his residence into one of the great palaces of London. Although the building, sadly, no longer exists, the saloon is recorded for us in an early 19th-century watercolor (No. 126). The seat furniture is impressive—ordered from the firm of cabinetmakers employed by George IV—and is now exhibited in the library at Chatsworth. This splendid room went through various stages of development (see No. 127) as the 5th Duke felt his way towards his own

ideas of what Chatsworth should be—a concern that has always been of paramount importance to the Dukes of Devonshire. And it is in this context that the furniture at Chatsworth should be appreciated and enjoyed: produced by the best craftsmen in Europe, it dates from many periods but it has always had a purpose and a setting.

177 *Coffer*

c. 1690
Walnut, sycamore and rosewood. The lid opens by means of a catch on the front plate. A second catch frees the outer section of the front panel which, when lowered, reveals the wall of the coffer and two drawers under the bottom lining.
H. 14, W. 25½ in. (35.9×65.4 cm.)
Literature: Ralph Edwards, *The Shorter Dictionary of English Furniture*, London, 1964, p. 664.

This coffer is among those 17th-century items of furniture at Chatsworth probably made for the 1st Duke's personal use by the celebrated cabinetmaker, Gerreit Jensen. Of Dutch or Flemish origin, Jensen settled in London and was cabinetmaker to the royal household from the reign of Charles II to that of Queen Anne. He was engaged by the 1st Duke on the decoration of some of his new rooms at Chatsworth between 1688 and 1698 and, among other activities, he provided glass for the windows of the South and East fronts and wainscoted the closet attached to the State Bedroom with lacquer panels and mirror glass. There is a very fine pair of arabesque marquetry cabinets-on-stands at Chatsworth which were probably provided by Jensen and these, together with this coffer, can be compared to other cabinet-pieces made by Jensen for William III and Queen Mary between 1690 and 1693. These include a writing table at Kensington Palace and a china cabinet at Windsor Castle. This type of coffer was needed for documents or valuables and was regarded as a work of art in itself. Some were decorated with lacquer or tortoiseshell and others with floral marquetry, oyster veneer or arabesque marquetry. They were usually placed upon stands especially made for them.

178 Two Hall Chairs

c. 1730–35
Mahogany.
H. 35, W. 25 in. (89.7×64 cm.)

These chairs are part of a large set of which seven are now at Chatsworth in the Entrance Hall and North sub-corridor. They were originally made for Lord Burlington's villa at Chiswick, and their architectural character and unique form suggest that they were designed by William Kent for that house. The maker is unknown. They are related to a second set of mahogany hall chairs also made for Chiswick, and of which 16 survive at Chatsworth. This second set is almost identical with the first except that the chairs have circular, instead of rectangular, pedimented backs. A 1770 inventory of the "Gallery fronting the Garden" at Chiswick House (Chatsworth archives) lists, among other items "Twelve mahogany Elbow Chairs." This short description does not make precise identification possible but a watercolor painting of the Gallery, executed 52 years later and nearly 70 years after Lord Burlington's death, shows two chairs from the pedimented set of which a pair is exhibited here (No. 125). It will be seen from the watercolor that they were then provided with red morocco cushions. They were certainly not, however, intended for comfort, nor hardly even for use. Lord Burlington's villa, which adjoined at that time his residence of much earlier date, was built solely for the purpose of housing his works of art and creating a suitable classical background for them. The furniture was, therefore, expressly designed to create an atmosphere of Palladian grandeur and severity.

179 Armchair

c. 1735
Carved and gilt wood. The lower part of the X-frame is canted to allow the carved husks to be seen from the front. The side rails are enriched with carved pendant motifs of scrolling leaves, and the square back legs are carved with scales at the sides. Damask modern.
H. 37½, W. 24 in. (95×61.5 cm.)
Literature: Margaret Jourdain, *The Work of William*

Kent, London, 1948, pp. 82–84, figs. 139, 140; Christopher Hussey, *English Country Houses, Early Georgian*, London, rev. ed., 1965, pp. 72–81; F. J. B. Watson, *Wallace Collection Catalogues: Furniture*, London, 1956, p. 241, pl. 36.

One of a set of four now at Chatsworth but made for the saloon at Devonshire House, Piccadilly. In view of the size and importance of the saloon, the set probably originally consisted of 12 or 16 armchairs, accompanied by two or more settees. William Kent, as the architect of Devonshire House and supervisor of the decoration of the interiors, very probably designed these chairs. The maker was possibly Benjamin Goodison (see No. 182). There is also a chair of this design in the Wallace Collection, London, and another at Windsor Castle. Comparable in general design to the Devonshire House chairs is a set of 12 carved and partly gilt mahogany armchairs and two settees provided for the saloon at Houghton Hall, Norfolk, designed by William Kent for Sir Robert Walpole. X-shaped supports, deriving from Classical sources, accorded with Palladian sympathies, but in this free and florid interpretation Kent was probably inspired by 17th- or early 18th-century Italian baroque furniture with which he was familiar. The combination of an X-shaped support in front and two plain legs at the back does not provide a wholly satisfactory design when the chair is viewed from all sides. But it should be remembered that in the 18th century the chairs would have been placed close to each other against the walls of the saloon and would have been seen, as a uniform set, from the front only.

180 Two Chairs

c. 1735
Carved and gilt wood. Damask modern. The present stuffing of the seat does not correspond to the original design.
H. 37, W. 24 in. (94.9×61.5 cm.)
Literature: Christopher Hussey, *English Country Houses, Early Georgian*, London, rev. ed., 1965, pp. 135–149.

Two of a set of three now at Chatsworth and originally part of a larger set made for the state rooms at Devonshire House, Piccadilly. Like the set with X-

shaped front supports provided for the saloon (No. 179), very probably also designed by William Kent. The maker has not been established, but possibly Benjamin Goodison (c. 1700–1767) of Long Acre, London was responsible for making both the set to which these two chairs belong and the set for the saloon at Devonshire House. He is known to have provided furniture for Lord Leicester at Holkham Hall, Norfolk, where Kent was involved from 1734 in the design of the house, interiors and furniture. Other items of furniture now at Chatsworth and made either for Chiswick House or Devonshire House can also be attributed to Goodison (see No. 182).

181 *Hall Settee*

c. 1735–40
Mahogany and oak.
H. 39, w. 48¾ in. (100×125 cm.)
Literature: Christopher Gilbert, *Furniture at Temple Newsam House and Lotherton Hall*, London, 1978, pp. 267–270; Helena Hayward, "The Drawings of John Linnell in the Victoria and Albert Museum," *Furniture History*, Vol. v, 1969, pp. 88–89.

This settee is one of a set of six which came to Chatsworth from Devonshire House, Piccadilly. Whether it was made for that house or was originally designed for Lord Burlington's villa at Chiswick is not known. It is related in style to others made for houses where William Kent is known to have worked. Among these is a pair, now at Temple Newsam House, Leeds, made in 1731 by James Moore, the Younger (d. 1734), for Sir John Dutton of Sherborne House, Gloucestershire. The Temple Newsam pair is after a design by William Kent published in 1744 in John Vardy's *Some Designs of Mr. Inigo Jones and Mr. William Kent* (Pl. 42). The Chatsworth settees introduce a new feature in their turned baluster legs and are somewhat later in date. Almost identical in style to these Chatsworth examples is another set of settees with turned baluster legs provided for the garden building, known as the Praeneste, at Rousham House, Oxfordshire. Between 1737 and 1740 William Kent was responsible for re-modelling this house, for designing interior features

and furniture, and for laying out the garden with its temples and grottoes. The close relationship of the Rousham settees and those at Chatsworth suggests that the latter were designed by Kent between about 1735 and 1740. As Kent was involved both at Devonshire House and Chiswick, their provenance also supports this suggestion. Their maker is not established; however, a pen and ink and wash design in the Victoria and Albert Museum by the young furniture-maker, John Linnell, shows a hall settee with similar panelled back and identically carved baluster legs. Either the Chatsworth settees or a lost design for them must have been known to John Linnell and it is possible that his father, William Linnell (d. 1763) of Long Acre, by whom he was trained and employed, may have been the maker.

182 *Library Writing Table*

c. 1740
Mahogany, walnut drawer linings and oak carcase. Gilt bronze mounts. The two sections on either side of the recess contain a small drawer above, a central cupboard opening on a pin hinge and two small drawers below. These drawers and cupboards are triangular in shape, necessitated by the polygonal form of the writing table. The two sections at each side are similarly arranged but with rectangular drawers and cupboards.
H. 35¼, w. 57 in. (90.4×146 cm.)
Literature: Geoffrey Beard, "Three eighteenth-century cabinetmakers: Moore, Goodison and Vile," *The Burlington Magazine*, July 1977, pp. 479–485.

One of a pair of library tables now at Chatsworth and reputedly made for Lord Burlington's villa at Chiswick. The tables were so designed that each could be placed against a wall or they could be set back-to-back in the center of a library. Although the maker is not documented, the style of the piece makes an attribution to Benjamin Goodison (c. 1700–1767), who had become royal cabinetmaker in 1727, convincing. Goodison would also have designed the table, with the approval of his patron. He was responsible for many magnificent pieces of early Georgian furniture, of a type acceptable to Palladian taste, with gilt enrichments and bold carved details. Notable

among them is a fine pair of mahogany library writing tables, which are very close indeed in general design to the table exhibited here, and a pair of mahogany commodes of similar character. These pieces were made about 1740 for Sir Thomas Robinson of Rokeby, Yorkshire, and now belong to Her Majesty The Queen. Sir Thomas Robinson was Master of the Great Wardrobe to George II and it is not surprising that he should have placed private orders with the royal cabinetmaker whose work he knew well. He was also a professed disciple of Lord Burlington and the two connoisseurs shared the same tastes.

183 *Pair of Corner Cupboards*

c. 1770
Mahogany, satinwood, rosewood, harewood, tulipwood, pine, etc. Scagiola top. The two doors swing open by means of a catch in the frieze above, revealing shelves within. The base mount running along the base is a later substitution.
H. 32¾, W. 29 in. (83.9×74.3 cm.)

One of three pairs of almost identical corner cupboards at Chatsworth. Corner cupboards, or "coigns" as they were sometimes described in the late 18th century, began to be decorated with marquetry in accordance with fashionable taste from about 1765 to 1770. The introduction of formal classical vases or urns reflected the interest in antiquity which was so strong in Britain and, indeed, in Europe, during this period. Motifs of the kind used on these corner cupboards were usually based upon engraved sources, and books illustrating ancient works of art—whether gems, sculpture or ceramics—were necessary references in the design department of a large furniture-making firm. Small cabinet-making workshops might purchase marquetry panels from specialists for mounting in cabinet pieces. The larger firms included those of Thomas Chippendale, John Linnell, and Ince and

Mayhew. It has not been established from whom these pieces were purchased by the 5th Duke, but a number of marquetry pieces and suites of seat furniture from leading London makers were acquired for the private apartments at Chatsworth in the late 18th century.

184 *Rosary*

Flemish (?); early 16th century.
Boxwood
Total length: 22⅜ in. (58 cm.)
Provenance: The presence of the English royal arms on the *Pater* bead shows that it was made for an English sovereign, and the style and workmanship indicate that the owner must have been Henry VIII (1509–1547). It was presumably made before his break with Rome in 1534, since after that event he would not have wanted a rosary, which was strictly associated with Roman Catholic practice. In the late 17th century it belonged to the Jesuit Père de La Chaise (1624–1709), confessor to Louis XIV of France, who gave or bequeathed it to the Paris house of his Order. In the 18th century it belonged to another Jesuit, Père Gabriel Brotier (1723–1789). It was bought in Paris by the 6th Duke early in the 19th century.

The rosary consists of a ring from which hang a cross, ten *Ave* beads, and a large bead for the *Pater noster*. The Cross is carved with the Crucified Christ and the four Evangelists on one side and the four Latin Fathers on the other. The *Ave* beads are each divided into five roundels and carved with the Apostles with Sentences of the Creed, Prophets and Sybils with relevant texts, and scenes from the Old and New Testaments. The *Pater* bead has three rows of eight roundels with further scenes and the two remaining Apostles. It is hinged and has another two scenes inside. The Rosary is an exceptional example of virtuoso wood carving.

Sculpture

ANTONIO CANOVA (1757–1822)

185 *Bust of Laura*

Marble; H. 21¼ in. (54 cm.)
Provenance: Bought from the sculptor by the 6th Duke, in 1819.
Literature: H. Honour, *The Age of Neo-Classicism* (exhibition catalogue), Royal Academy, London, 1972, No. 326; J. Kenworthy Brown, "A Ducal Patron of Sculptors," *Apollo* XCVI, 1972, p. 322.

In 1818 Canova made two busts of Beatrice and Laura, the ideal women loved by the poets Dante and Petrarch. He sold the latter to the 6th Duke of Devonshire who later recorded that "it required all the Duchess of Devonshire's (Elizabeth Foster) powers of persuasion, added to my entreaties, to make him part with her." It is one of a series of ideal busts which Canova executed in his last years in a somewhat more severe style than he had formerly employed for such works. Another version of the bust, with prominent veins in the marble, is in the collection of Professor Mario Praz, Rome.

Canova was the 6th Duke's favorite sculptor, and there are five other works by him in the great neoclassical Sculpture Gallery which the Duke created at Chatsworth.

SIR JACOB EPSTEIN (1880–1959)

186 *Lady Sophia Cavendish*

Bronze; H. 18 in. (45.7 cm.)
Commissioned by the present Duke.

This infant portrait of Lady Sophia Cavendish (1957), younger daughter of the Duke and Duchess, was one of the last commissions undertaken by the sculptor before his death in 1959.

ANGELA CONNER

187 *Harold Macmillan*

Bronze; 13½ in. high (34.3 cm.)
Commissioned by the present Duke, 1972.

There are several portrait busts at Chatsworth by Angela Conner, who works primarily as a painter in London and New York. Harold Macmillan, British Prime Minister from 1957 to 1963, is the Duke's uncle by marriage, and was in office at the same time as President Kennedy. The two leaders formed a strong friendship, which was reinforced by a common link with the Cavendish family: Kathleen Kennedy, the President's sister, was, before her own death in 1948, the widow of the present Duke's elder brother William, who was killed in action in 1944.

China

Although much of the large collection of china at Chatsworth, both oriental and European, is now displayed throughout the house, most of the services and individual pieces it comprises were originally bought or commissioned for use rather than collected for their beauty or rarity. The oriental wares date mainly from the period when the 1st Duke's house was being built and furnished, and were at that time the only porcelain available, imported into Europe in great quantities. Later, much of the household's requirements could be provided locally, following the establishment of a Derbyshire factory in 1756. One of the Derby services included in the exhibition (No. 193) shows views of Chatsworth and other Cavendish seats, while another (No. 191) has picturesque views of surrounding parts of Derbyshire.

There are in the collection some pieces of extreme rarity, such as the "Medici Cruet" made in Florence in the late 16th century—one of the earliest examples of European attempts to imitate the hard-paste porcelain of China and one which, unfortunately, could not be included in the present exhibition. The exhibition does include, however, a very rare early Meissen figurine of Augustus the Strong, Elector of Saxony (No. 189), as well as two Dutch tulip-vases (No. 188) from a series of vases and other Delftware bought by the 1st Duke following the fashion set by King William and Queen Mary. Apart from this particular provenance, however, and that of a number of pieces not acquired until the present century, the functional origins of the collection are revealed by the fact that virtually no specific references to china at Chatsworth or Devonshire House appear in the surviving account books and inventories of the day.

188 *Two Delft Tulip-Vases*

One hexagonal, the base on lion paw feet and painted with the Virtues of Prudence, Faith, Fortitude, Hope, Justice and Charity, supporting seven separate tiers; H. 41 in. (104.1 cm.). Marked *AK* for Adriaen Koeks. The other square, the base on crouching lions holding globes, and painted with allegories of Earth, Air, Prudence and Liberty, supporting six separate tiers; H. 42½ in. (106.7 cm.). Marked *AK* for Adriaen Koeks.
Provenance: probably bought by the 4th Earl, later 1st Duke.
Literature: Michael Archer, *Pyramids and Pagodas for Flowers, Country Life*, 22nd Jan. 1976, pp. 166–169.

The elaborate multi-tiered pots—each tier with four or more nozzles—which evolved in Holland in the 17th century for the display of cut flowers became known in England as tulip-vases. Very few contemporary representations of them in use have survived, but these show that the vases were in fact intended for a variety of flowers, and not just tulips. They were made mainly at Delft, and towards the end of the century the chief producer was Adriaen Koeks, working usually to the designs of Daniel Marot, court architect to William of Orange. Foremost among the patrons of Koeks was the Princess Mary, who became Queen of England as William III's wife following the Glorious Revolution of 1688. Many of the vases she ordered are still to be seen in the palace which William rebuilt and enlarged at Hampton Court, near London, setting a fashion for fanciful Delftware of this kind which lasted until more sober tastes prevailed in the early decades of the 18th century.

189 *Augustus the Strong*

White porcelain, H. 4.5 in. (11.5 cm.)
Meissen, c. 1715.
Literature: cf. W. B. Honey, *German Porcelain*, London, 1967, pl. 3A, p. 14.

Augustus the Strong (1670–1735) was both Elector of Saxony (1694–1733) as Frederick Augustus I and King of Poland (1697–1706 and 1709–1733) as Augustus II. He took a keen interest in porcelain and its manufacture, and after the alchemist Böttger discovered the secret of making hard-paste porcelain of the Chinese type, Augustus in 1710 had a porcelain factory established at Meissen, north of Dresden.

Figures of Augustus the Strong in Böttger's earlier invention of a hard red stoneware, sometimes called *Japis-Porzellan*, were produced in large quantities, as were figures in white or colored porcelain. But few have survived. The present example is one of two identical porcelain figures at Chatsworth and is of extreme rarity in that it follows exactly the Böttger stoneware model of circa 1713. Only two other examples of this porcelain model, both colored and of slightly later date, are recorded.

The sculptor is unknown. The most recent suggestion is that both the stoneware and the porcelain figures were the work of Johann Joachim Kretzschmar, who worked with the Saxon court sculptor, Balthasar Permoser, on the sandstone figures adorning the Zwinger in Dresden.

190 *Selection of Pieces from a Dinner Service*

White porcelain, each piece painted in colors, with birds perched on branches, butterflies and moths: a dessert plate, a large oval dish, a large circular dish, and a knife and fork.
Berlin, c. 1780.
Provenance: Warren Hastings, Governor-General of India; probably bought by John, 1st Baron Redesdale; thence by descent to Lord Redesdale, father of the present Duchess of Devonshire; bought by the present Duke in 1948.

The entire service is very large, comprising more than 200 pieces. The Berlin factory was purchased in 1763 by Frederick the Great of Prussia and then entered its most famous period. It has continued as a royal and later state-owned factory until the present day.

191 *Selection of Pieces from a Dessert Service*

Porcelain, each piece painted in colors with scenic views of Derbyshire, set within borders of pink and green garlands and waved gilt rims: two circular dishes, two oval dishes, two heart-shaped dishes and one shell-shaped dish.
Derby, c. 1790.
Provenance: King George V; 9th Duke.

The service, which comprises 38 pieces in all, was a gift from George V to the 9th Duke as a mark of gratitude for a period of convalescence the King spent with Queen Mary at Compton Place, a seaside house belonging to the Duke in Sussex.

192 *Cabinet Cup and Saucer and Matching Tray*

Porcelain, each piece enamelled in blue with a ducal coronet above a monogram, *GD*, for Georgiana, Duchess of Devonshire, on a gold vermiculé ground enclosing fanciful snakes and birds.
Derby, c. 1800.
Provenance: Made for Duchess Georgiana.

From a service including eight other cups and saucers.

193 *Five Dessert Plates with Views of Country Houses, with the accompanying watercolor designs*

Plates: bone china, the central medallion painted on a deep blue ground with gilt borders; D. 9¾ in. (24.7 cm.)
Derby, c. 1830.
Provenance: 6th Duke.
Designs: watercolor; D. 5¾ in. (14.6 cm.)
Painted by Zachariah Boreman.

The plates are from a large service produced in the "revived rococo" period when the factory was owned by Robert Bloor. The original watercolor designs are by the well-known painter of Derby porcelain, Zachariah Boreman, who worked at the factory from

1775 to 1795, much in the style of the English land-scape watercolorist, Paul Sandby. The houses depicted are all Cavendish family seats: Chatsworth and Hardwick, both in Derbyshire, Bolton Abbey in Yorkshire, Chiswick near London, and Lismore Castle in County Waterford, Ireland.

194 *Pair of Famille Verte Vases*

White porcelain, painted in enamel colors with vertical panels of butterflies, birds and flowers; H. 12 in. (30.5 cm.) Chinese, K'ang Hsi period (1662–1722).

The so-called "famille verte" palette became very popular during the reign of the Emperor K'ang Hsi, when so much Chinese porcelain was produced for export to Europe. Chatsworth, like several great houses of the period, is known to have had a room wainscoted with colorful lacquer panels in the oriental style, doubtless a setting for the display of fine or curious pieces of oriental porcelain.

Index of Artists, Authors and Craftsmen

BY CATALOGUE NUMBER

Index of Sitters

ILLUSTRATIONS

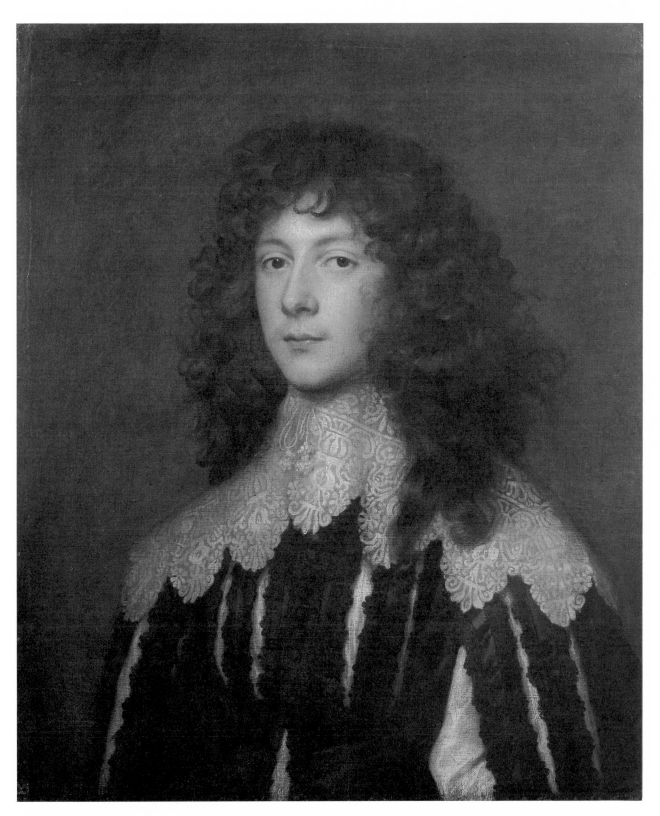

1. Sir Anthony van Dyck, *Charles Cavendish, 2nd Son of the 2nd Earl of Devonshire*

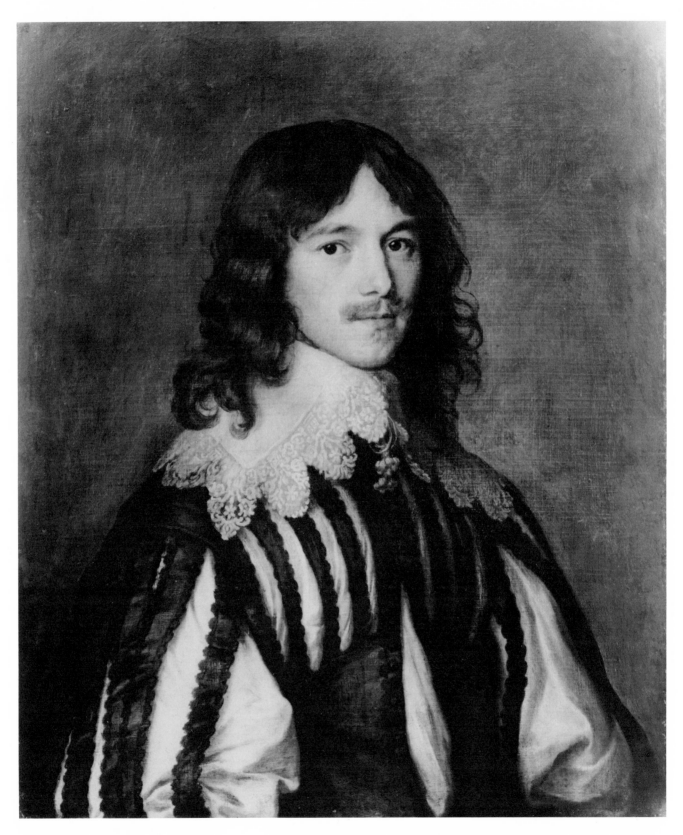

2. Sir Anthony van Dyck, *Lucius Cary, 2nd Viscount Falkland*

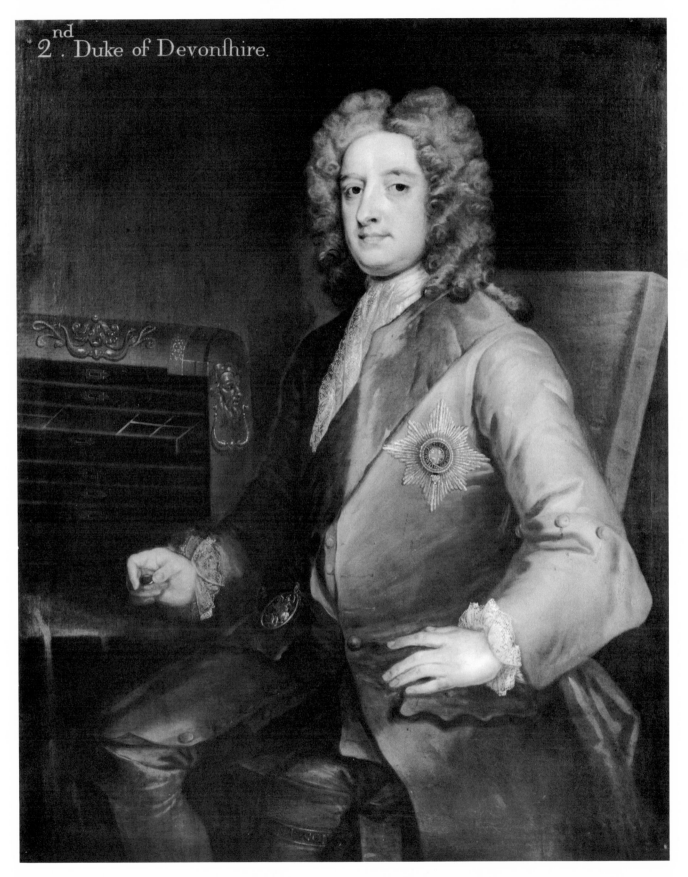

3. Attributed to Charles Jervas, *William Cavendish, 2nd Duke of Devonshire*

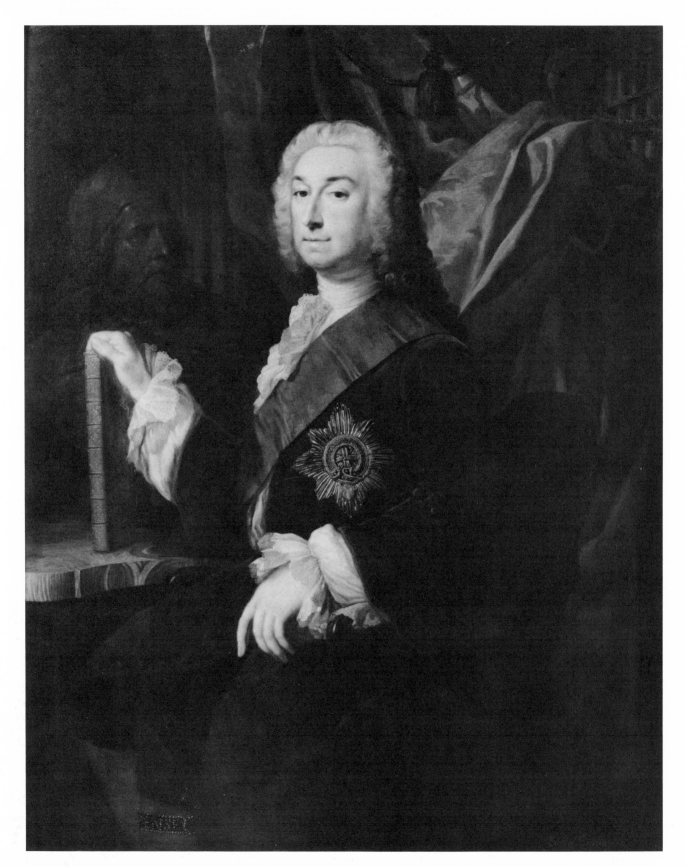

4. George Knapton, *Richard Boyle, 3rd Earl of Burlington*

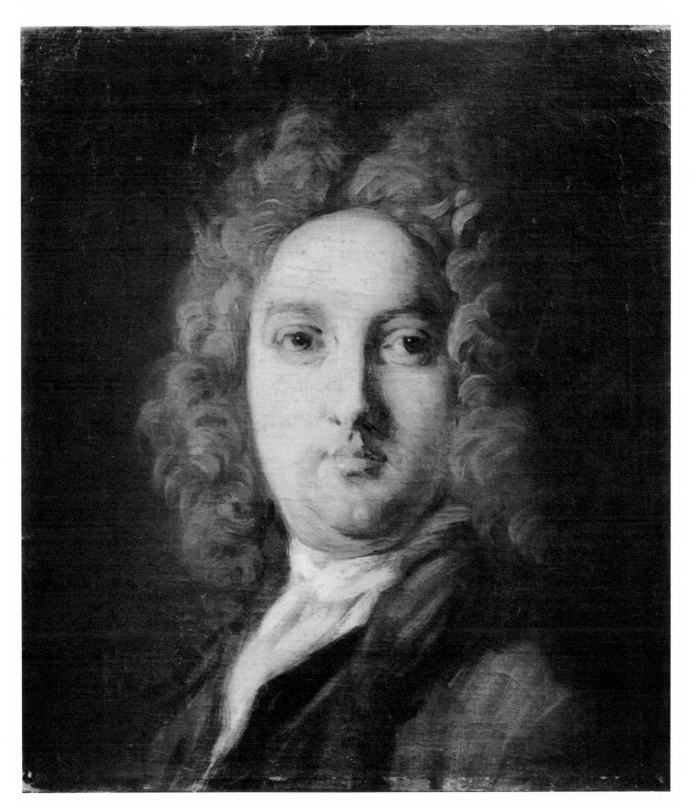

5. Benedetto Luti, *Portrait of the Architect William Kent*

7. Thomas Hudson, *William Cavendish, 4th Duke of Devonshire*

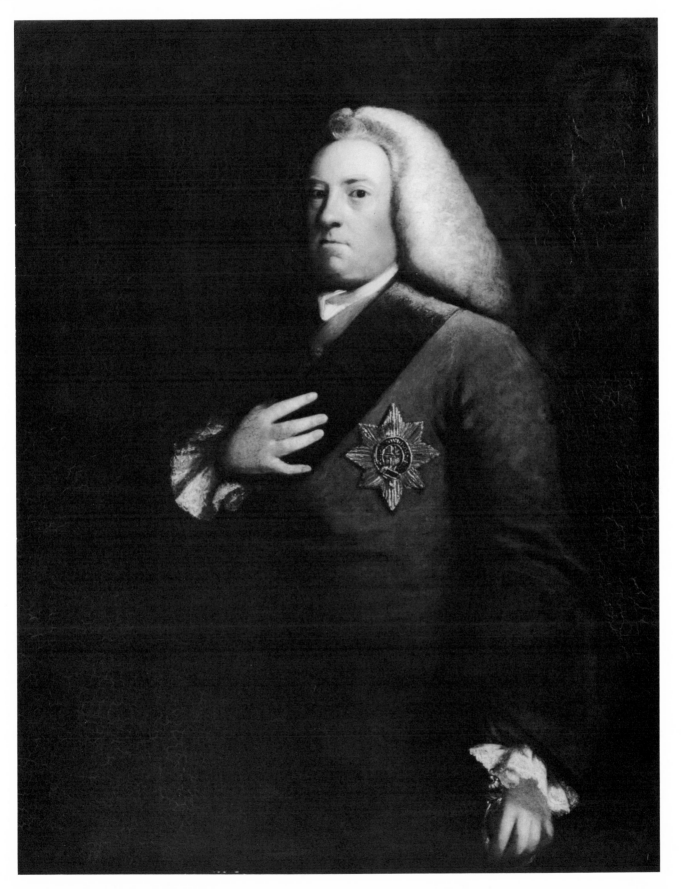

6. Sir Joshua Reynolds, *William Cavendish, 3rd Duke of Devonshire*

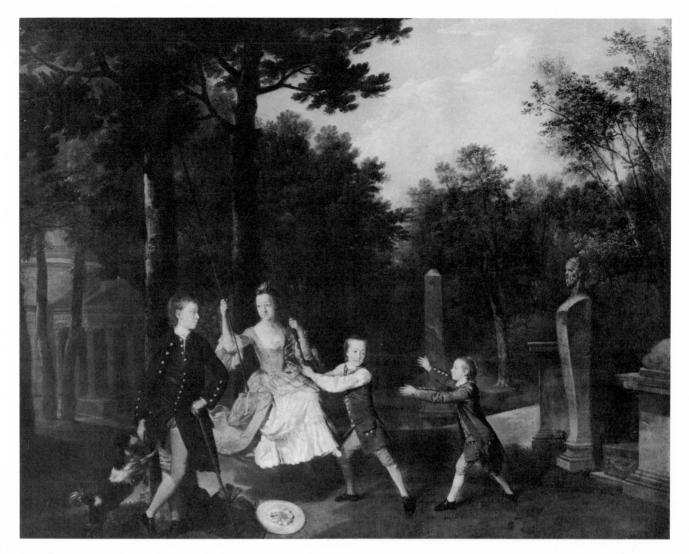

8. Johann Zoffany, *The Children of
the 4th Duke of Devonshire*

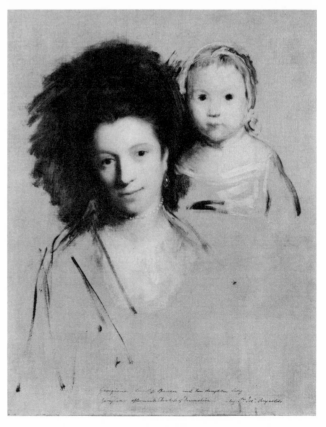

10. Sir Joshua Reynolds, *Georgiana Poyntz,
Countess Spencer, with Her Infant Daughter*

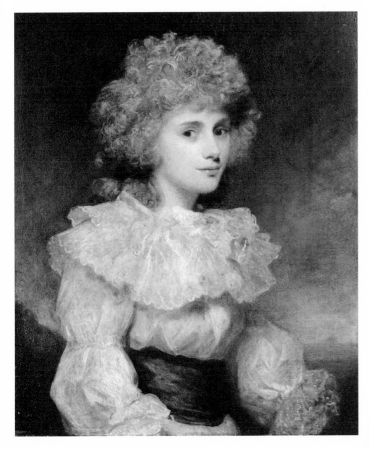

13. Sir Joshua Reynolds, *Lady Elizabeth Foster,*
Later Duchess of Devonshire

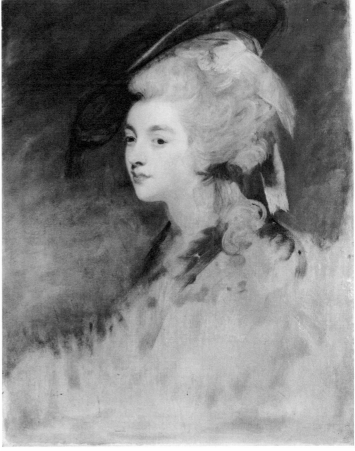

11. Sir Joshua Reynolds, *Georgiana Spencer,*
Duchess of Devonshire

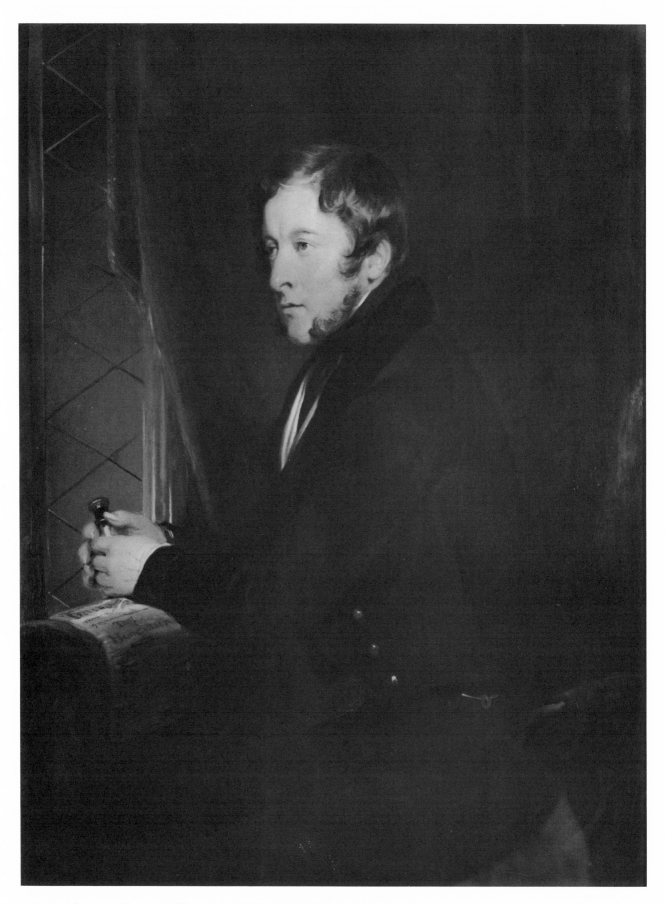

15. Sir Edwin Landseer, *William Spencer Cavendish, 6th Duke of Devonshire*

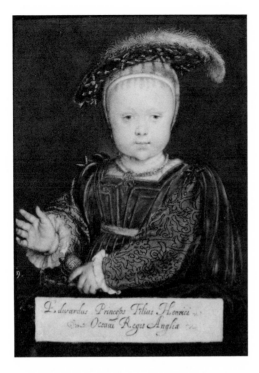

16. Portrait miniature of Edward,
Prince of Wales, by Peter Oliver
after Hans Holbein, early 17th century

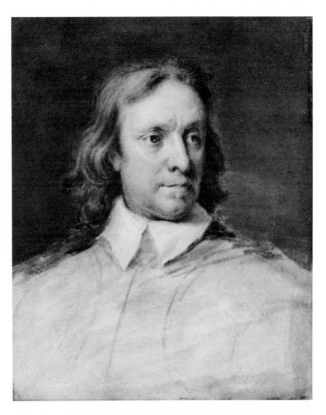

17. Portrait Miniature of Oliver Cromwell,
by or after Samuel Cooper, mid-17th century

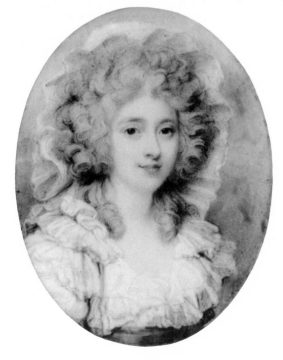

23. Portrait miniature of Lady Georgiana Spencer,
Duchess of Devonshire, by Richard Cosway,
late 18th–early 19th century

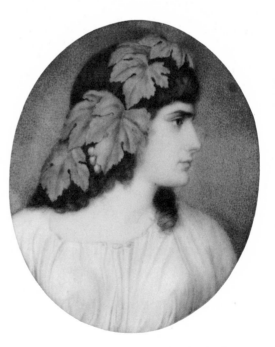

25. Portrait miniature of Lady Elizabeth Foster,
English School, late 18th century

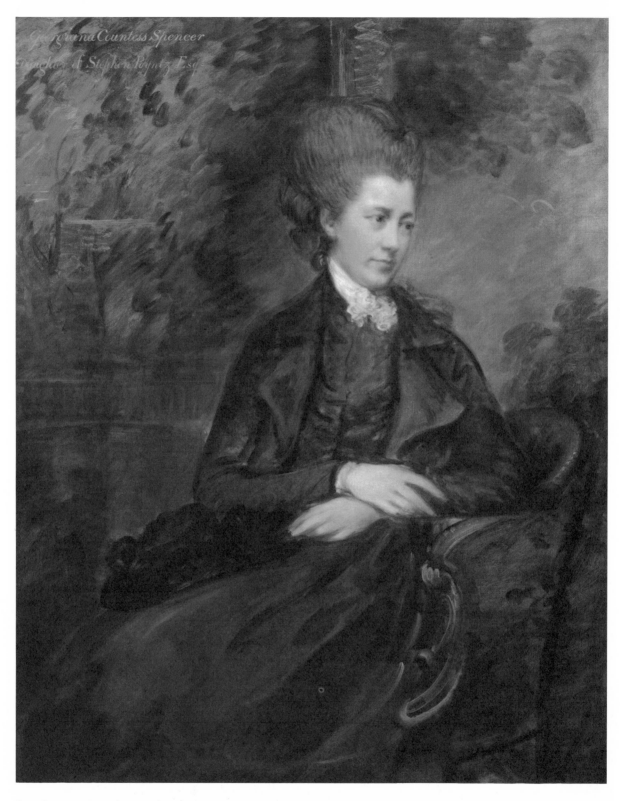

9. Thomas Gainsborough, *Georgiana Poyntz, Countess Spencer*

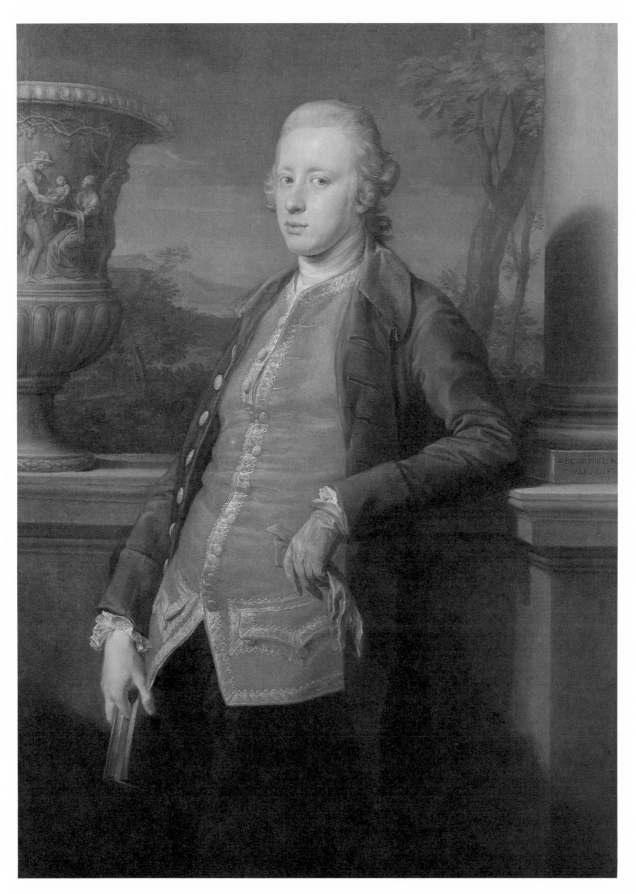

14. Pompeo Batoni, *William Cavendish, 5th Duke of Devonshire*

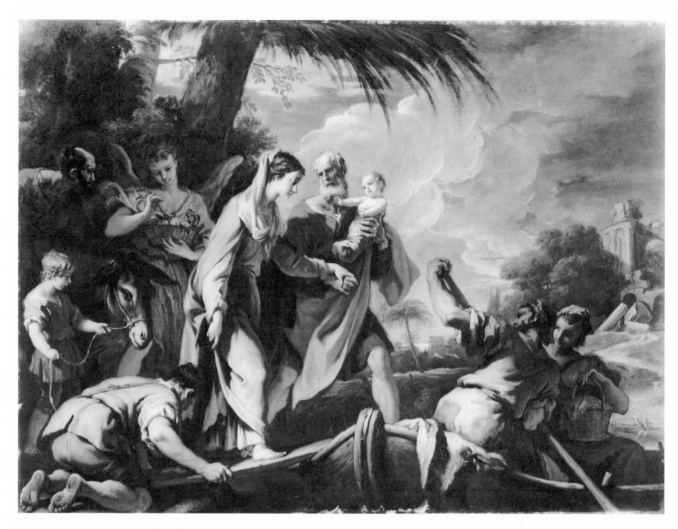

28. Sebastiano Ricci, *The Flight into Egypt*

29. Venetian School, *An Allegory of Justice*

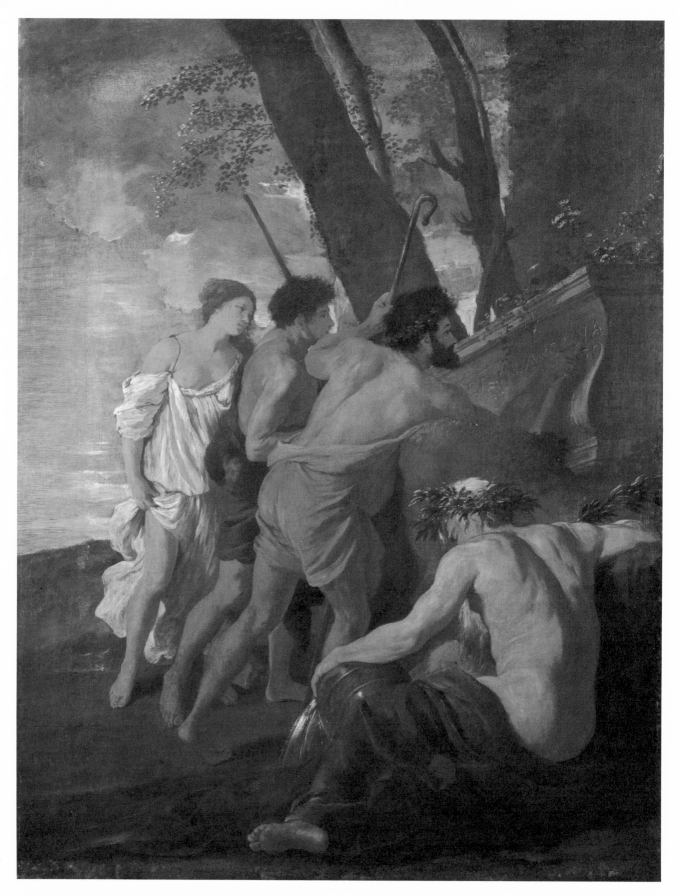

31. Nicholas Poussin, *The Shepherds in Arcadia*

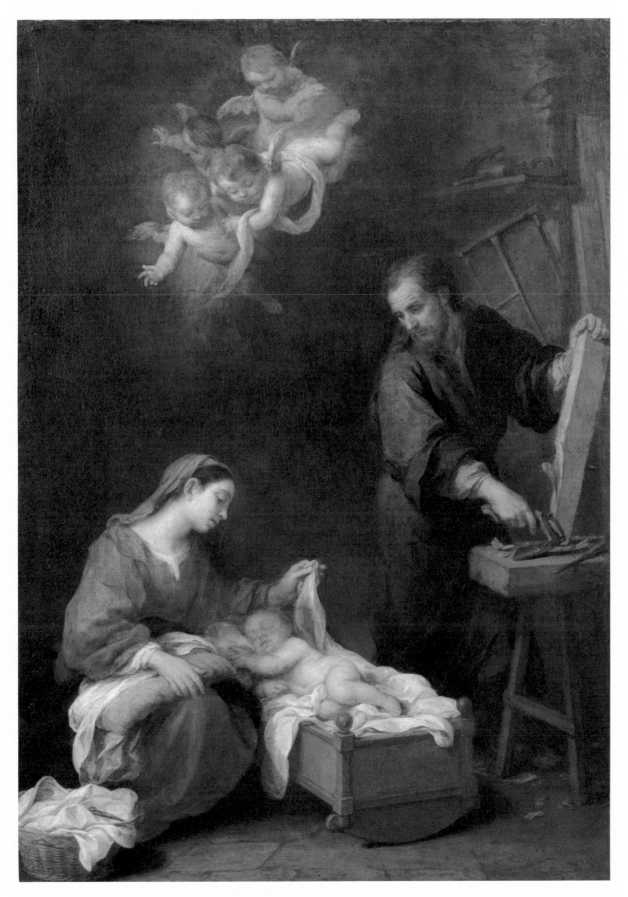

36. Bartolomé Esteban Murillo, *The Holy Family*

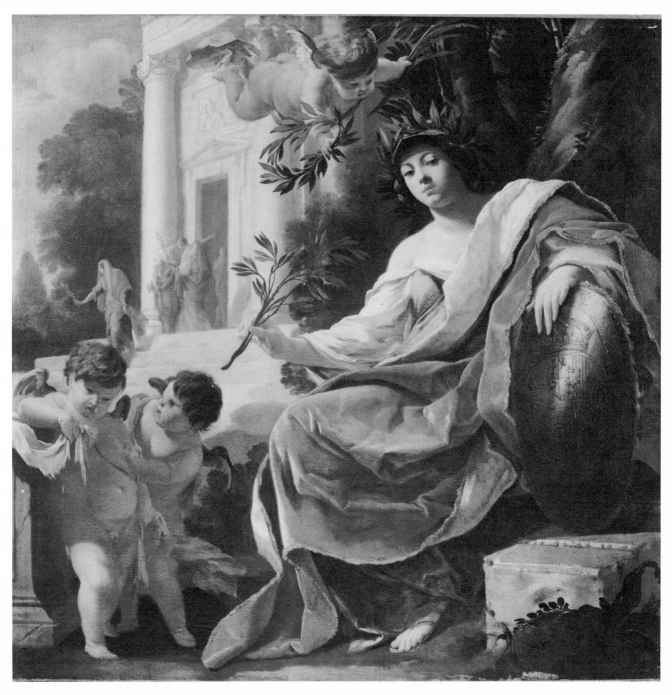

30. Simon Vouet, *An Allegory of Peace*

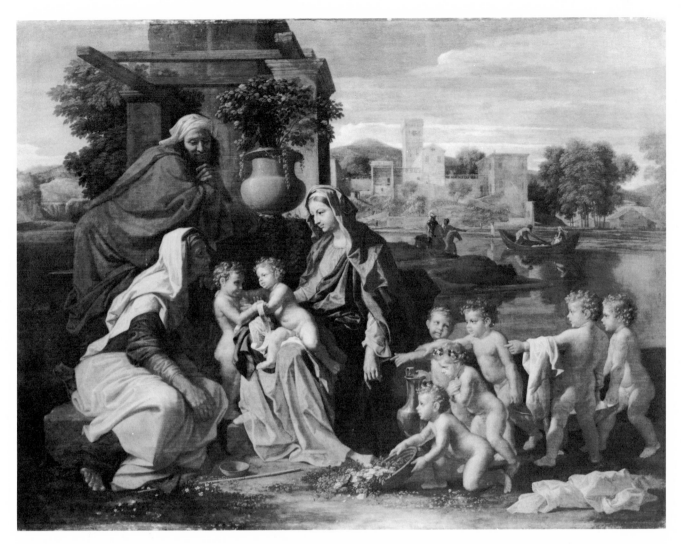

32. Nicolas Poussin, *The Holy Family with St. John, St. Elizabeth and Six Putti*

27. Sebastiano Ricci, *The Presentation of Christ in the Temple*

34. Gaspard Dughet, called Gaspard Poussin, *Landscape with Cephalus Hunting*

121

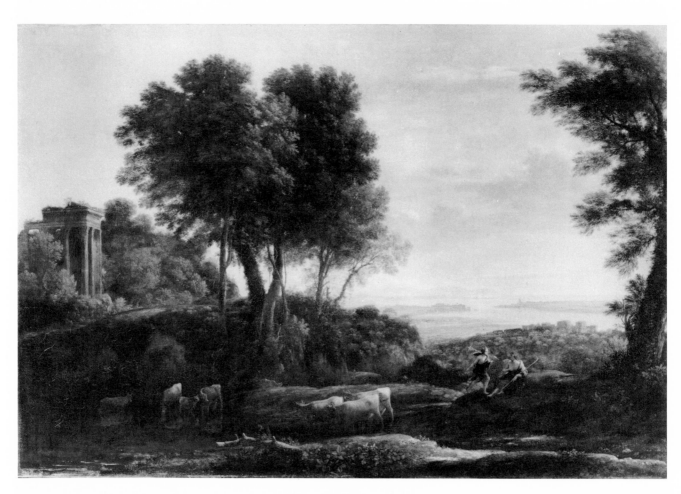

33. Claude Gellée, called Claude Le Lorrain, *Landscape with Mercury and Battus*

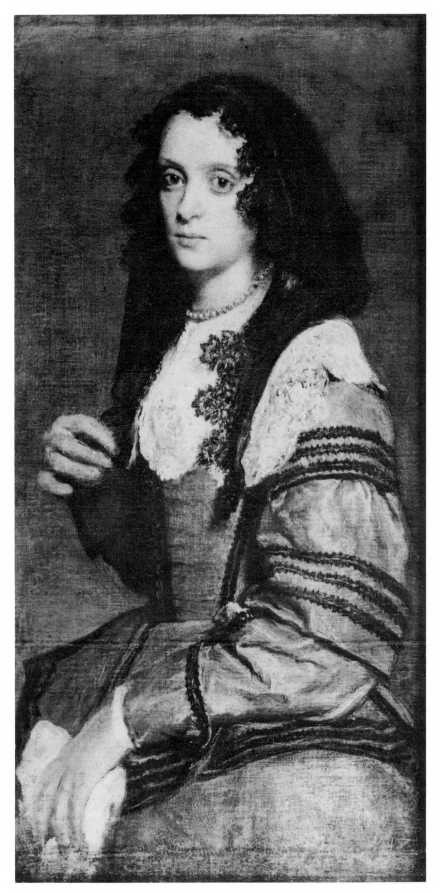

35. Attributed to Diego Rodriguez
da Silva y Velázquez,
Portrait of a Lady in a Mantilla

123

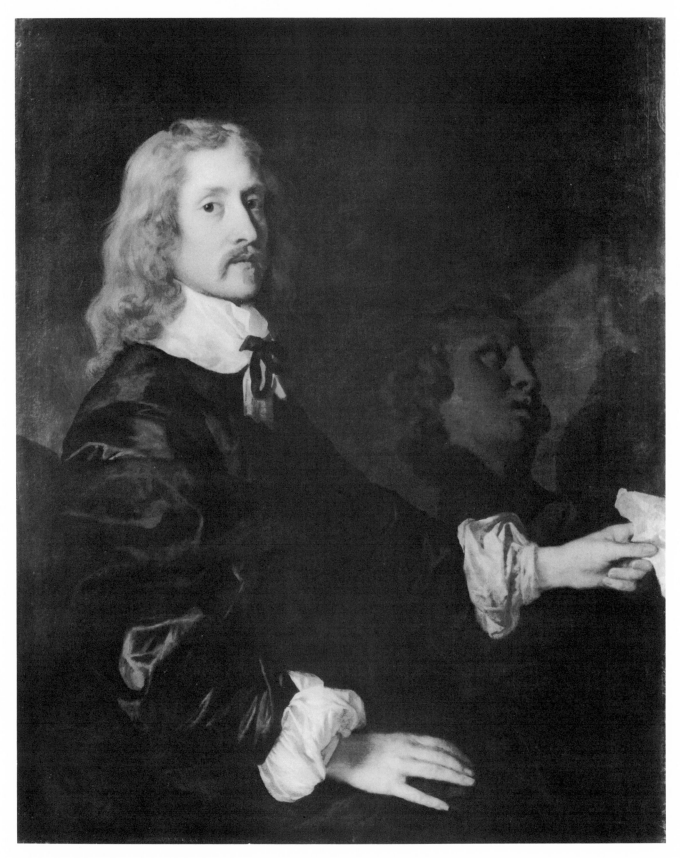

38. Sir Peter Lely, *Portrait of a Man*

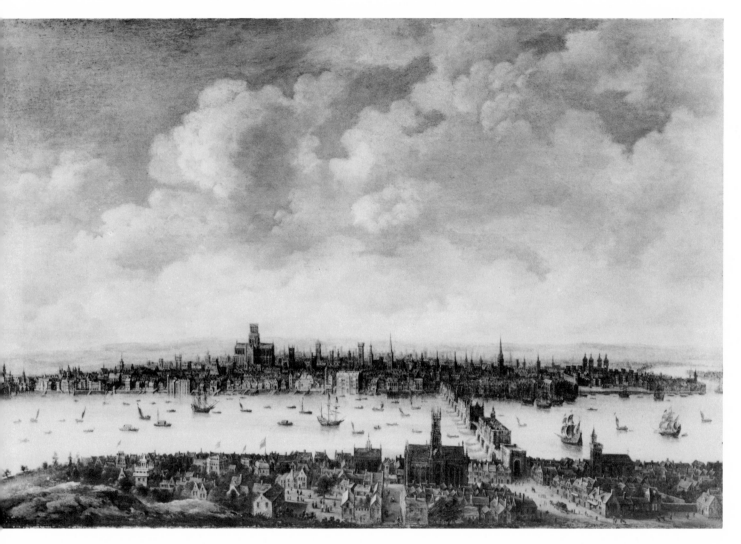

40. Thomas Wyck, *View of London*

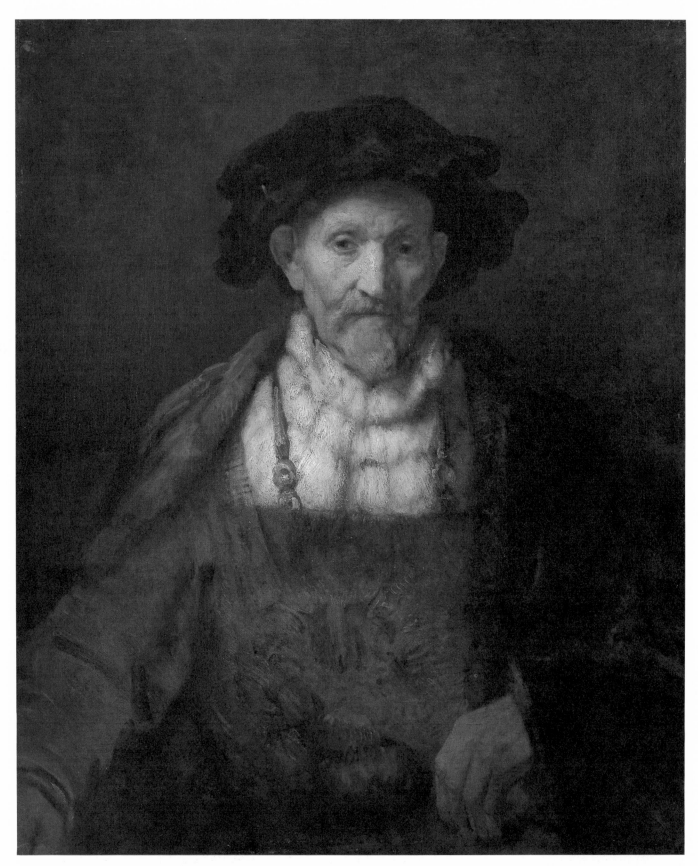

39. Rembrandt van Rijn, *Portrait of an Old Man*

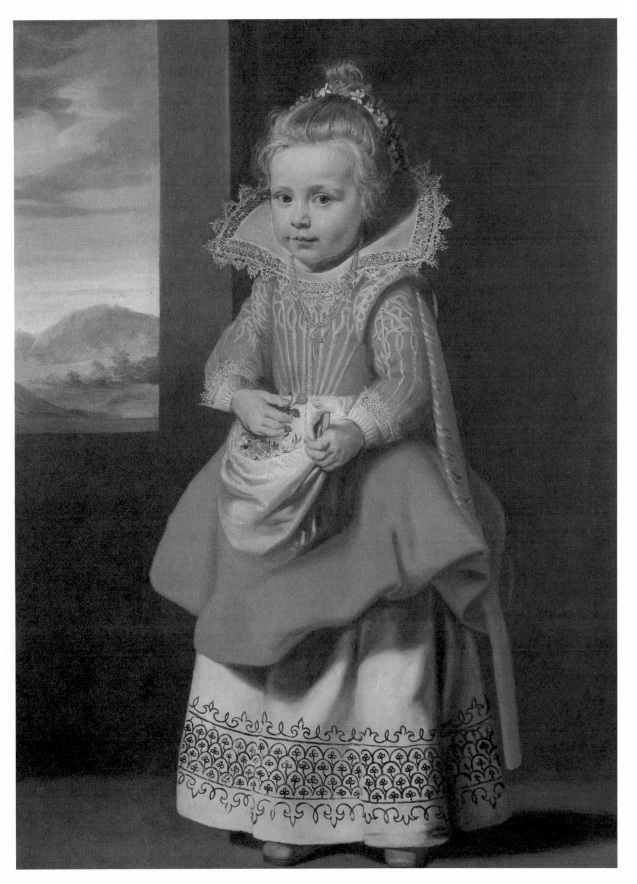

37. Cornelis de Vos, *Portrait of a Little Girl*

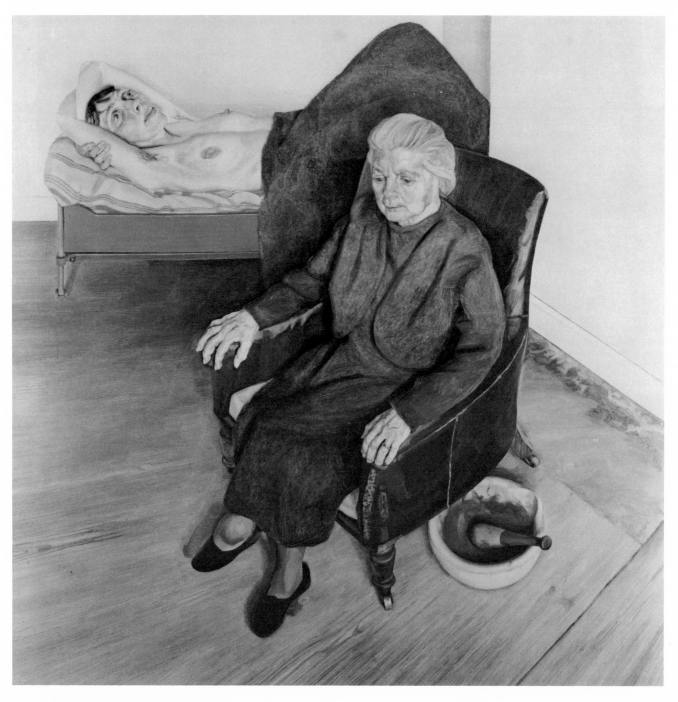

41. Lucian Freud, *Large Interior, London, W.9*

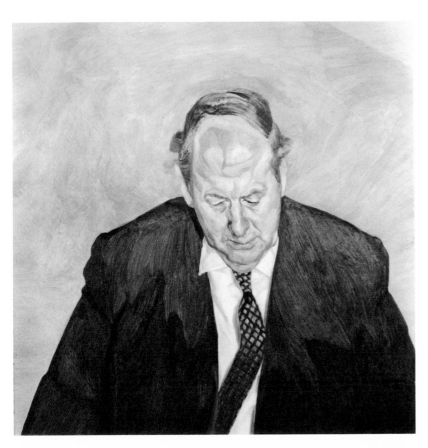

42. Lucian Freud, *Portrait of a Man:*
 Andrew Cavendish, 11th Duke of Devonshire

43. Lucian Freud, *Woman in a White Shirt:*
 Deborah, Duchess of Devonshire

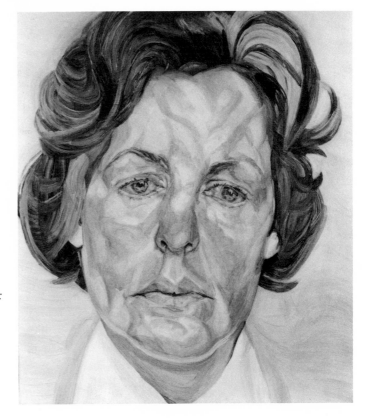

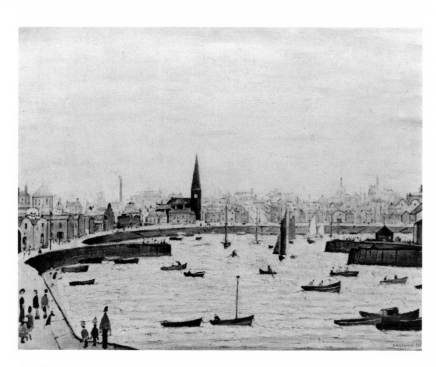

44. Lawrence Stephen Lowry, *Harbour Scene*

45. Susan Crawford, *Assessing the Field:
The Mare Park Top with Lester Piggott*

46. Florentine School, *Pilate Washing His Hands*, and *Study of Four Dogs*

47. Anonymous, Italian School, *A Duck in Flight*

48. Anonymous, Italian School, *Periwinkles and Violets*

49. Anonymous, Italian School, *A Monkey*

50. Anonymous, Italian School, *A Snake*

51. Anonymous, Italian School, *A Hawfinch*

52. Andrea Mantegna, *Battle of the Sea-Gods*

56. Vittore Carpaccio, *A Scene of Presentation*

53. Domenico Ghirlandaio, *Head of a Woman*

54. Leonardo da Vinci, *Leda and the Swan*

55. Follower of Leonardo da Vinci, *Heads of a Woman and Child*

57. Rafaello Santi, called Raphael, *Studies for the Madonna of the Meadow*

58. Rafaello Santi, called Raphael, *Woman Reading to a Child*

59. Rafaello Santi, called Raphael, *Studies for the Conversion of St. Paul*

61. Rafaello Santi, called Raphael, *Studies of a Man's Head and Hand*

66. Francesco Mazzola, called Il Parmigianino, *A Bearded Figure Sleeping*

60. Rafaello Santi, called Raphael, *Three Men in Attitudes of Terror*

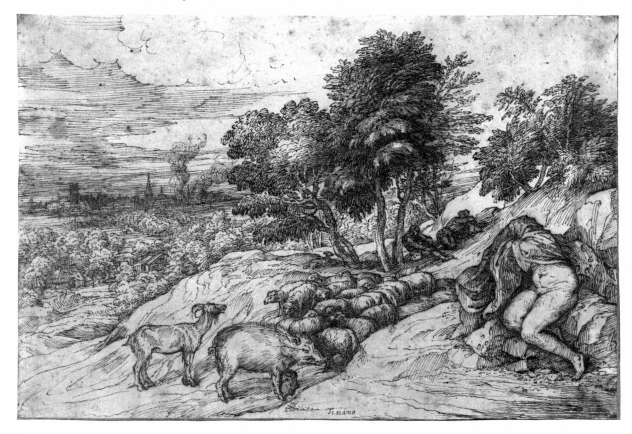

64. Attributed to Tiziano Vecelli, called Titian, *Pastoral Landscape*

62. Rafaello Santi, called Raphael, *Study for the Transfiguration*

Ritratto di Leone x°

63. Attributed to Giulio Romano, *Head of Pope Leo X*

65. Francesco Mazzola, called Il Parmigianino, *Design for the Vault of the Steccata, Parma*

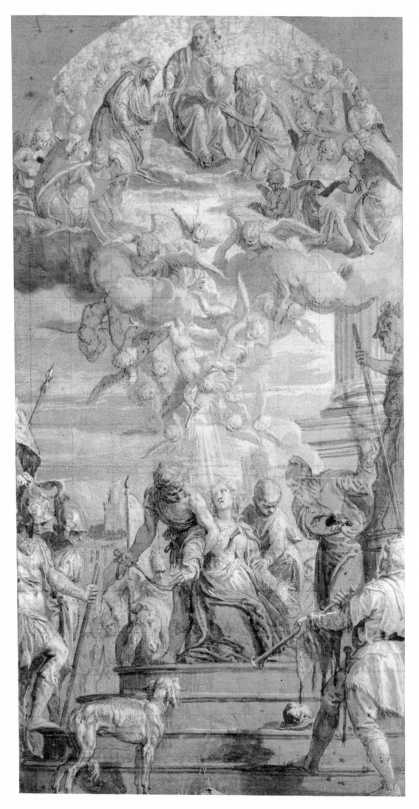

67. Paolo Caliari, called Veronese, *The Martyrdom of St. Justina*

68. Federico Barocci, *Head of a Boy*

69. Annibale Carracci, *Shepherd Boy Piping*

70. Giovanni Benedetto Castiglione, *Tobit Burying the Dead*

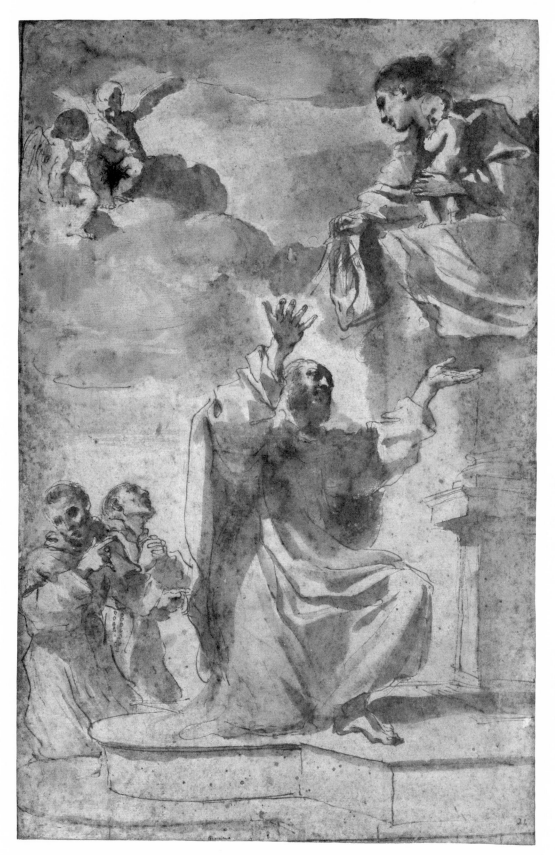

71. Giovanni Francesco Barbieri, called Guercino, *The Madonna del Carmine Offering the Scapular to S. Albert*

72A. Jacques Callot, *The Taking of Christ*

72B. Jacques Callot, *Christ Before Pilate*

153

73. Claude Gellée, called Le Lorrain, *Moses and the Burning Bush*

74. Claude Gellée, called Le Lorrain, *The Disembarkation of Cleopatra at Tarsus*

75. Claude Gellée, called Le Lorrain, *Jupiter and Callisto*

76. Claude Gellée, called Le Lorrain, *Ascanius Shooting the Stag*

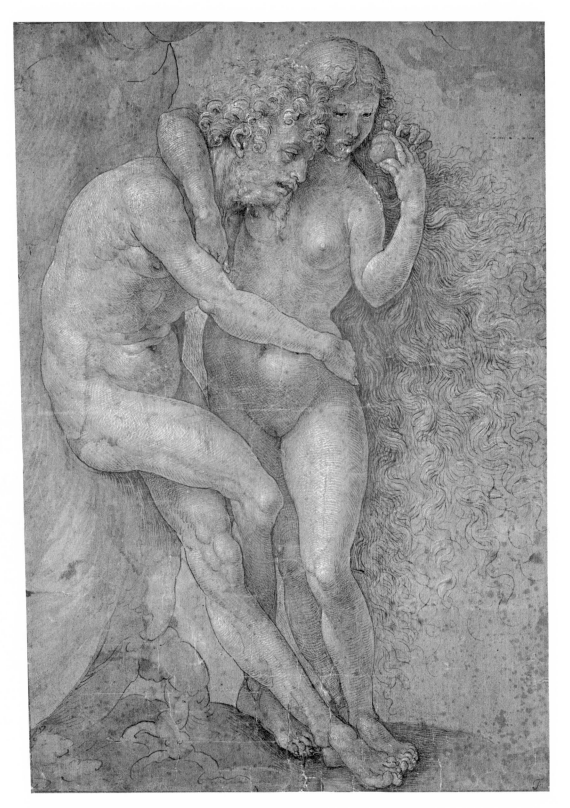

77. Jan Gossaert, called Mabuse, *Adam and Eve*

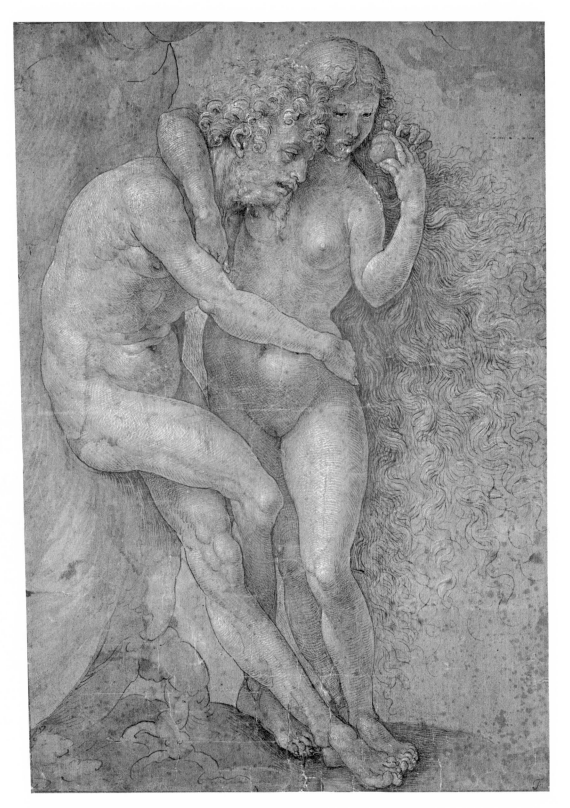

77. Jan Gossaert, called Mabuse, *Adam and Eve*

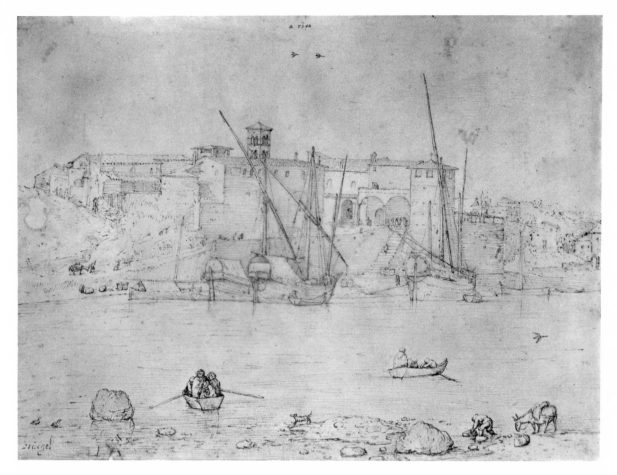

78. Pieter Bruegel the Elder, *View of the Ripa Grande, Rome*

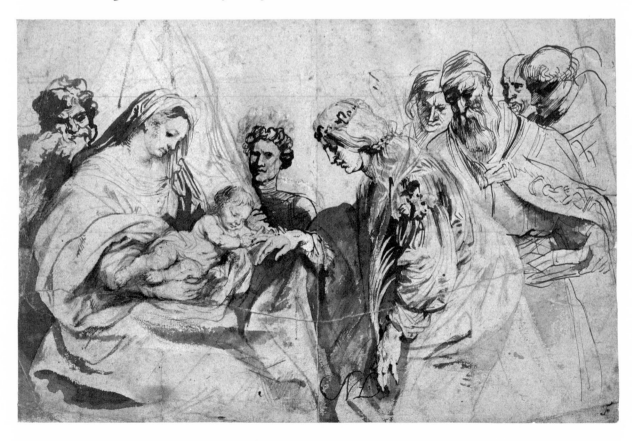

82. Sir Anthony van Dyck, *The Marriage of St. Catherine*

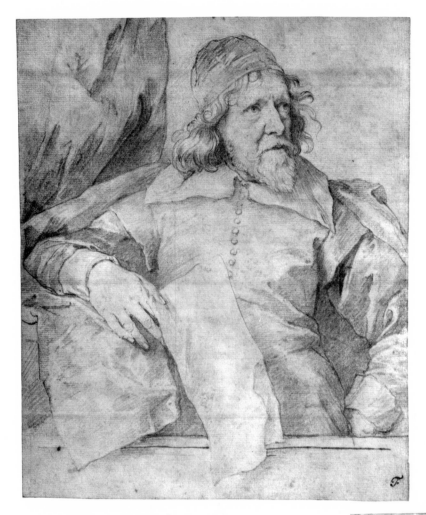

84. Sir Anthony van Dyck, *Inigo Jones*

85. Sir Anthony van Dyck,
*Head and Forequarters
of a Horse*

80. Sir Peter Paul Rubens, *Woman Churning*

81. Sir Peter Paul Rubens, *Tree Trunk and Brambles*

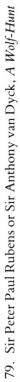

79. Sir Peter Paul Rubens or Sir Anthony van Dyck, *A Wolf-Hunt*

83. Sir Anthony van Dyck, *Horatius Cocles Defending the Bridge over the Tiber*

86. Sir Anthony van Dyck, *A Study of Cows*

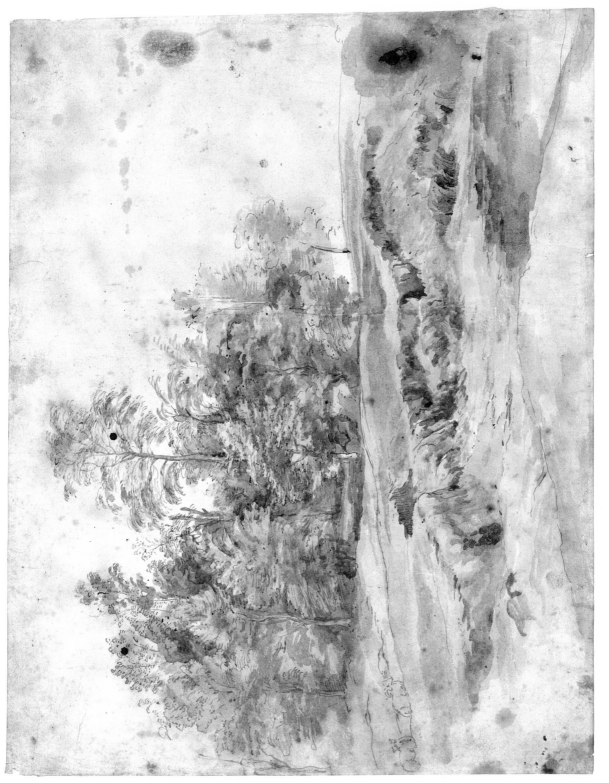

87. Sir Anthony van Dyck, *A Clump of Trees by a Country Road*

88. Albrecht Dürer, *The Virgin and Child with the Infant St. John*

89. Hans Burgkmair, *Portrait of a Man*

90. Hans Holbein the Younger, *Portrait of a Scholar or Cleric*

91. Hans Holbein the Younger, *Portrait of a Youth*

92. Rembrandt van Rijn, *Isaac Blessing Jacob*

93. Rembrandt van Rijn, *An Actor in His Dressing Room*

94. Rembrandt van Rijn, *View on the Amstel*

95. Rembrandt van Rijn, *View on the Bullewijk with a Rowing Boat*

96. Rembrandt van Rijn, *Two Thatched Cottages*

97. Rembrandt van Rijn, *View over the Nieuwe Meer with a Sailing Boat*

98A. Samuel Palmer, *The Bellman*

98B. Samuel Palmer, *Morning*

177

99. Hilaire-Germain-Edgar Degas, *Study of a Horse*

100. Andrea Mantegna, *The Battle of the Sea-Gods*

101. Federico Barocci, *The Annunciation*

179

102. Giovanni Benedetto Castiglione, *Noah and the Animals Entering the Ark*

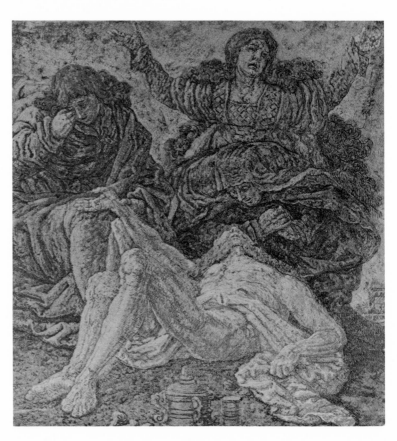

103. Hercules Seghers, *Lamentation over the Dead Christ*

104. Sir Anthony van Dyck, *Jan Snellinck*,
 black chalk

105. Sir Anthony van Dyck, *Jan Snellinck*,
 etching, fourth state

106. Peter de Jode and Sir Anthony van Dyck, *Jan Snellinck*,
 etching, first state of a plate afterwards completed as an engraving

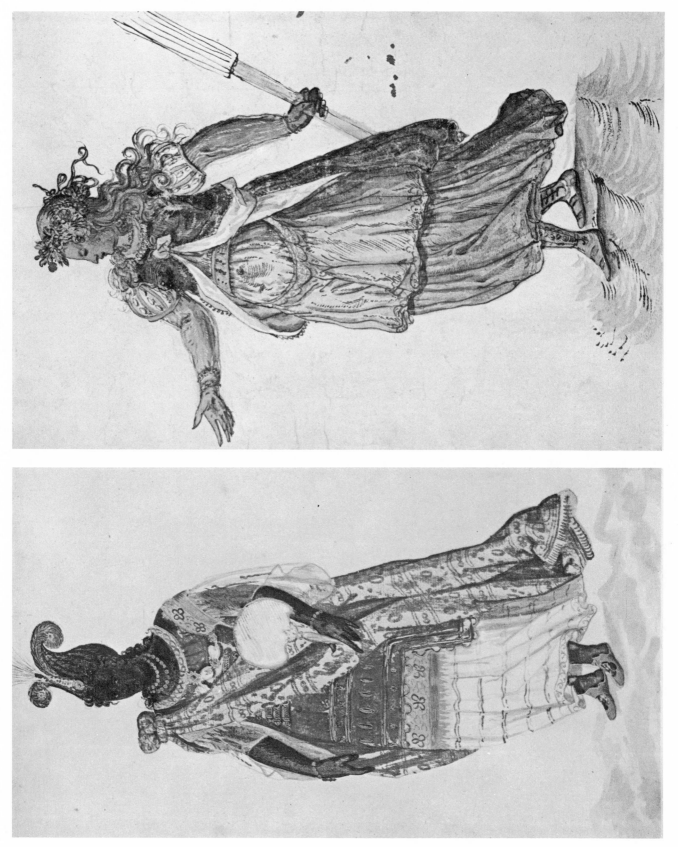

108. Inigo Iones. *A Masquer as a Nero Nymph, Daughter of Niger* 109. Inigo Iones. *A Torchbearer as an Oceania*

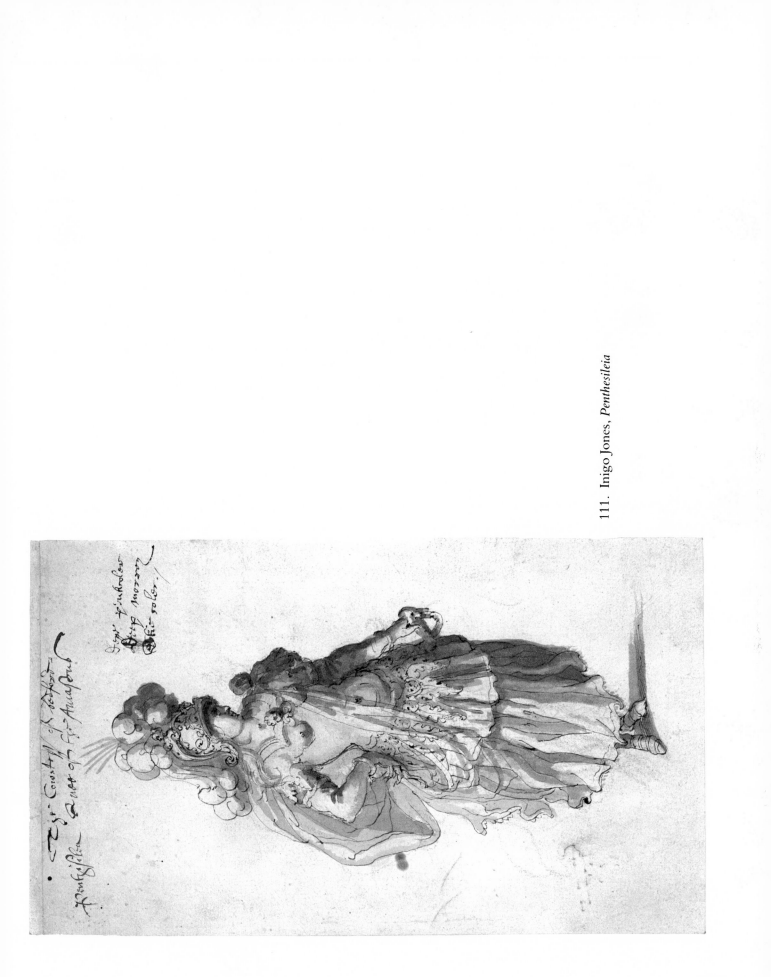

111. Inigo Jones, *Penthesileia*

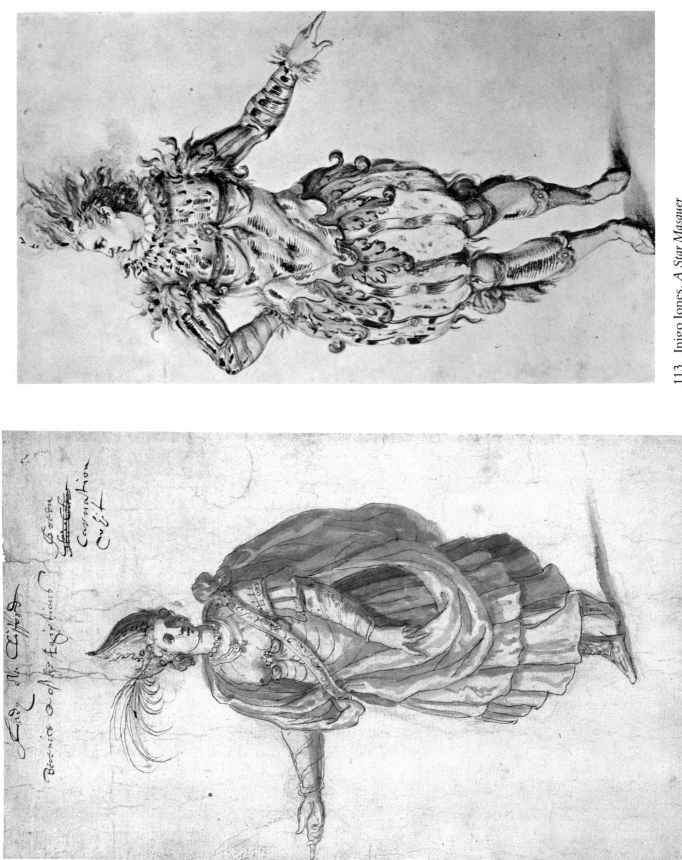

113. Inigo Jones, *A Star Masquer*

117. Inigo Jones, *London Afar Off*

115. Inigo Iones, *Border and Scene with a Stag Hunt*

116. Inigo Jones, *Border and Standing Scene*

114. Inigo Jones, *A Fiery Spirit Torchbearer*

110. Inigo Jones, *The House of Fame*

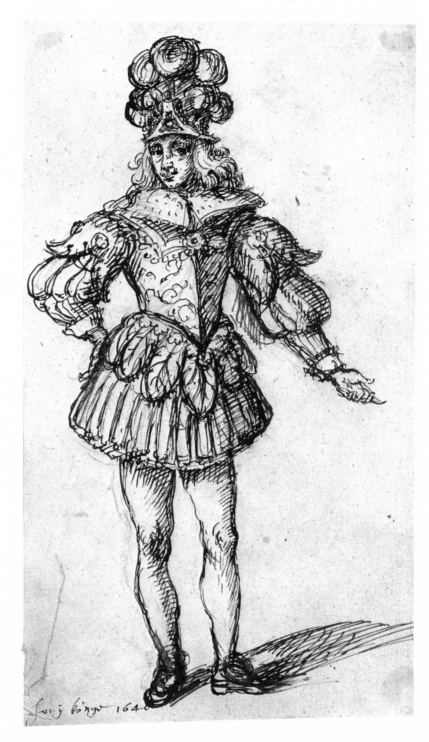

118. Inigo Jones, *The King as Philogenes*

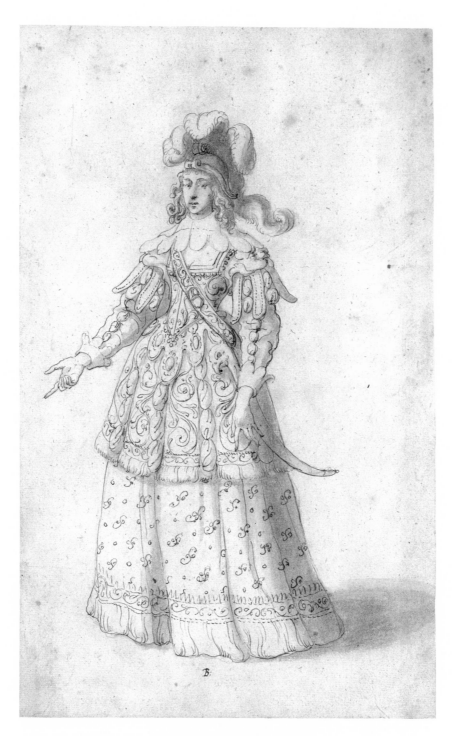

119. Inigo Jones, *A Lady Masquer in Amazonian Habit*

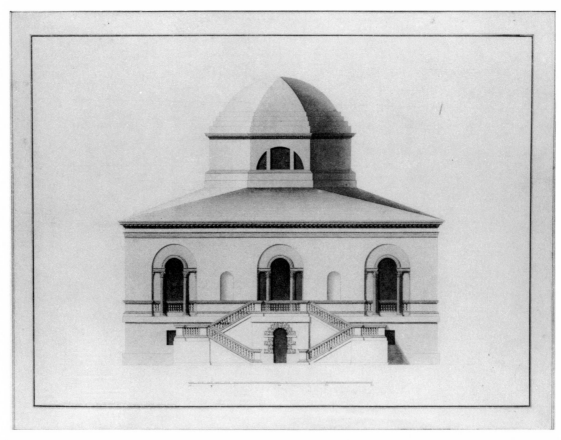

120A. Henry Flitcroft after Lord Burlington, *Chiswick Villa: Rear Elevation*

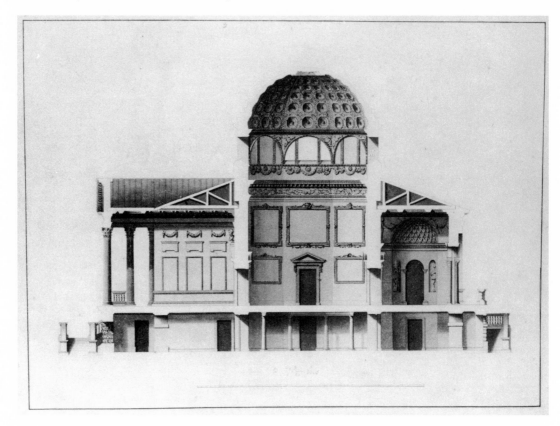

120B. Henry Flitcroft after Lord Burlington, *Chiswick Villa: Section*

121A. Lord Burlington, *The Orangery at Chiswick House*

121B. Henry Flitcroft, *The Orangery at Chiswick House*

122A. William Kent, *Chiswick Villa from the Southwest*

122B. William Kent, *Chiswick: The Exedra*

194

122c. William Kent,
Chiswick: The Cascade

124. William Kent, *Design for
a Cascade at Chatsworth*

125. William Hunt, *The Gallery, Chiswick Villa*

126. William Hunt, *The Saloon, Devonshire House*

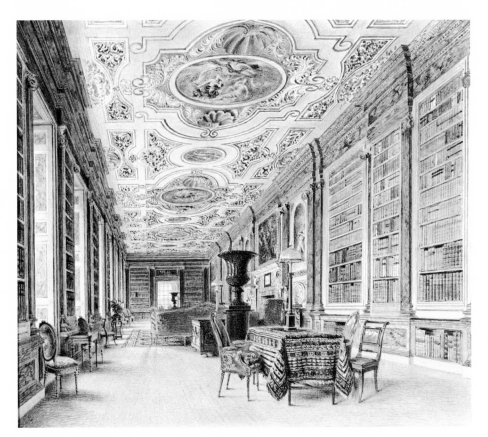

127. William Hunt,
The Library, Chatsworth

197

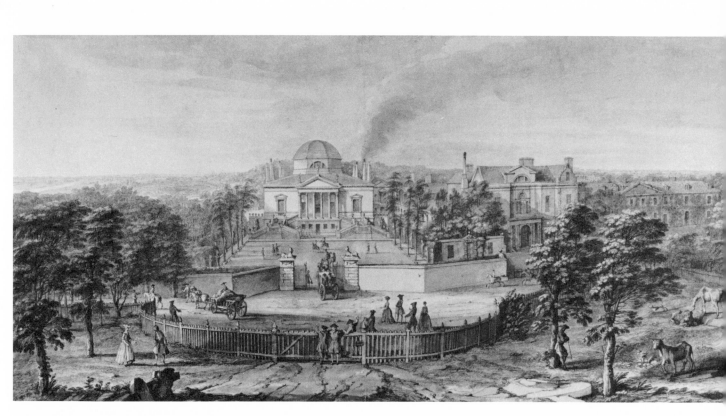

123A. Jacques Rigaud, *Chiswick Villa*

123B. Jacques Rigaud, *The Gardens of Chiswick*

129. William Turner ("Turner of Oxford"), *Bolton Abbey from the River Wharfe*

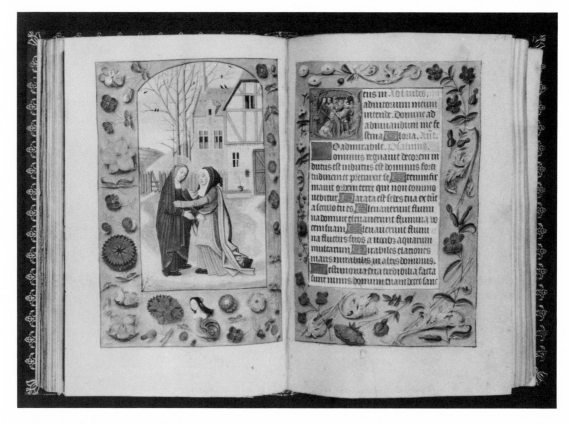

132. Page from a Book of Hours, Flemish, c. 1500

139. Illustration from *Hypnerotomachia Poliphili*, by Francesco Colonna, Venice, 1499

140. *De Serpentibus*, by Nicolo Leoniceno,
 bound by Claude de Picques for Jean Grolier,
 Bologna, 1518

141. *Descriptio Britanniae*, by Paulus Jovius,
 bound by the "Cupid's Bow" binder for Jean Grolier,
 Venice, 1548

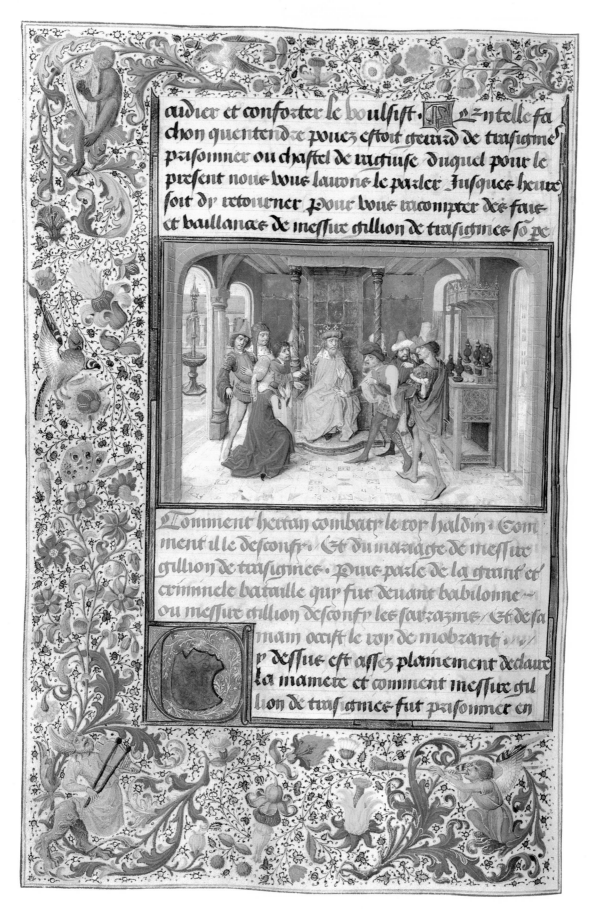

130. Page from the *Roman de Gillion de Trazegnies*, Bruges, c. 1470

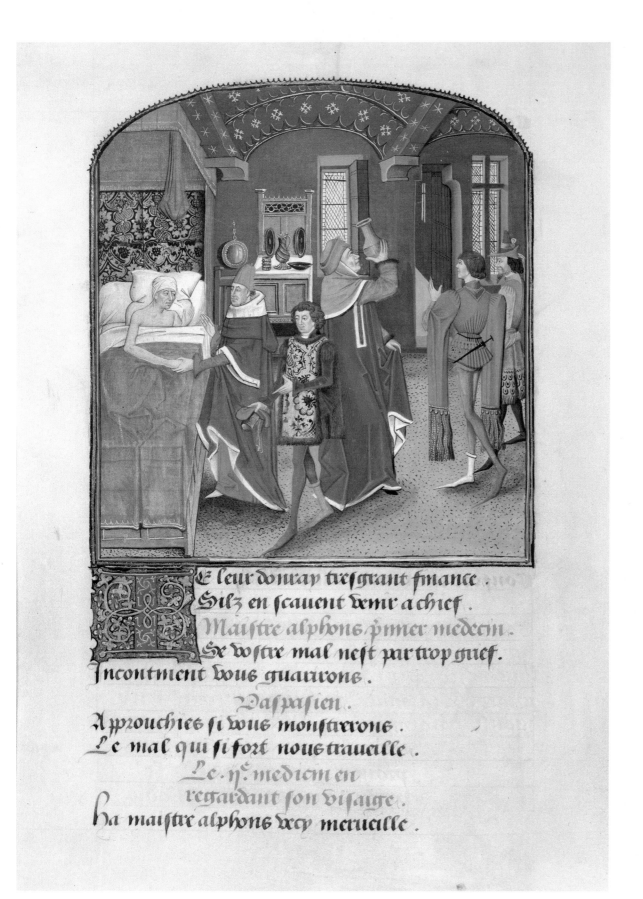

E leur donray tresgrant finance.
Silz en scauent venir a chief.

Maistre alphons pmier medecin.
Se vostre mal nest par trop grief.
Incontinent vous guarirons.

Vaspasien.
Approuchies si vous monstrerons.
Le mal qui si fort nous traueille.

Le .ij.e medicin en
regardant son visaige.
ha maistre alphons vecy merueille.

131. Page from the *Vengeance de Notre Seigneur*, Bruges, c. 1465–68

142. Illustration from *The First and Chief Grounds of Architecture*, by John Shute, London, 1563

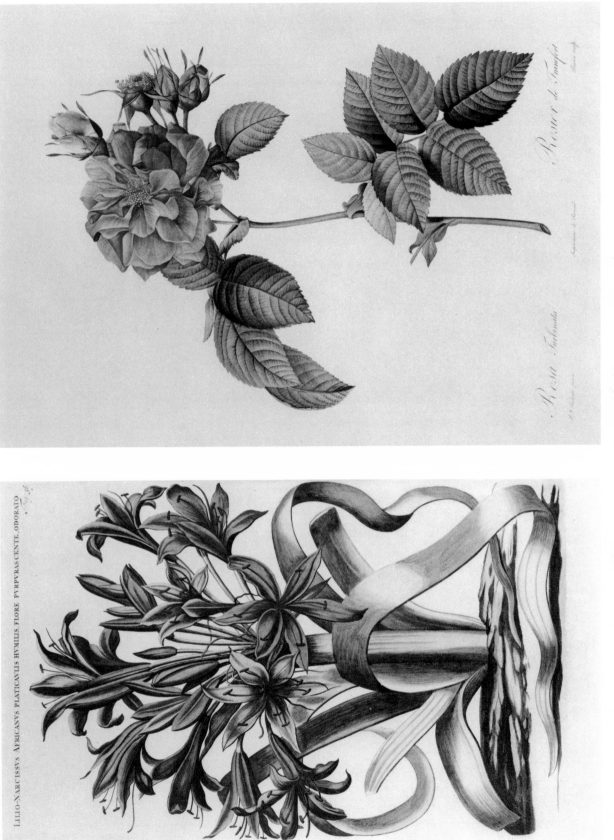

146. Illustration from *Les Roses*, by Pierre-Joseph Redouté, Paris, 1817–24

145. Illustration from *Horti Medici Amstelodamensis Rariorum Plantarum Descriptio et Icones*, by Jan and Caspar Commelin, Amsterdam, 1697, 1701

147. Two illustrations from *The Beauties of Flora*, by Samuel Curtis, Nottinghamshire, 1820

206

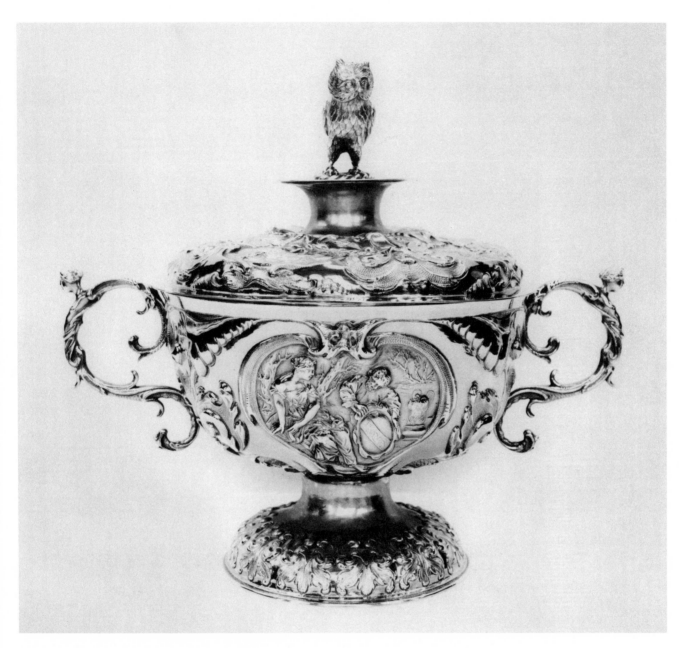

148. Savile cup and cover, London, c. 1650

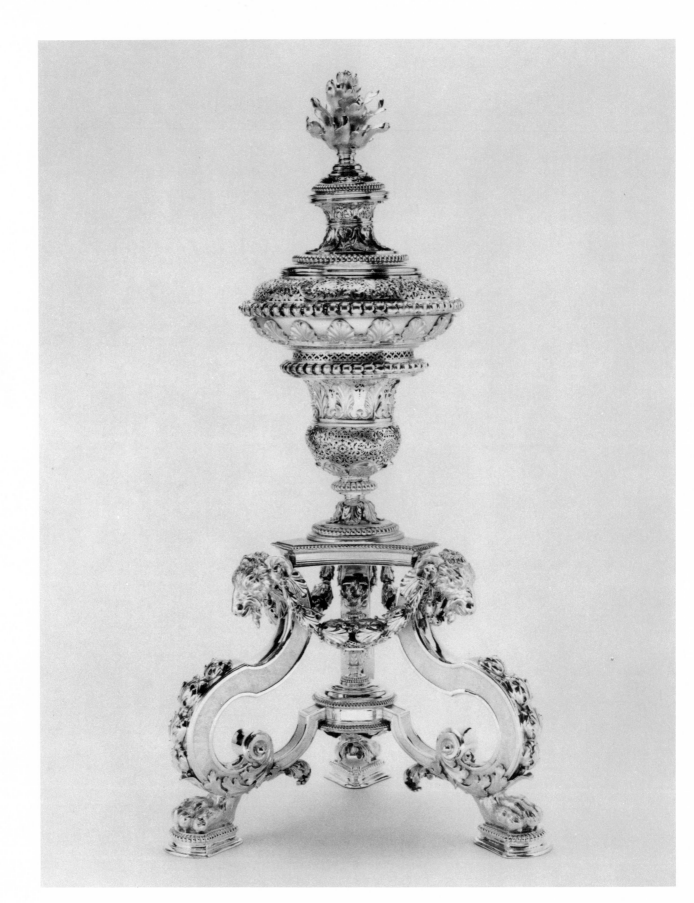

153. Perfume burner, probably London, c. 1690

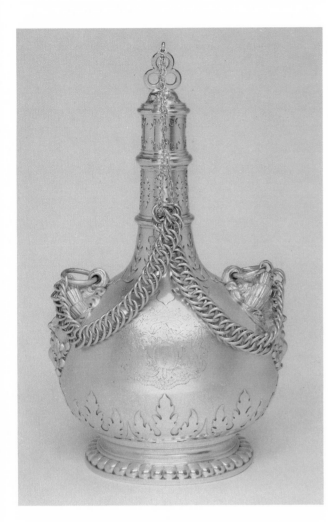

152. "Pilgrim" bottle, by Adam Loots (?),
 The Hague, 1688

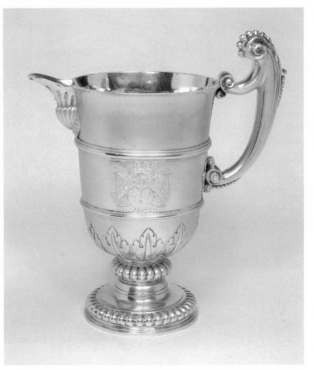

150. Ewer, by Ralph Leake,
 London, c. 1685

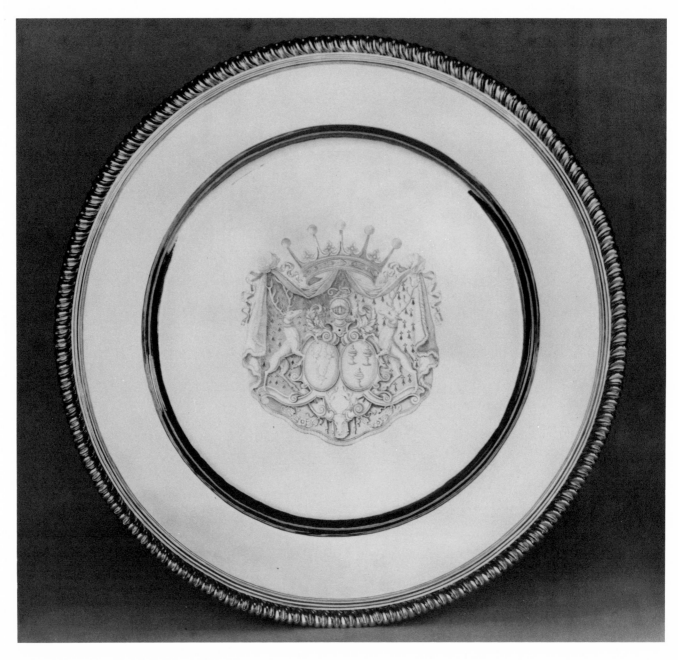

151. Rosewater dish, London, 1683–84

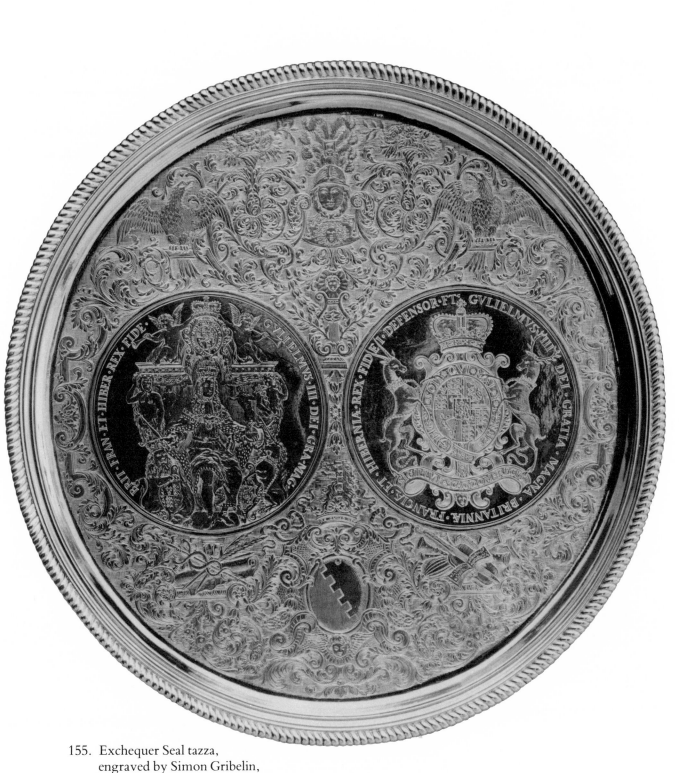

155. Exchequer Seal tazza,
engraved by Simon Gribelin,
London, c. 1702

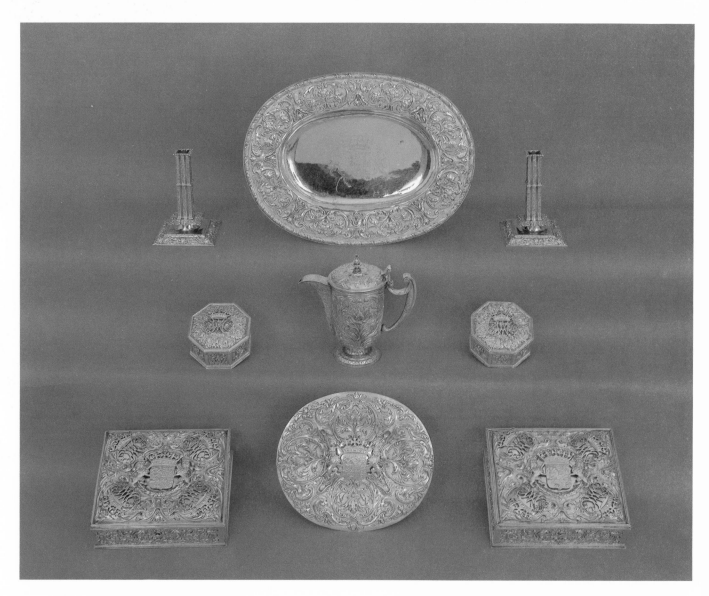

149. Items from a 23-piece toilet service,
 by Pierre Prévost, Paris, 1670

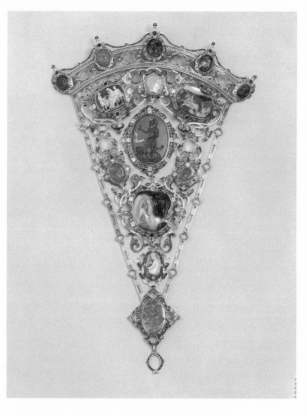

176. Stomacher from the Devonshire parure,
 by C. F. Hancock, London, c. 1856

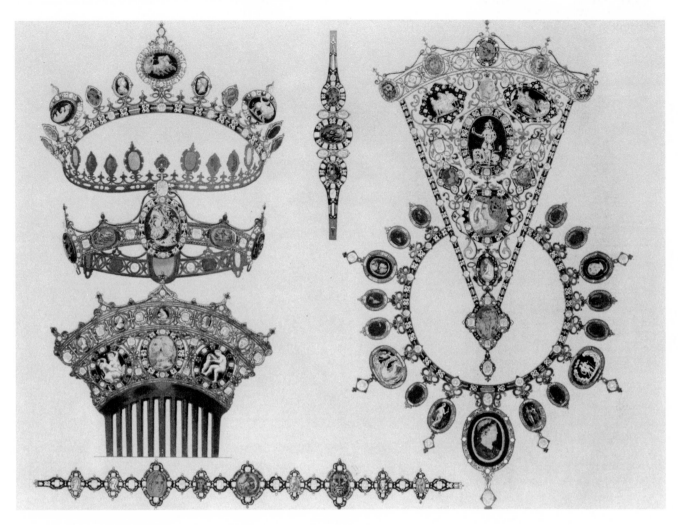

176. The Devonshire parure, by C. F. Hancock, London, c. 1856

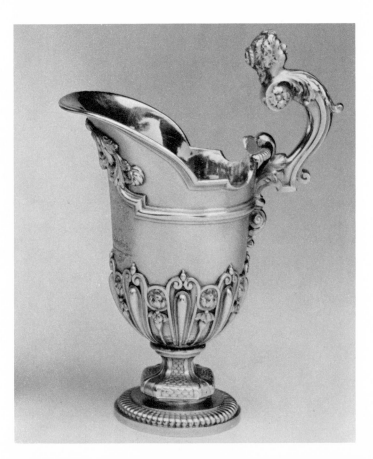

156. Ewer and basin, by Pierre Platel, London, 1701

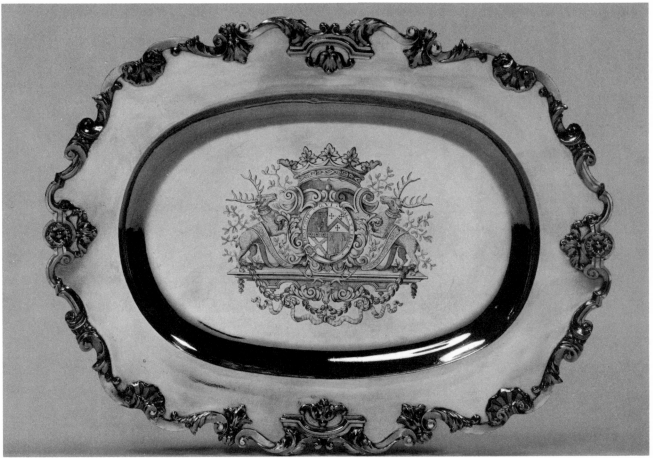

157. Silver table top, engraved by Blaise Gentot, Paris, c. 1710

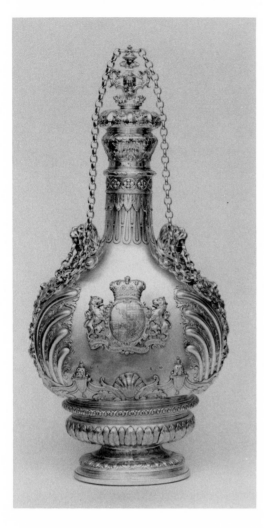

158. "Pilgrim" bottle, by Anthony Nelme,
London, 1715–16

159. Two leaf-pattern fruit dishes,
London (?), mid-18th century

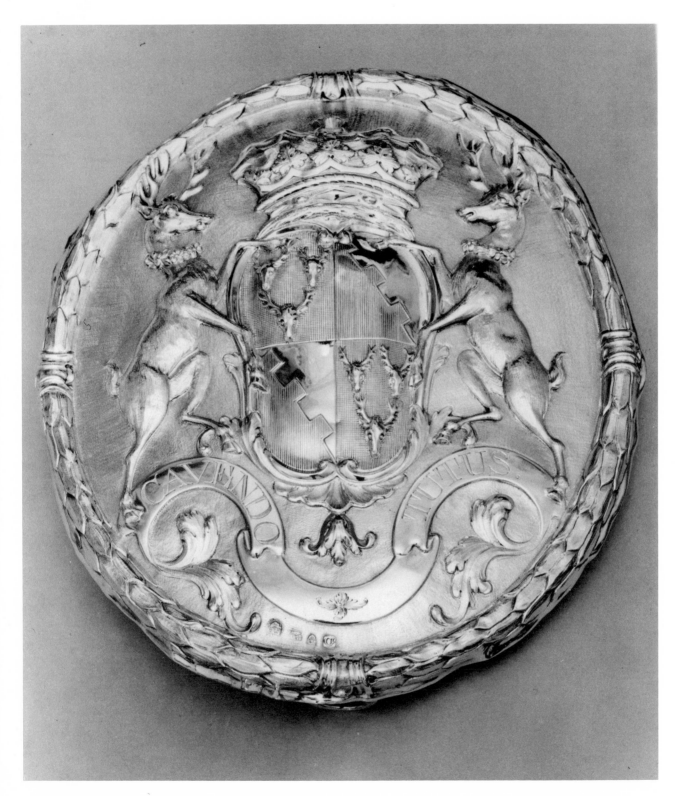

160. Badge embossed with the arms of the Duke of Devonshire, by John Parker and Edward Wakelin, London, 1769–70

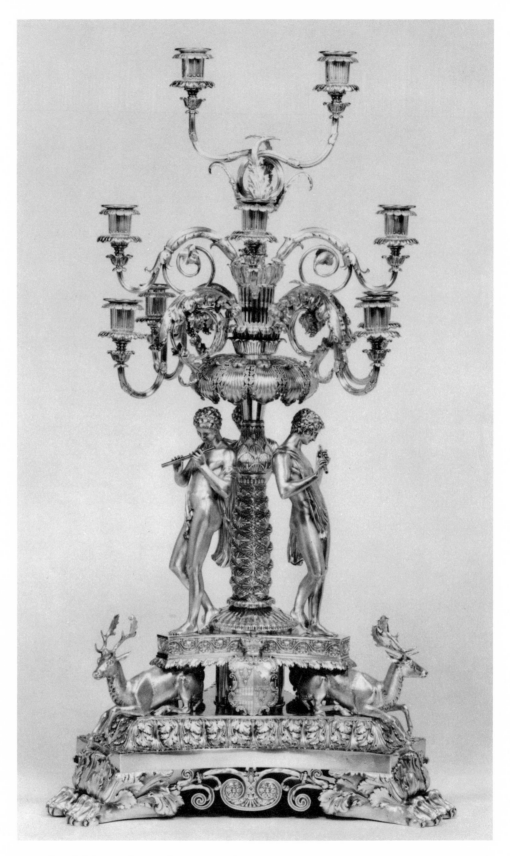

161. Candelabrum, by Paul Storr, London, 1813–14

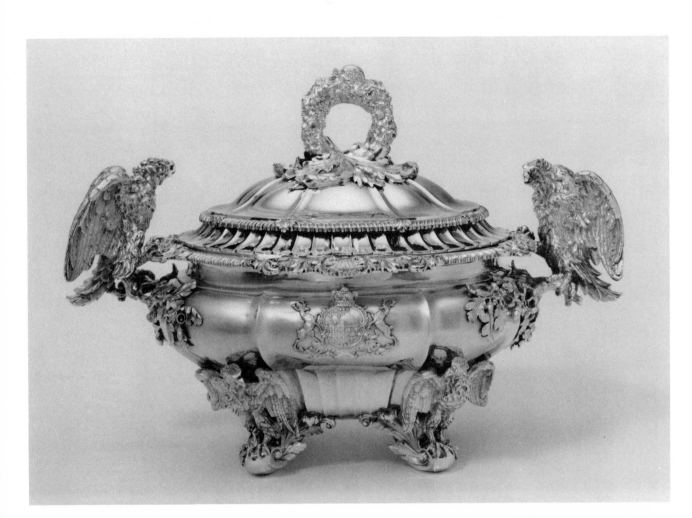

162. Soup tureen,
 by Paul Storr,
 London, 1820–21

163. Dog collar made for
 the 6th Duke's mastiff,
 by Robert Garrard II,
 London, 1832

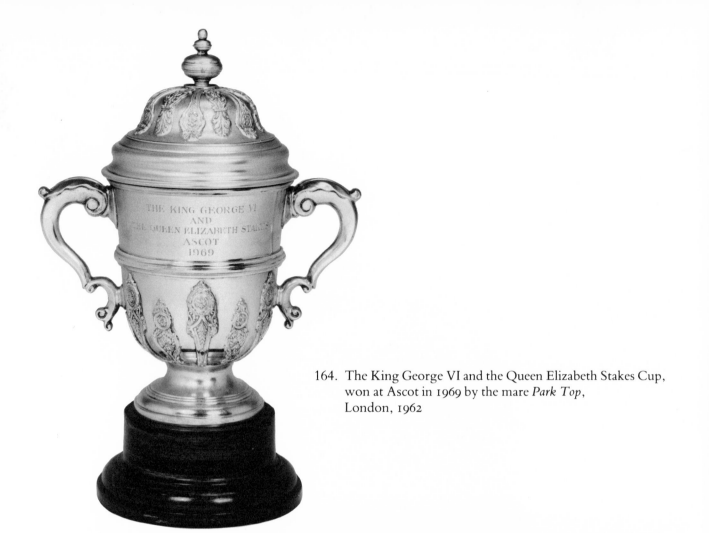

164. The King George VI and the Queen Elizabeth Stakes Cup,
won at Ascot in 1969 by the mare *Park Top*,
London, 1962

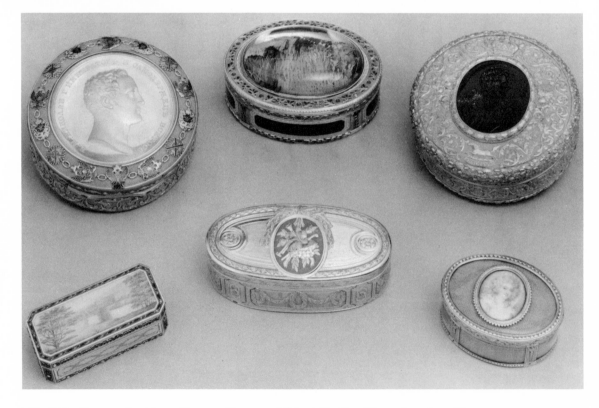

165–170. Group of gold snuffboxes. *Top row, left to right:* Cat. Nos. 169, 167, 168
Bottom row, left to right: Cat. Nos. 170, 165, 166

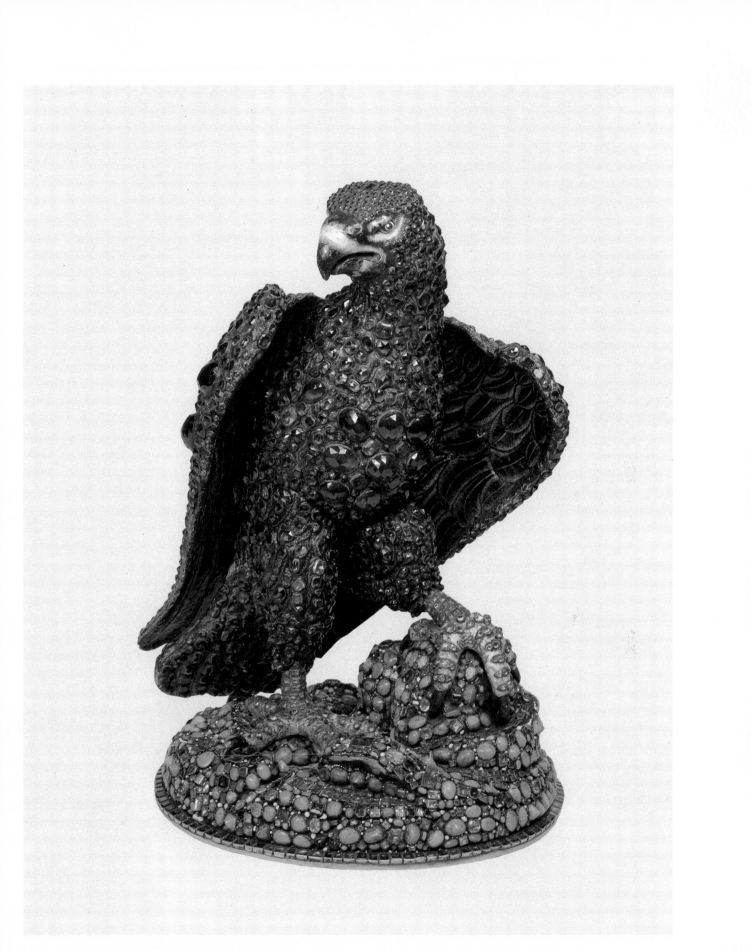

174. The Kniphausen "Hawk," 1697

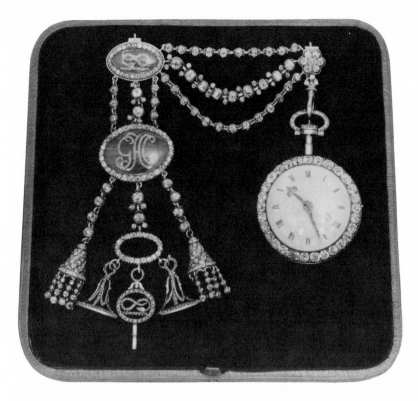

175. Watch and châtelaine set with diamonds, early 19th century

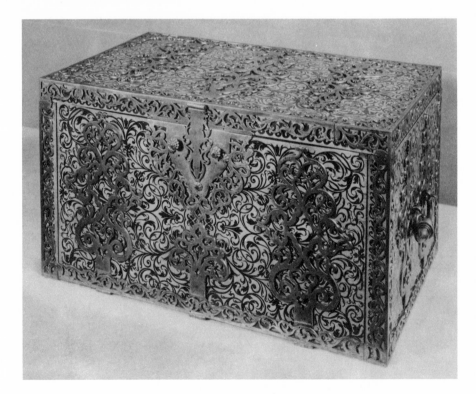

177. Coffer, probably made by Gerreit Jensen, London (?), c. 1690

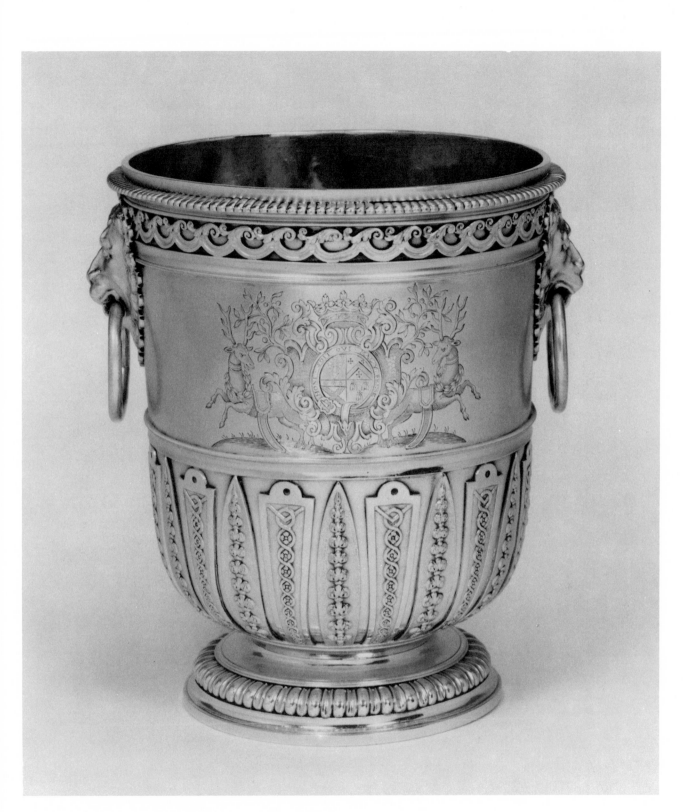

154. Wine cooler, by David Willaume, London, 1698–99

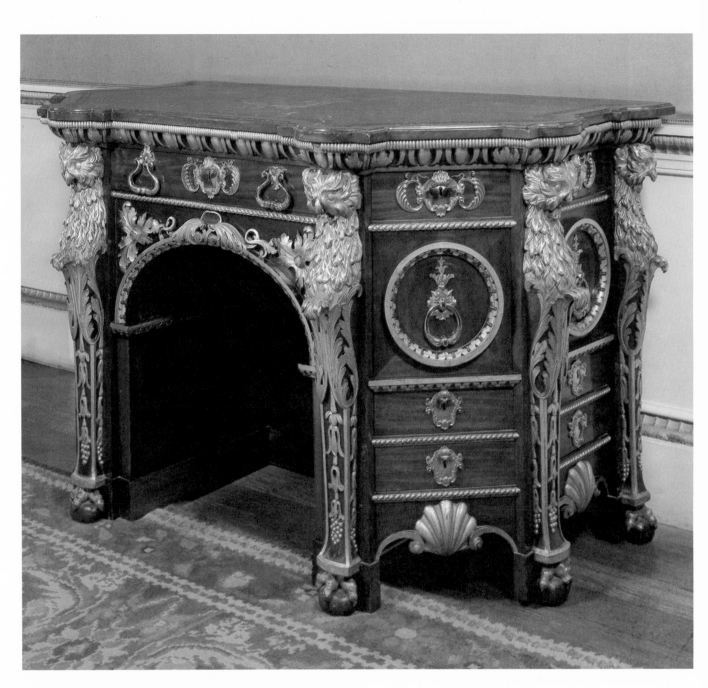

182. Library writing table, c. 1740

171. Flintlock fowling piece, by Isaac de Seret, London, c. 1690

172. Flintlock double action fowling piece, by Landreville, London, c. 1690

173. Pair of French percussion duelling pistols with accessories, by Jean Le Page, Paris, c. 1840

178, 181. Two hall chairs and a settee, probably designed by William Kent, c. 1730–40

179, 180. Three chairs, probably designed by William Kent and made by Benjamin Goodison, c. 1735

183. Corner cupboard,
London (?), c. 1770

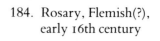

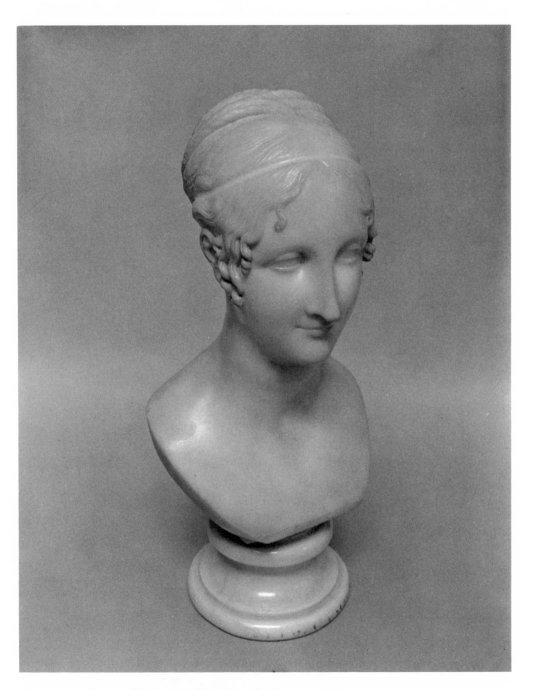

185. Bust of Petrarch's "Laura," by Antonio Canova, 1818

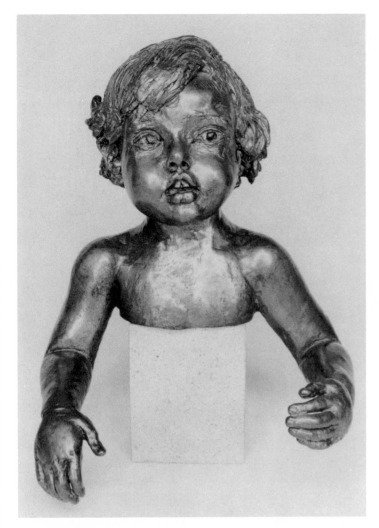

186. Infant portrait of Lady Sophia Cavendish (b. 1957), by Sir Jacob Epstein

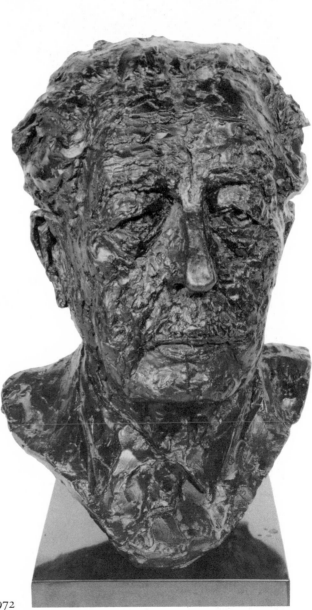

187. Portrait bust of Harold Macmillan, by Angela Conner, 1972

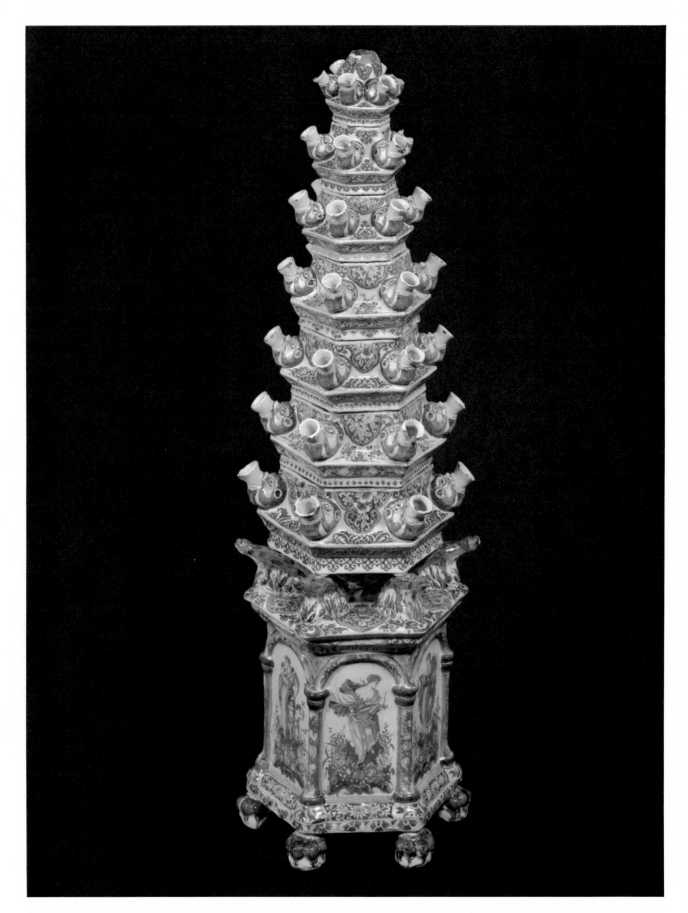

188. Delft tulip vase, by Adriaen Koeks (active 1687–1701)

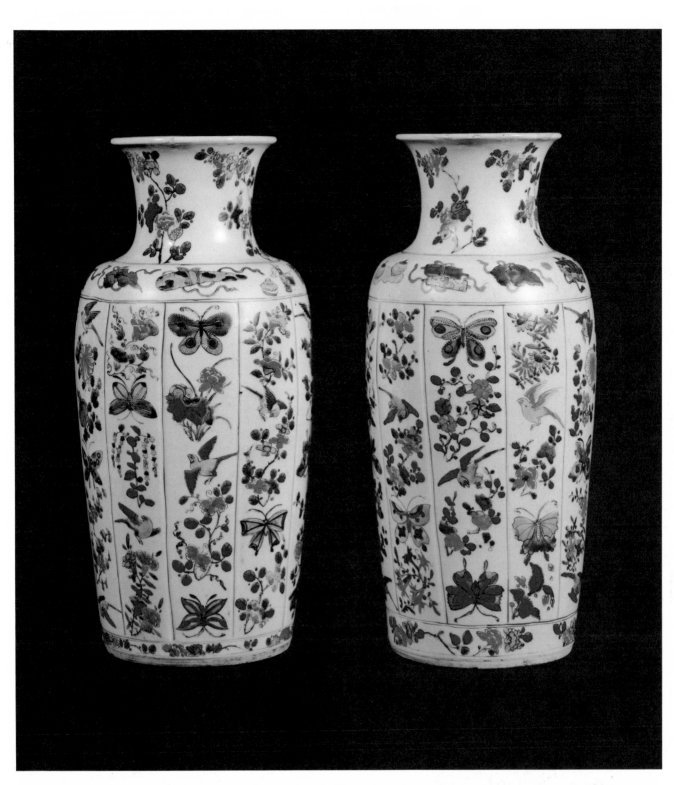

194. Pair of famille verte vases, Chinese, K'ang Hsi period (1662–1722)

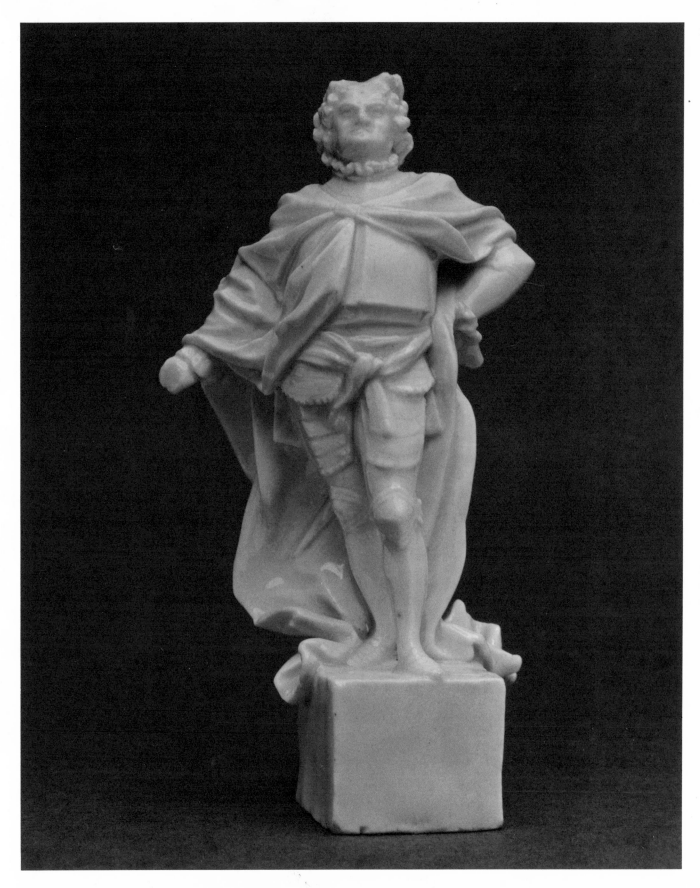

189. Figurine of Augustus the Strong, Meissen, c. 1715

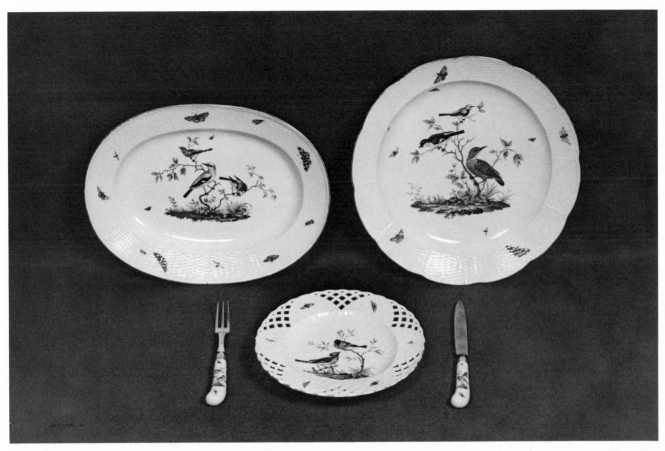

190. Pieces from a dinner service, Berlin, c. 1780

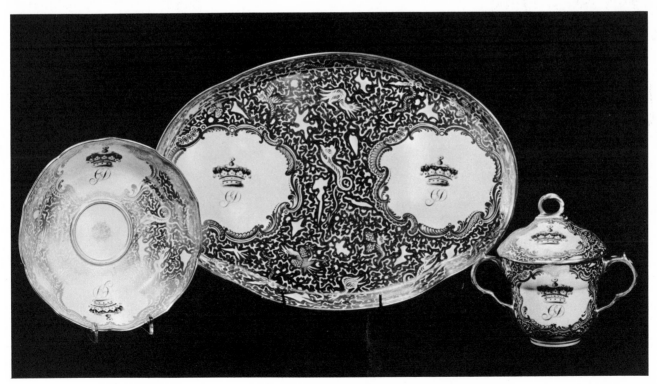

192. Cup, saucer and matching tray made for Duchess Georgiana, Derby, c. 1800

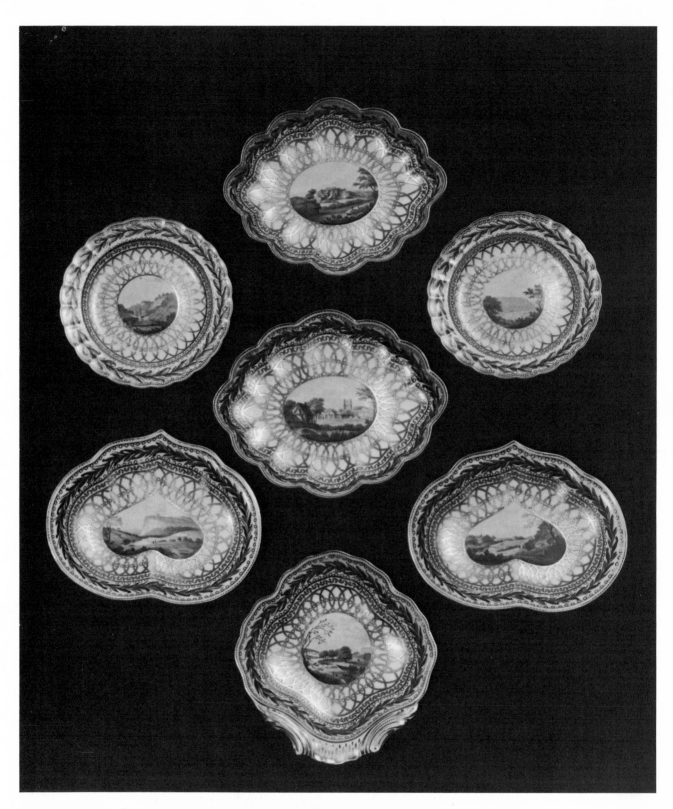

191. Pieces from a dessert service, painted with scenic views of Derbyshire, Derby, c. 1790

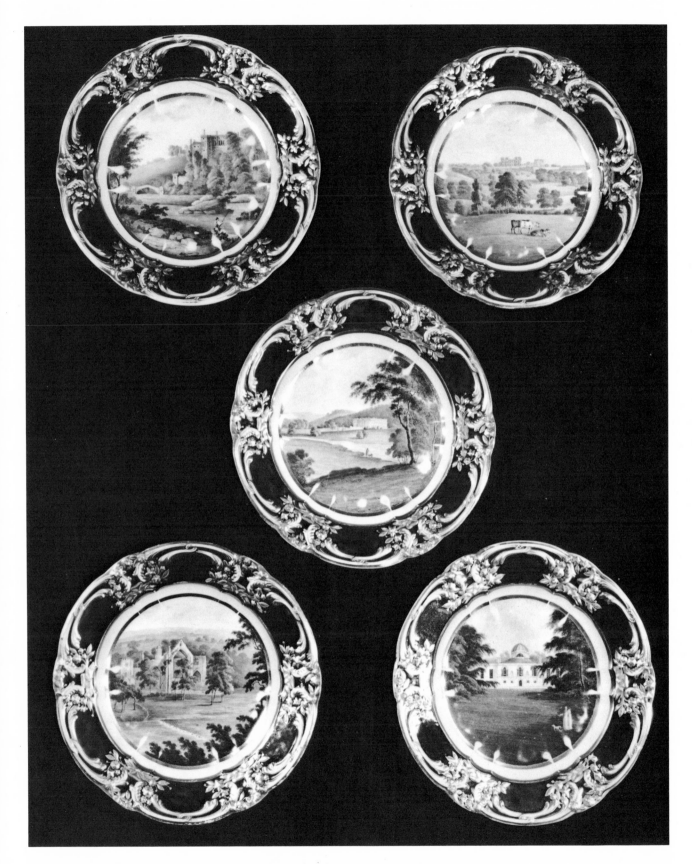

193. Five dessert plates with views of Cavendish family seats
Top row: Lismore Castle; Hardwick *Center:* Chatsworth *Bottom:* Bolton Abbey; Chiswick